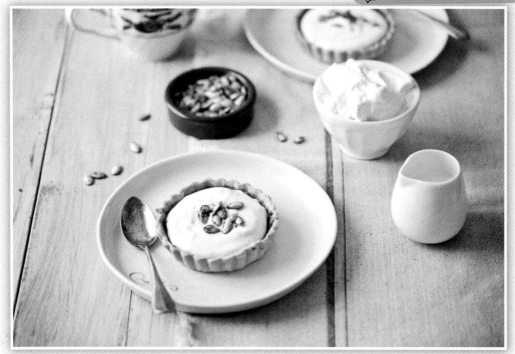

Plate to Pixel

Digital Food Photography & Styling

Hélène Dujardin

WILEY

Wiley Publishing, Inc.

Plate to Pixel: Digital Food Photography & Styling

Published by
Wiley Publishing, Inc.
10475 Crosspoint Boulevard
Indianapolis, IN 46256
www.wiley.com

Copyright © 2011 by Wiley Publishing, Inc., Indianapolis, Indiana

Published simultaneously in Canada

ISBN: 978-0-470-93213-1
Manufactured in the United States of America

10 9 8 7 6 5 4 3 2

For general information on our other products and services or to obtain technical support, please contact our Customer Care Department within the U.S. at (877) 762-2974, outside the U.S. at (317) 572-3993 or fax (317) 572-4002.

Wiley also publishes its books in a variety of electronic formats. Some content that appears in print may not be available in electronic books.

Library of Congress Control Number: 2011924116

About the Author

Hélène Dujardin moved from France to the US in the late 90s with a Masters in History, a suitcase and an old film camera. Soon after, she decided to follow her first passion, food, and so began honing her skills in various dining establishments. She became the pastry chef at a French restaurant and she stayed there for five years. Yet photography was never very far from her heart. Hélène started taking pictures of food for the restaurant staff to help them recreate her desserts when she was not on duty. On her days off, she often walked around town, photographing the beauty of common things.

Upon leaving her pastry position in 2006, Hélène launched the award-winning blog *Tartelette*, where she dedicates herself to the art of food, photography, and styling. It didn't take long for photography to become more than a hobby. Hélène progressed quickly from enthusiast food photographer to professionally working with local and national magazines. She also began photographing and styling numerous cookbooks.

Photo by Diane Cu

Hélène's food photography and styling work has been praised online and in print by publications such as *Elle* magazine, *Forbes* magazine, *The Times* Online, *Saveur* magazine, CNN, *Martha Stewart* and more.

Her photographs reveal her passion for natural light, seasonal and fresh ingredients, a love of travel and genuine interest in people. Hélène currently lives in Charleston, South Carolina, with her husband and their two rescue dogs.

Credits

Acquisitions Editor
Courtney Allen

Project Editor
Jenny Larner Brown

Technical Editor
David Verdini

Copy Editor
Jenny Larner Brown

Editorial Director
Robyn Siesky

Business Manager
Amy Knies

Senior Marketing Manager
Sandy Smith

Vice President and Executive Group Publisher
Richard Swadley

Vice President and Executive Publisher
Barry Pruett

Book Designer
Erik Powers

Media Development Project Manager
Laura Moss

Media Development Assistant Project Manager
Jenny Swisher

Acknowledgments

First and foremost, I would like to thank my husband, William, for holding me through this process. Words fall short to convey how lucky I am for his guidance whenever I got lost.

Thank you to my parents, Monique and Jacques, for being just the greatest parents in the world. I am forever thankful for their gift of encouraging me to seek beauty all around.

I would like to thank my brother Arnaud and his wife, Stephanie, for their constant enthusiasm and positive attitude. I will never forget my niece Lea channeling her aunty during the summer of 2010, when she took pictures of foods we cooked together. I hope to read this book with her and her sister Camille soon.

To my grandfather, Papi René: I know, I know… I told you I'd open my own bakery by age 35. I wrote a book instead. I hope you're okay with that!

Thank you, Mamie Paulette for giving me this passion I have for food, making it well and sharing it with others, either around our table or through my photographs.

Thank you, mama Ruth and papa Bill for always making this life my home. Your support and love know no boundaries.

Taylor, your genuine friendship and love of photography are gifts indeed. Thank you for all your help and enthusiasm.

Anita, Jen, Jeanne … my three musketeers: thank you for your amazing support, care and sass. You guys are just the best. Move closer!

Thank you, Matt Amendariz and Lara Ferroni. Your genuine advice, constant kindness and open heart are gifts to the photography community.

Carrie and Tami, your capacity for humor, authenticity and courage has been great motivation throughout this project.

Thank you, Courtney Allen for giving me the opportunity to write this book and show others the fantastic world of food photography and food styling.

A special thank you to Jenny Larner Brown for editing my words as well as she did. I don't know what was worse: the extra-long sentences or the French coming through at times.

Thank you David Verdini for making sure I crossed all my Ts and dotted all my Is regarding technical terms and concepts. I enjoyed learning new things at the same time.

And thank you Erik Powers for the beautiful design of this book as well as the long hours spent working to lay out all the words and images so well.

Thank you to all my friends and readers for their support and enthusiasm during this project.

To my brother Thierry (1962-2000)

He was, in my eyes, one of the most inspiring photographers out there. He saw with his heart. His spirit never left my side the whole time I was writing this book.

Contents

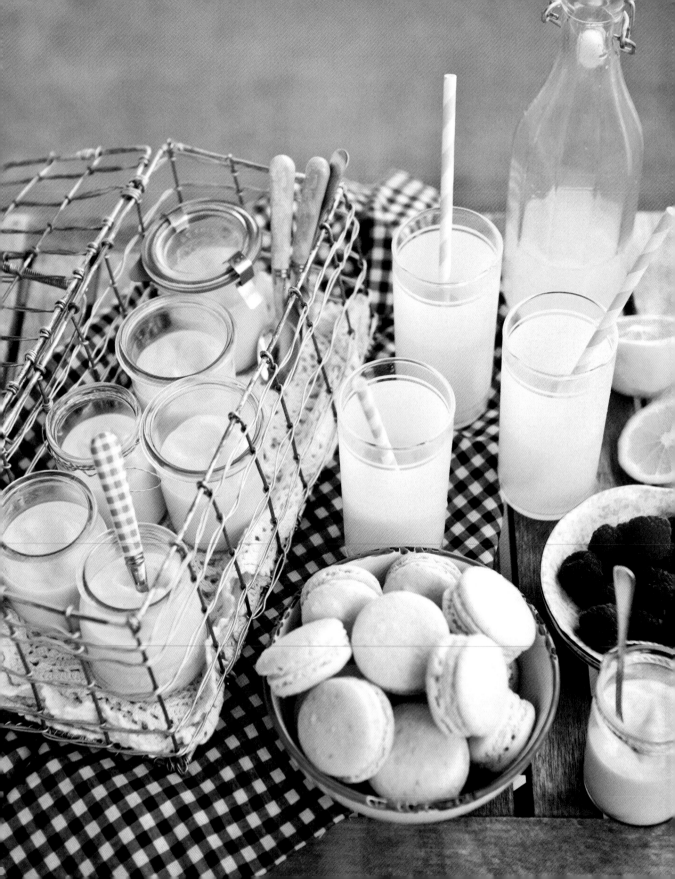

Introduction

*Follow your heart, but be quiet for a while first. Ask questions,
then feel the answer. Learn to trust your heart.*

—Anonymous

I know it sounds unusual, but I fell in love with food
photography the way I fell for my husband, the one true
love of my life. It was completely unexpected, gorgeous,
unsettling. It moved me and scared me. It made me
curious and brave. It left me hungry to learn more.

I was a senior in high school on a fabulous two-week
excursion through Greece. On the first morning, we did
the obligatory visit of the market in Athens. And within
minutes, my head was spinning from the buzz happening
all around me. Vendors screaming, tourists pushing,
bicycles and motorcycles zooming through crowds of
pedestrians … and display after display of artifacts—and
food! Oh, the food.

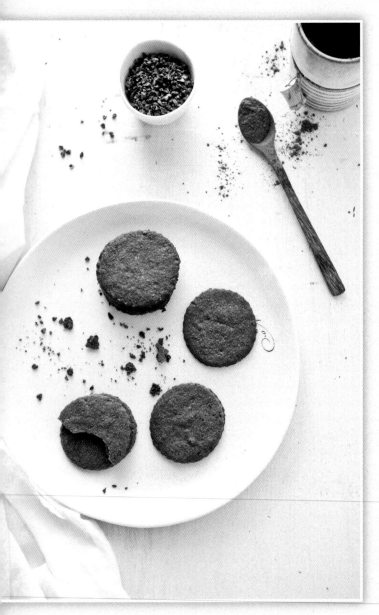

Ingredients used in a recipe, such as the cocoa nibs and cocoa powder in these cookies, make the perfect natural props for a composition.

f/3.5, ISO 400, 24-70mm L

Everywhere I turned, there was color; there was smell; there was taste. Instead of letting myself go with the flow and join the excited agitation of my companions, I got overwhelmed. I took a step back … and a long, deep breath … and loaded my camera with black and white film. I know! Love at first sight is utterly crazy, isn't it?

I had never encountered food and color like this. It had never been presented to me this way. I went home and spent hours in the dark room looking at those black and white images. I had so much to learn, but I was completely hooked! I wanted to do it again. This time in color.

For many years, I played around with photographing food but not very seriously. It was not the field I was studying at school, and there was little free time to practice. It took another ten years or so before food photography came knocking on my door, so to speak.

That knock came when I was working as the Pastry Chef of a French restaurant. I was finding it increasingly difficult to get the night staff to plate the items I had carefully made … according to my instructions. I would write lengthy descriptions that no one would read. I even tried creating drawings to illustrate the look I envisioned. Admittedly, my drawings were pretty bad; any three-year-old would have laughed at them. But nothing was working.

Then, one day, a light bulb went off in my head: *A picture is worth a thousand words!* I brought my Polaroid to work and started taking shots of each plated item to show the staff what I wanted from them.

After a few years like this, I was convinced that Pastry Chef was my calling, and I decided to make myself a little portfolio to show potential employers what I could do with some dough. Within a few hours of taking pictures of my desserts, I was already aware of a realization that was making me grin from ear to ear.

It was not the ten pounds of chocolate I had just tempered or the perfectly shaped sugar cages coming out of my kitchen. Rather, it was the way I was translating these pastries with images. I was manipulating the light around me to put that perfect shine on my chocolate. I was managing to tie together all that *mise-en-place* by adding a little sprinkle of powdered sugar to the top of my almond croissant. Ah-ha! Epiphany!

I can't say that the rest is history; but from that point on, everything I did led me a step or two closer to what I am doing now—whether I was aware of it at the time or not. That day truly felt like Christmas morning. Years later, my photography work still gives me that same feeling.

And I remember distinctly the day I told my husband I was going to start a food blog—what I referred at the time as an *online*

Backgrounds come in all shapes, sizes and colors. Here, a recycled green vintage ceiling tile enhances the yellows and blues of the other elements in the shot.

f/4.5, ISO 500, 100mm, Macro L

Make use of light and shadows as well as complementary colors, such as blues and oranges, as natural composition tools.

f/3.5, ISO 640, 100mm, Macro L

recipe journal. I created the front page, put a recipe up and posted a little story with it. I turned to him and said, "I need a camera to take a picture … to show people the final dish." The next day he handed me an entry-level camera and told me to have at it.

I was a bit disappointed. Okay… I was very disappointed. I wanted the nice camera with the lenses and the cool gear. But I knew he was doing me right, and his choice was largely due to the fact that I picked up and dropped a new hobby every year or so. Little did either of us know at the time that food photography would become my career. What he *did* know was that without photography fundamentals, I'd get nowhere … no matter what kind of camera I had.

Now that I work as full-time food and lifestyle photographer, I still marvel at what I am able to achieve and learn. I work every day. Even when I don't have an assignment, I practice … every day.

You may have an ultimate desire to make a career of food photography; or perhaps you just want to take a good food shot for your blog or article, master a challenging new subject for your photography portfolio, or check out the "food photography thing." It doesn't matter. Learning, practicing—or what I really want to dub *playing*!—to get great images that make your mouth water will be much more rewarding when you take control of all the photographic elements that get you there.

Let's use an analogy. Unless a prodigy, you can't expect to pick up a violin and play a melodic rendition of Beethoven Sonata No.9 without first learning music. And even when you learn how to read music and play a violin, you may never actually play Beethoven; but at least you will know the fundamentals that enable you to play jazz, rock, funk, whatever. You will be in charge of your artistic decisions.

Photography is similar. Knowing some basic photographic principles allows you to access a world of light and artistic interpretation … to play with and enjoy, modify and create—in a way that matters to you and your audience.

The information in this book is meant to help you create a process for photographing food that begins long before your assignment and extends beyond the click of your shutter button. There are guidelines for creating beautiful photographs, but your particular process will be driven by your individual personality, equipment, style and budget … and it will help you convey the messages and evoke the feelings you envision for your pictures.

The more you know and learn about your camera, light, composition and styling, the more capable you'll be to get the most out of your camera gear and photography work. Your recipes are important to you and your family. Let your photography capture that spirit. Learn, play, enjoy the process!

1 ✦ Photography Basics

Photography is the method of recording the image of an object through the action of light, or related radiation, on a light-sensitive material. The word is derived from the Greek word photos (which means light) and graphein (which means, to draw).

—Encyclopedia Britannica

To draw with light …

Without light, we can't see. Nor can we create a scene or make a picture. Light is everything to photography.

Yet what I love most about photography is that an individual image is the result of so many different considerations, decisions and factors. Aside from the lighting, there are decisions on what kind of camera to use, camera settings and modes, composition techniques and even photo-editing options. Every one of these elements affect the story you tell with your images.

So learn and practice the basic techniques of photography; experiment and explore different combinations of elements; erase if you must; and do it again. You'll find that your technique becomes second nature and the images you create get better and better. And the most wonderful part of all is that there're always more aspects to discover and explore. The possibilities are truly endless.

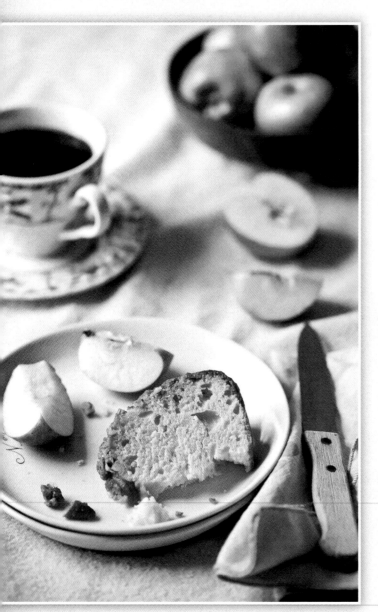

Use light and shadows to capture the mood of tea time during a rainy afternoon.

f/3.5, ISO 400, 100mm, Macro L

Light is Everything

At a workshop this past summer, a budding food photographer candidly asked me why every photographer she'd met talks about light so much. My mind started jumping in all different directions. I was so excited to show her why. But I didn't want to freak her out, so I contained my excitement and calmly gave her the very definition of photography that's printed at the start of this chapter. And then we talked about how viewers typically respond to a photograph of food.

As expected, the first thing people usually say about a food photograph is something about the dish. And the second thing they tend to notice—consciously or not—is how the light hits a certain part of the dish … or doesn't. Light and shadows, too much or too little, will make a viewer like or dislike a photograph as much as the food it presents.

Assessing light and figuring out how to use it in food photography is very much like courtship and the pursuit of capturing someone's heart. To find the right light, you must observe, explore and discover. The beauty of digital photography is that you can erase and start over. It's never a waste of time, but rather a learning experience—much like dating … except, of course, the erasing part.

Whether your ambient light comes naturally or from artificial sources, there are many ways you can capture and apply it. Several key points come into play, including where to find

quality light, how to direct it for your purpose, and how to incorporate shadows and *high key* (very bright) notes. (See the Glossary for the definition of specific terms used throughout this book.)

The elements of lighting and how your camera settings and modes work with your lighting circumstances are covered in Chapter 3 (Natural Light Photography) and Chapter 4 (Artificial Light Photography). And please, refer to Chapter 2 (Camera Settings and Modes) as we explore other photography elements. Everything works together to create your photographs.

Camera Schmamera: Does it matter?

After you read the next chapter on Camera Settings and Modes, you may think that this book applies only to people with a dSLR camera, that it's not for those with a Point and Shoot (P&S). But that's not the case.

Whether you have a dSLR or a P&S, the basic principles of good photography remain constant. To create beautiful images, you need to understand light, shadows, composition, aperture, ISO, white balance and other fundamentals. And even when you become well-versed in these areas, the choice of camera seldom matters to how well a photographer executes basic techniques. I see gorgeous photography created with P&S cameras, and I see terrible photography from dSLRs. It's not the camera that makes the photograph. You do.

Take full opportunity of bright summer light to show a clean crisp atmosphere in a scene.

f/3.2, ISO 640, 100mm, Macro L

All of these cameras work; we just need to work on making time to use them all!

f/1.8, ISO 400, 50mm

So why invest in a dSLR, you may be wondering. Well, frankly, it's a control thing. A dSLR simply offers more creative control. And, I have to add, the reproduction quality of a JPEG taken with a dSLR will usually be better than one taken by even a high-end P&S, because of the higher data-recording capability offered by the better sensor available in dSLRs. But more on this later …

For me, it was first about the control. I remember the day I picked up my little pocket camera, handed it to my husband and said, "I need to upgrade." What I needed was a proper lens and better sensor. At that point, I had learned and used every function my camera offered, and I was ready for more control. Again, this was after I knew that camera—what each bell and whistle was and what it did.

So, if you're just getting started, don't let yourself be dazzled by special features, cool accessories and size. Photography is pricey. Obviously, most photographers no longer invest in film and developing materials/services, but there are P&S cameras that cost as much as entry-level dSLRs nowadays. And then there are the extras: the lenses you'll want, the memory cards, flash units and so much more.

So I strongly recommend that you do your research before choosing a camera. I definitely know that the itch that comes with wanting camera equipment can be stronger than reason; but especially with electronics, it's important to know your options … and be clear on what you actually need.

Think first about your budget and about how much you can realistically afford to spend on a camera, potential upgrades and photography equipment. Think about what you currently own and the repercussions of switching to another brand. This is important, because each brand speaks a different language. When giving camera recommendations, I always qualify my advice saying that I "speak Canon—not Pentax or Nikon." These brands are different and they each feel a bit different.

So read as much as you can about your options, and decide which is right for your budget and your situation before purchasing a P&S or dSLR of any brand.

A final bit of advice here: Despite the convenience of online shopping, nothing compares to hands-on experience with a camera. Go to a store and hold a few different makes and models to find out how they feel.

If you go the dSLR route, I suggest that you take the time to rent a few different bodies with one basic lens … and see how you like each option. A camera is not just a pretty toy or a seasonal purchase. It's an investment—usually a substantial investment. And I'm not just talking money. I am in love with my Canon cameras. They offer an extension of the way I see things—from my heart through the lens. I'm so glad I explored the options and found the camera that was really right for me … before I committed!

Know the Basics

No matter what brand or model of camera you choose, certain key settings and modes will be available. It's critical for a photographer to know how to use these universal tools of the trade. And it's not easy. These elements can be isolated to generate specific results, but they need to work together in a controlled and balanced way to create the magic you want to see.

This image captures the simplicity of a morning scene at the breakfast table.

f/2.8, ISO 125, 24-70mm L

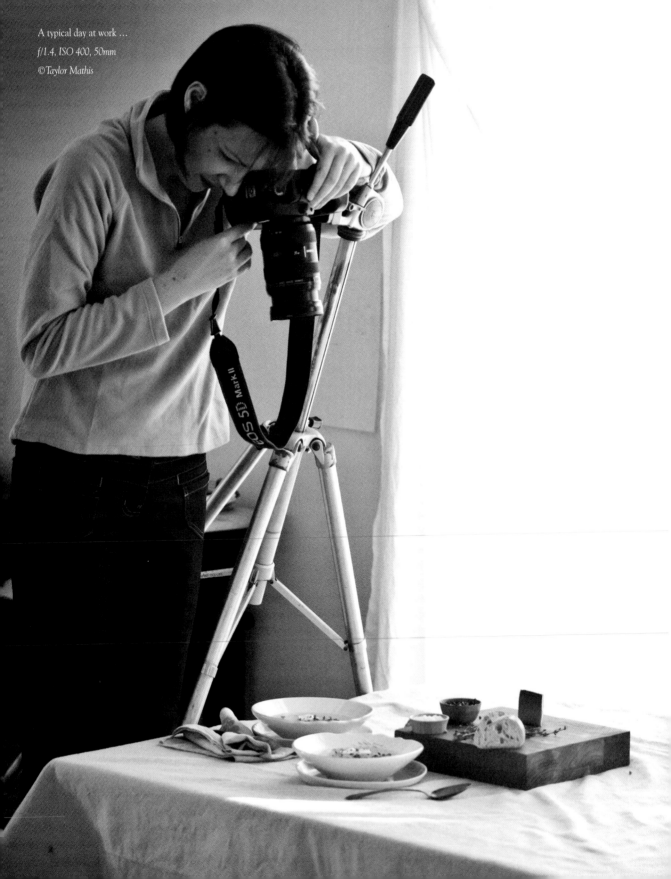

Some of these settings—such as white balance, ISO, aperture and shutter speed—are indispensable photography tools. They help you achieve an appropriate exposure in your pictures … no matter how much or how little light you have available, where it comes from, or how strong it might be. You'll find that these settings open a big wide world of options—for depth of field and composition, for instance—that enable you to convey a striking story … without a thousand words.

When it comes to picking camera modes (e.g., Manual, Aperture, Shutter Speed Priority and so forth), I often equate the selection to choosing your favorite ice cream. There will be an ultimate favorite and then you'll have flavors that you enjoy off and on, depending on the situation. In order to pick your favorite way to take a picture, you have to try as many settings as possible. Each one has a purpose and value; so the more you know, the more diversity you can put toward your photography.

Just, please … step away from the Auto setting as early as possible. Yet don't be afraid to back off of the Manual mode in some situations. Your camera offers different modes for a reason. Use the one(s) that best fit your shooting situation, and play with the others to see how they work there, too.

Keep in mind that different types and brands of cameras have different ways to label camera modes and refer to them. Call it marketing genius or just plain frustrating. Either way, the technology available in some P&S cameras makes it possible to have professional-quality photographs. The top lines of each brand come close to offering the control and quality of a dSLR, including mode options that include Manual, Auto, Aperture Priority and Shutter Speed Priority as well as Low Light, Landscape, Kids & Pets, Sports, Poster Effect, Fisheye Effect, Miniature Effect, Foliage and more. Sometimes a single P&S (also sometimes referred to as a *compact camera*) will have all of these options! And you think dSLRs are confusing?!

But don't be overwhelmed by options. Photography, the art of writing with light, takes time to learn. And the really wonderful thing is that there is always something new to learn no matter how much you already know!

Make Quality Decisions

When I first sat down to write this book, I knew I would feel more vehemently about certain topics than others. And one of my hottest buttons is the choice we have to shoot images in a JPEG format … or RAW. This is especially true if you have a dSLR.

I started shooting JPEG files in the first six months I had my dSLR … mostly because I kept reading about people who would try to use the RAW format and find it quite difficult to manage this format in post processing. *Post processing*, by the way, refers to the manipulation of an image file, including the process of transforming a RAW file to make it a JPEG. I was also worried about how much storage space RAW files require on a camera and the computer.

Yet I knew how much better it was for me to shoot RAW. So one day I said, "Ah, what the heck. I can edit the JPEG file if I struggle too much with the RAW." Now? Well, now I never shoot JPEGs unless I have no other option … and I'm stranded on a deserted island, so to speak. Yes, it definitely required an adjustment period to switch to RAW, but it was so worth it!

There's more information on RAW files in Chapter 8 (After Capture), but for now think of it as the uncompressed, most complete data set your camera sensor will record.

When you look at a RAW image file on your monitor, you'll see that it is not as sharp or contrast-y as a JPEG file. This can be surprising, given the fact that RAW files have so much more image data available. But an image formatted as a RAW file is initially less sharp and has less contrast than a JPEG file because, unlike a JPEG, the RAW image has not yet undergone sharpening algorithms.

Think of a RAW file as a film negative that needs to go through chemical baths before becoming an image. *RAW* means exactly that: It is untreated (like a negative) and needs to go through post processing before it transforms into the image it will become.

The need to process a RAW file is one of the things that makes people shy away from using this format when shooting images. And post processing a RAW image is not as straightforward as the method for editing a JPEG file. But honestly, once you get your groove, both formats take about the same amount of time to post process.

These two screen captures show the difference in sharpness and contrast of a processed and unedited RAW file. Some post-processing programs will automatically apply white balance, contrast and sharpness when uploading a RAW file (e.g., Adobe Creative Suite products), but most won't.

Again, think of post processing exactly like working from a film negative in a dark room. Now do you see the potential? Technically, an image does not need to be post processed to be viewable. Both RAW and JPEG files can be seen without editing, but the editing … even on a minor scale … can take your image from A to A+.

That said, it's technically impossible to load as much data as a RAW file contains into any document without problems, and some online programs won't allow you to load any RAW anything, so to speak. So while you don't *have* to do anything with either of these image files, it is much better if you do. Leaving them alone is like running ten miles of a half marathon and quitting. Why bother with the first ten miles if you're not going to finish?

So the reason photographers bother with the extra work of using the RAW format is that image data will never be lost when using a RAW image. Conversely, every time you manipulate a JPEG and save it, you lose some image data. If print quality is important to you, then this is something to consider.

Here's why: Unlike with RAW files, when taking a photo in the JPEG format, the camera *firmware* (the internal software) automatically removes some of the color data and resolution as it moves information from the sensor and saves it as a photo file. That loss of information helps to compress the image into a smaller file size, but it means a loss of tone nuance, color and sharpness. Your printed photograph is thus less rich than it is if you're working with a RAW image file.

So, as you can guess, the data capacity of a RAW file comes with a price. These are very large files, especially compared with a JPEG file. Retaining all the data available in a RAW requires more space on your camera card and your computer. But if you have an organized system for storing your images, this may not be much of an inconvenience. To me, the file size issue is less important than having access to the utmost color and data quality for my photographs.

Get the Look

To me, one of the greatest thrills of photography is the sheer number of subjects that can be photographed. You can use a camera to record everything you find. Some people focus on a single kind of item, while some prefer to be a student of all things—from landscapes to dogs, people to flowers, buildings to furniture. And, of course, some of us focus on food.

Just like landscape or portrait photography, there are some basic guidelines worth knowing when you start composing an image of food. These guidelines can help you decide when to place a subject off center, consider the Rule of Thirds, use a wide or macro perspective, and so forth. So while props are fun and they can add a lot to your image, keep in mind that they can only take you so far. You simply need to develop your eye for strong composition if you want to create strong imagery. For instance, there are ways to enhance a simple plate of pasta with just light and subject placement. It's not all about props and food styling.

So be prepared to apply your knowledge of camera modes and settings to what you'll learn about composing and styling food. Only by combining these different types of techniques can you tell a strong and engaging story about a recipe, food item or dish.

People who casually look at photographs of food on blogs, restaurant menus, cookbooks, and other online or print publications usually have no idea how much happens from plate to paper/ screen when it comes to food photography. And they don't need to know. In this book, I focus on what I call *basic* or *natural* food styling.

These terms refer to the practice of manipulating, or styling, food at different stages of cooking. It's different from *commercial* styling, for which instruments, materials and techniques must be used that home cooks typically aren't interested in adding to their food. Things like Vaseline and blow dryers … and even using mashed potatoes as a base to build fluffy salad bowls.

I have nothing against commercial styling. The fact is, I haven't worked in that capacity, so I have little to say about it. But some of my very close friends are commercial food stylists, and I've picked up tricks and tips from them to style my food shots—without making the dish inedible.

In fact, I will always remember my first professional job. I was working alongside a seasoned and talented photographer, and he kept saying to the stylists, "Make it real!" … to describe what he needed in terms of both styling and composing. So don't fret if you have to rearrange your food items on the plate or substitute a small piece of an important element for a larger one. You may even need to add a dab of water to your fish to keep it looking moist for your shot.

Some manipulation of your subject(s) may be necessary to make your food pop and/ or stay looking fresh and natural. These are acceptable "make it real" procedures that don't compromise the integrity of the food you're photographing.

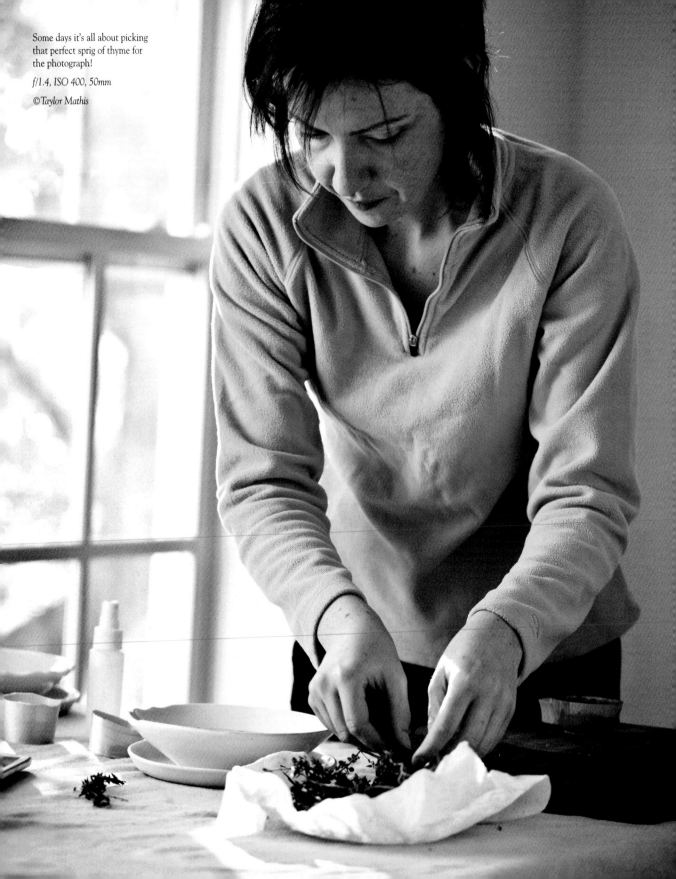

Some days it's all about picking that perfect sprig of thyme for the photograph!

f/1.4, ISO 400, 50mm

©Taylor Mathis

The entire point is to make your viewer say, "Oh dear, I want that for dinner!" instead of "Hmmm, that salad looks a bit limp." If your styling efforts can do this, then I say it's worth it. Just remember to think about styling in terms of enhancing rather than tricking.

The world of food photography is an ever-changing compilation of composition, styling, creation and exploration. There is always a new way to use light and capture the beauty in food. To excel with food photography, one only needs a vast reserve of patience, dedication and passion. Got all that? Well, then grab your camera and let's get started…

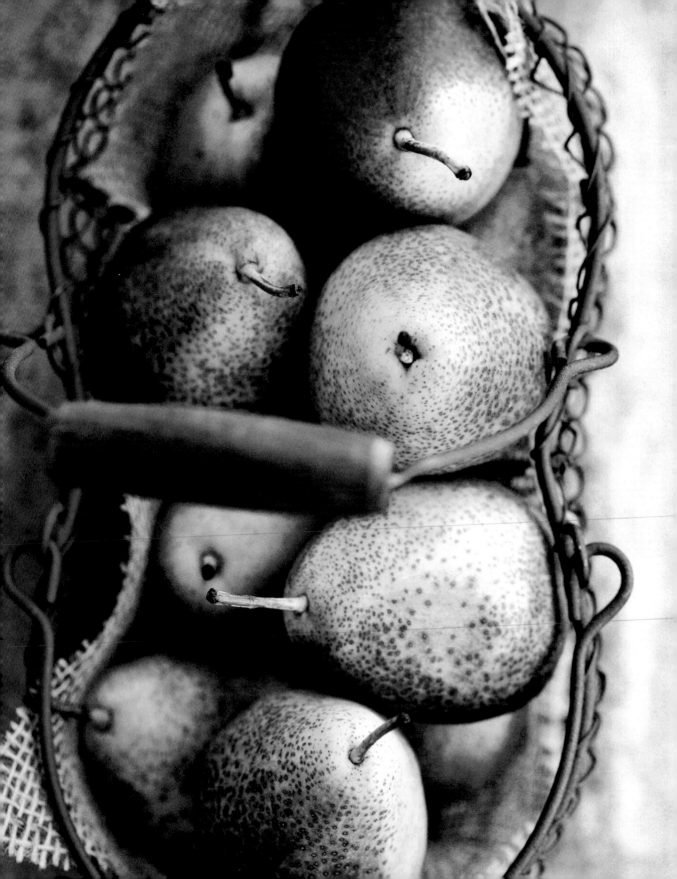

2 ✤ Camera Settings and Modes

Do you ever feel as if your camera is in charge of the picture you're trying to take—instead of the other way around? Are you groaning right now, thinking about it? I know, in these times, it's as if your camera is ambushing your vision for the image, refusing to translate a dish into the appetizing photograph you know it can be. Well, this chapter is meant to take you out of the comfort zone of auto settings to give you more control over your camera and open the door to greater creative freedom.

I wish I could tell you to go grab your camera, gather a few props and some great food and that we'll set them down, move them around the frame and … within 20 minutes or so … you'll have a good dozen to choose from. Actually though, now that I think more about it, that wouldn't be much fun.

The more you know about your camera and what it does/ how it interprets a scene, the more control you'll have when photographing food … and other subjects, too. By mastering your camera settings, you can find real joy in the creative process of shooting. Trust me. That's how I got the bug. Make the camera work for you!

Basic photography techniques will never steer you wrong. And knowing them is as important to creating appealing images as good vocabulary and spelling skills are to writing. Once you have the fundamentals, you can play with them to develop the story you want to tell.

Exposure

One of the most basic principles in photography is *Exposure*, which refers to the amount of light received by your camera's sensor (or film). No matter what camera mode you use (Manual, Aperture Priority, Shutter Priority, etc., which are explained later in this chapter), an over- or under-exposed picture can ruin the entire feel you are aiming to portray. Of course, there is a time and place for creative expression that plays with exposure to enhance a particular mood, even for food, but let's first try to get a handle on how to achieve "balanced" exposure.

Three elements affect the exposure of a photograph:

- **Aperture:** A term that refers to the size of the opening of the lens iris or diaphragm. Usually referenced as an f/stop.

- **Shutter Speed:** The amount of time that the camera sensor is exposed to light when a photograph is being taken. This is measured in seconds or fractions of seconds.

- **ISO:** A measure of how sensitive the sensor is to light. Most cameras' ISO scale ranges anywhere from 100 to 6400+, depending on the brand and model.

Aperture

Aperture refers to the size of the opening of your lens, and it determines the amount of light that gets to your camera sensor (or film, if you're not using a digital camera). Aperture affects the exposure and depth of field in your image.

Think about aperture in terms of your eyes. Your iris controls the diameter and size of your pupils as well as the amount of light that reaches them. When there is little light available, your pupils expand to create a larger opening and gather more light. When there is a lot of light, your pupils constrict and allow in less light.

In the case of your camera, the aperture (the diameter of your lens opening) is also controlled by an iris that *opens up* or *stops down* the amount of light that reaches your camera sensor.

Unless you're working with fixed-aperture lenses, such as those found on point-and-shoot cameras, the aperture of a lens is measured in f/stops (e.g., f/1.8, f/3.5, f/16, etc). The f/stop references the ratio of focal length to aperture diameter. Every full f/stop doubles or halves the amount of light that hits your sensor. So, you ask, what does that mean?

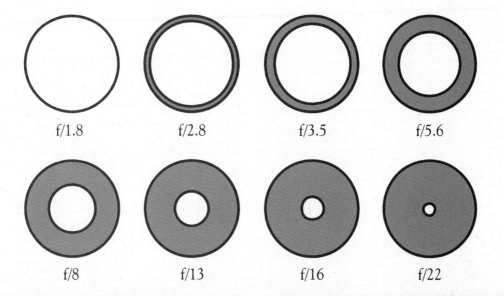

f/1.8 f/2.8 f/3.5 f/5.6

f/8 f/13 f/16 f/22

❋ Fast lens, fast aperture, fast f/stop = wide aperture = more light reaches the sensor

❋ Slow lens, slow aperture, slow f/stop = smaller aperture = less light reaches the sensor

❋ Stop down f/stop = increase f/stop = narrow aperture

❋ Open up f/stop = decrease f/stop = widen aperture

Well, the higher your f/stop number, the smaller your aperture and the less light that comes in. The lower the f/stop number, the larger the aperture, which leads to more light coming in. This is ideal in low-light situations, but be aware that a wide/ large aperture creates a very small area of actual focus. And a very narrow focal point is unlikely to produce the shot you're envisioning. It might be as tiny as an almond on top of crumble! Obviously, this dramatically restricts visibility in your photograph and undermines your ability to communicate information about a dish.

It can be a frustrating concept. Only when I started thinking about it in terms of my eye pupils did it begin to make sense. You either squint or open your eyes depending on the amount of light that's in your environment. More light leads to squinting, right? And that's how it goes with your camera's aperture setting, too.

The maximum aperture on your lens, also referred to as *lens speed*, will be represented by a low number. The minimum aperture range will be a high number. In that regard, you will hear many refer to lenses with large maximum apertures, such as f/1.2 to f/1.4 or f/1.8, as fast lenses. These lenses will enable you to shoot in low-light conditions. Again though, the price of this capability is a small area of actual focus.

Conversely, lenses that allow you minimum apertures of, say, f/16 to f/20 or f/22 feature slow shutter speeds, which can result in a good bit of *camera shake* if you're shooting without a tripod. This is because a slow shutter speed ensures that the shutter stays open longer and therefore picks up movements that occur—by the photographer or a subject. Camera shake shows up as blur in your photo. More information on shutter speed is provided in the next section.

Practice using the Aperture Priority mode of your camera in different environments to see what it does. The beauty of digital photography is that you can shoot 50 photos and see instant results. When you're done, you can erase the images and end up with no wasted film or storage space.

If you practice in the Aperture Priority mode of your camera, you'll see that this mode adjusts the shutter speed to get you as close as possible to a good exposure. You can also practice in Manual mode, but this requires you to adjust your shutter speed and aperture manually.

One of the great things about Aperture, aside from helping you create good exposure, is the control it offers you over the image's depth of field. We'll explore depth of field in Chapter 5: Composition.

Shutter Speed

One of the other components of exposure is shutter speed, which refers to the length of time your camera sensor is open and exposed to light. I'm going to use the eye metaphor again—because what is your camera if not an extension of your vision?

Think of shutter speed as the speed at which you blink your eyes, which affects the amount of light received by your pupils. In the same way, the shutter speed you choose for your camera determines the period of time that the mechanical shutter between the lens and the sensor opens and closes.

Shutter speed is measured in seconds … or fractions of seconds (e.g. 1/80 – 1/100 – 1/400 and one second two seconds, etc.). Just like with metrics and volumes used in baking, brands don't always agree on the same nomenclature for displays. But most cameras will display 1/80 as 800, 1/400 as 400 and one second as 1. Check your camera manual to see how it represents shutter speeds.

So how does Shutter Speed work with the light and your camera? Well, the higher the number, the faster the shutter speed, which results in less light entering your camera. The lower the number, the slower the shutter speed, which allows more light to enter your camera.

Slow shutter speeds are helpful in low-light situations, but this setting can be difficult to use without a tripod. Since the shutter is open for a relatively long period of time, the image that results will show the effect of any movement as blur. A hand-held camera is very likely to move during this time … and thus produce some camera shake, or blur. Also consider the weight of your lens if you are shooting hand-held, and adjust the shutter speed to a faster setting to avoid camera shake.

In food photography, the Shutter Priority setting on your camera is not commonly used. Manual or Aperture Priority are used more often, unless the image is intended to capture motion, like wine being poured in a glass, milk splashes, syrup pouring onto a stack of pancakes, and so forth.

Set your shutter speed based on how much movement you want to show in your photograph. A fast shutter speed will freeze motion. A slow shutter speed will capture motion by adding blur, which can give the movement a soft quality.

As with Aperture Priority, use the Shutter Priority mode of your camera to test out the effect of different settings. This mode will adjust the aperture to help you get as close as possible to a good exposure. Or, practice in Manual mode and be prepared to adjust your aperture manually. (Modes are covered later in this chapter.)

Just as f/stops double or halve your aperture opening, shutter speeds double or halve the amount of light that enters your camera. If you shoot in Manual mode, and you are setting up your exposure by doubling your shutter speed, you'll need to increase your aperture by one stop also.

ISO

In film photography, the International Organization for Standardization (ISO), which was developed by the American Standards Association (ASA), indicates how sensitive a film is to light. Low numbers indicate less sensitivity and a finer grain. To visualize grain, think about the difference between a crisp image (fine grain) versus a static-like image (coarse grain).

In digital photography, ISO refers to the sensitivity of the camera's image sensor. The principle that applies to film also applies to digital; so a low ISO number indicates that the sensor has low sensitivity to light. Low sensitivity results in a finer grain (or more sharpness) in a digital photograph.

In Auto mode, the camera will select the most appropriate ISO for the situation. But since we're trying to gain more control of camera settings, overriding the Auto mode will enable you to choose a specific ISO that correlates with the shutter speed and aperture you set to achieve a balanced exposure.

Most cameras' ISO scale can range anywhere from 100 to 6400-plus, depending on the brand and model. How do you decide which setting is best?

In a perfect shooting environment, the ideal setting is among the lowest options. But think of ISO as the little creative helper of shutter speed and aperture. The ISO can be set low or high; you just have to decide how much grain, or *noise*, you want to see in your final shot. Or determine how much post processing you're willing to do to eliminate noise/ grain. Different types of editing software have different functions to manage noise reduction. Find information on photo editing tools in Chapter 8 (After Capture).

High ISO settings support faster shutter speeds and/ or smaller apertures, which are helpful in low-light situations. A high ISO can also help you create more depth of field without changing a multitude of settings. The major drawback of a high ISO setting is an increase in grain or digital noise in the final image. (See series of ISO pictures on the right.)

That said, digital noise isn't always a bad thing. I think some shots are gorgeous with a bit of grain, especially still-life photographs or black-and-white kitchen scenes, where the food is less of a focal point than the people making it. However, if you're shooting a fresh bowl of soup and the ISO is so high that is adds a lot of noise to the picture, the lint dusting effect may not be ideal.

Salad at low ISO of 100: This shot has virtually no grain, or digital noise.

f/3.5, ISO 100, 100mm, Macro L

Salad at low ISO of 250: Still very minimal grain visible.

f/3.5, ISO 250, 100mm, Macro L

Salad at medium ISO of 640: Grain becomes visible.

f-3.5, ISO 640, 100mm, Macro L

Salad at medium-high ISO of 1600: The digital noise is becoming a problem.

f/3.5, ISO 1600, 100mm, Macro L

Salad at high ISO of 3200: The digital noise in this image would show greatly on prints.

f/3.5, ISO 3200, 100mm, Macro L

Salad at very high ISO of 6400: The digital noise looks like dust particles at this point.

f/3.5, ISO 6400, 100mm, Macro L

If you're trying to photograph a plated dish quickly, or if the available light is not quite right for a low ISO (and you don't feel like setting up artificial light), consider bumping up your ISO number. It will safely add light to your shots without making you adjust other settings, such as shutter speed and aperture.

When picking your ISO, keep in mind the following factors:

- Amount of available light
- Permissible grain in out-of-camera photograph
- Amount of post processing you are willing to do
- Shutter speed you can use in the situation
- Aperture setting that will accommodate the scene

I typically start a natural-light shoot at 100 ISO and finish at 500 ISO. That's because I prefer to keep shooting in natural light. To handle the downsides of this decision, I tolerate a bit of grain and use a tripod to avoid camera shake. Although I'd rather use long exposures and reduce grain in post processing if necessary. I like the quality of late afternoon light, and I do love long exposures; but I know it's a personal choice. Play around with different camera settings, and see what works for your images—and your image needs.

Finding Balance

Now you know the big three elements making up your exposure. They're Aperture, Shutter Speed and ISO, in case you've been drifting off. So keep in mind that it takes a practice to make them work together to generate the kind of images you envision.

If this is your first time (or relatively first time) trying to wrap your head around exposure settings, I don't recommend making up a towering plated dessert that needs to be shot in ten minutes. Chances are you'll end up cussing like a sailor and throwing your arms up in the air yelling, "Why is this so complicated?!" But with some practice, you'll see that it's not … so complicated. Trust me.

Instead, on a day that you're off work and relatively free, put a few apples or other kind of produce in a bowl and place it in a spot where you are most likely to photograph. It does not have to be in your kitchen. I started on the living room coffee table next to the largest window in my house. It can be any place you choose.

What's important is that you observe how the light hits the food at different times of the day and that you try to capture a photograph using the elements

we've covered in this chapter so far. See how they work together and against each other. For instance, note when one setting affects one component but not all. Just try. Erase. Try again. Before you know it, you'll have a working understanding of these camera settings and how to use them to your advantage.

Metering

Here's one other component to achieving balanced exposure. *Metering* refers to the way a camera measures the brightness of the subject to be photographed in order to determine the appropriate exposure. Although the exact names vary from one brand to the next, a photographer will be able to select between the following options on his/ her camera:

- Spot Metering (Nikon) and Partial Metering (Canon) allow you to meter the subject at the center of the scene. Only a small area of the frame is metered. This type of metering is especially helpful with backlit subjects, because it lets you measure the light bouncing off the center of the subject and expose appropriately for that area (instead of the brighter light in the background). Photographers doing a lot of close-up shots of food will also appreciate being able to measure the light at the center and in a small area of the frame, and meter appropriately for the capture.

- Center-Weighted Average Metering (Canon) or Center-Weighted Metering (Nikon) will average the exposure of about 80% of the frame. This setting gives priority to the center portion of the frame though, which works great for still-life pictures and portraits.

- Evaluative Metering (Canon), or Evaluative/Matrix Metering (Nikon), is usually the default setting on most cameras. The camera measures the light in several areas of the frame and then analyzes this data to calculate (with algorithms proprietary to each manufacturer) the best exposure for the circumstance.

While setting your exposure, metering is an added tool that gives you even greater control. This is always a good thing to know when you are having problems with exposure and need to try a couple of different settings.

White Balance

As the quality of light changes through the course of a day and in different lighting conditions, your White Balance setting will need to be adjusted in order to accommodate changes in the color casts of whites and neutral tones throughout a scene.

Adjusting the White Balance setting is necessary so that the colors in your picture are represented as close as possible to real life colors, where whites are neutral white—and all the other colors are balanced to reflect the ones you see in a scene with your naked eye. Make this adjustment when you set up your exposure.

If you've tried to shoot under your kitchen light at 5pm in the winter using Auto White Balance, you know what I'm talking about. Everything has an orange cast to it. This happens because different light sources have different color temperatures, which are measured using the Kelvin scale. If your camera offers a Kelvin reading to adjust your white balance, it might be a good idea to get familiar with it, especially in post processing. For now, it's just important to know that a high number on the Kelvin scale indicates a cool (blue) light, and a small number represents a warm light.

While our eyes adjust automatically to these differences, your digital camera can't. Instead, it has different modes available for you to adjust the white balance. Since all camera brands and models are created differently, read through your manual to get familiar with the White Balance settings that your camera offers.

Most digital cameras offer a preset of White Balance modes—including Daylight, Cloudy, Tungsten, Auto—as well as a custom function that offers yet another level of control by enabling you to set the white balance manually. Your camera may have more or fewer options, or it might name the options differently, than the ones described below; but these are the most common White Balance modes:

* **Auto:** The camera will meter the light and adjust the white balance automatically. This setting works in many situations, but it can be too restrictive for some shots.

* **Daylight:** Since I shoot mostly in natural light, I often use this setting … when I don't manually customize my white balance.

* **Cloudy:** This setting offers a nice warm touch to a daylight setting. I find it particularly helpful when I shoot late Fall and early Winter afternoons. It tones down some of the silver cast of items that would benefit from a warm touch, such as breads, cakes, fruits, etc.

* **Tungsten:** I use this setting when shooting indoors and with incandescent (bulb) lighting, such as in restaurants. This mode cools down the colors nicely.

* **Flash:** This mode is similar to Cloudy on most cameras, and it offers the same warm touch.

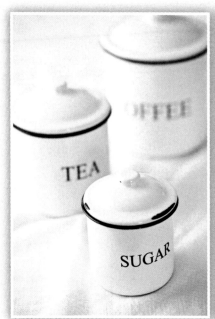

Auto White Balance

f/3.5, ISO 400, 100mm, Macro L

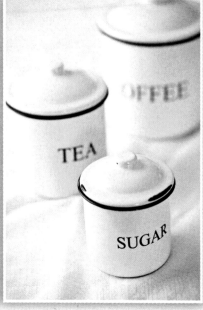

Daylight White Balance

f/3.5, ISO 400,100mm, Macro L

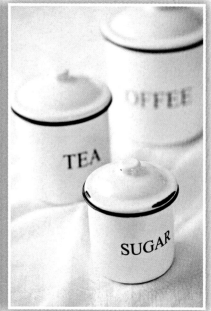

Cloudy White Balance

f/3.5, ISO 400, 100mm, Macro L

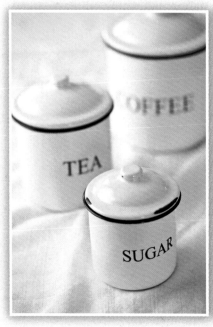

Tungsten White Balance

f/3.5, ISO 400,100mm, Macro L

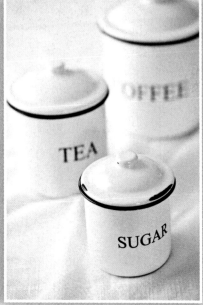

Flash White Balance

f/3.5, ISO 400, 100mm, Macro

You can, of course, go a step further and custom set your white balance. The specific how-to may differ by brand and model, but the principle remains the same: You essentially give your camera a reading of what whites should look like, and your camera takes it as a reference point to adjust the surrounding colors.

Schedule Time to Practice Settings

As with any photo situation that involves camera setup, your results are much more likely to be positive if you first assess what you are going to do, what you want to convey and how much time you have to do it. Make your camera settings work for you; they're available for a reason.

Consider establishing a schedule for exploring the different settings:

Monday might be your 20-minute shooting session, while Thursday might be an entire day off dedicated to shooting multiple recipes.

Who knows? The only *wrong* way to photograph is to not use your camera. So if you're going to have it in your hands, you might as well learn how to benefit from the tools it offers you to create great shots!

You'll need to follow the specifics on Custom White Balance in your camera manual, but basically you take a picture of a white surface (paper, board or other white item). Be sure that the white object covers the entire frame of your camera. Then, use this image to set your white balance according to the manual's directions.

If you are really into custom white balance, there are several products available to pros that are not outrageously expensive or overly complicated to use. Check out Digital Calibration Target or Expodiscs. (See Resources in appendices for website addresses.)

You can also use grey cards in post production. If one image is shot with the grey card in it and one is shot without it, the adjustments can be made as you process and compare the two versions.

You can adjust and re-adjust at will in post production. But the beauty of getting the shot set correctly *before* you press the shutter button is more time to photograph—and do other stuff you enjoy. Minimizing time in front of a computer to fix images means more time to cook and shoot new images and hang out with friends and family.

Achieving out-of-the-camera accuracy is more likely if you shoot a scene within a short period of time. But if you must shoot at different times of the day, or if you are experimenting and getting creative, then you'll need to adjust your white balance setting for the various conditions. This is a great situation if you have a block of time set up for your photography, but not so great if you are trying to shoot your eggplant parmesan before dinner and before it gets completely cold.

Camera Modes

Photographers can be pretty adamant about the camera modes they favor. Discussions among photographers often resemble the banter of chefs postulating on their preferred cookware. So how do you decide which one to pick?

The short answer is to try them all and pick the one you're most comfortable using. But that would be short changing you. Each camera mode has its purpose—and pros and cons—that has very little to do with preference.

Auto Mode

As you (likely) know, Auto mode is available … and it's always an option for quick and easy photographs. But I'm not going to elaborate on the Auto setting here, because we're working on gaining more control over creating photographs. So while Auto mode can be very helpful in some cases, using it means that the camera makes all the decisions for you … aperture, shutter speed, light metering—everything! And relying on your camera to make all these important adjustments can only take you so far.

We've been talking about taking control to achieve great images. So be the boss of your camera. When you challenge yourself to interpret a scene and respond to it, your creativity will soar.

Manual Mode

You've probably heard photographers say, "Manual, Manual, Manual! You have to learn Manual." And while it's true that you do have to set everything yourself in Manual mode, do you know why it's important to know how to manage a camera manually?

It's because … if you find yourself in a situation in which all the other buttons on your camera are broken—or if you're handed a completely different type of camera to shoot a series of pictures—knowing how to set up a shot in Manual mode means that you could still achieve great images. You'd apply the basic rules of aperture and shutter speeds and have sound results … no matter what camera you had to use. These components are constant. They won't change, no matter what country you are in or what language you speak.

I personally consider Manual mode my safety spot. I favor Aperture Priority mode (described below) about 60% of the time, because I really get my kicks from playing with depth of field. But that's just me; it works for me. Yet I have found myself in situations where I would have been in serious trouble if I had not known how to revert back to Manual and adjust aperture, shutter speed and ISO separately to get "the shot."

Manual mode allows you complete control of your camera and unlimited versatility. Here's how it works: Let's say you've figured out the best ISO for your picture, and you decide to shoot in Manual mode—adjusting only the aperture and shutter speed. They work like opposite sliders/ arrows on a sliding scale. When you increase one, you have to decrease the other to keep the same exposure.

For example, if you want to shoot Manual and you put your energy in getting that well-loved shallow depth of field (which has the signature blurry background that often appears in food magazines), then open up your f/stop (decrease the numbers) and increase your shutter speed. It works the opposite way to achieve deep depth of field.

Or let's say that you want to focus on time rather than depth of field. You're capturing liquids in motion. In this case, you need to play opposite scales … between the shutter speed and aperture … to keep getting the correct exposure. To freeze liquids in motion, increase your shutter speed and open up your f/stop. To capture flow, or show motion, please refer to the Shutter Priority section further below.

Manual does not have many downsides, but it does require a full understanding of exposure and the relationship between depth of field (aperture) and time. It's also easy to find yourself with the wrong settings, especially when a situation changes abruptly.

When I photograph food-centered events, such as chefs' exhibitions, a busy night in the kitchen—with dishes flying in and out, things happening fast and furiously—I tend to set my camera to Aperture Priority mode (described below), because there are too many changes … happening in the span of seconds … to stay in tune. Manual would make it tricky to catch all the shots in a quick-changing situation.

Aperture Priority

One primary difference between Manual and Aperture Priority modes is that the latter automatically adjust the shutter speed after you select the aperture and ISO. This makes it a bit easier (than when in Manual) to set your exposure properly.

Aperture mode also makes it easier to control depth of field in your images—whether you're going for a shallow depth of field, where only a small portion of your photograph is in focus (and the rest is blurry), or a deep depth of field, where everything throughout the image is in focus.

Wide aperture and a low f/stop shows a very shallow depth of field. *(upper left)*

f/1.8, ISO 500, 50mm

Wide aperture and a low f/stop results in a shallow depth of field. *(upper right)*

f/2.8, ISO 500, 50mm

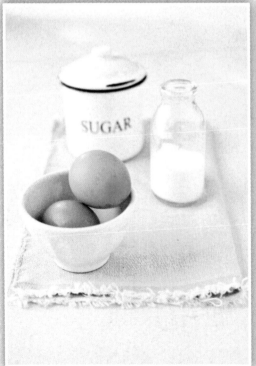

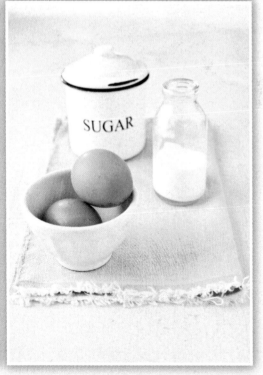

Wide aperture and a low f/stop provides medium shallow depth of field. *(lower left)*

f/3.5, ISO 500, 50mm

Medium wide aperture and medium f/stop generates somewhat shallow and somewhat deep depth of field. *(lower right)*

f/5.6, ISO 500, 50mm

When aperture is narrow and f/stop is high, the shutter speed slows down and the depth of field becomes deeper. *(upper left)*

f/8, ISO 500, 50mm

Narrow aperture and high f/stop reveals more and more details on the subject and on the background. *(upper right)*

f/13, ISO 500, 50mm

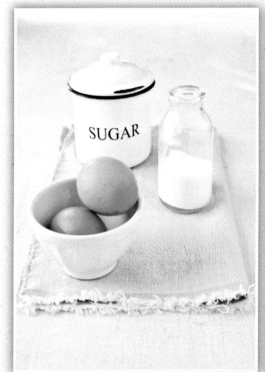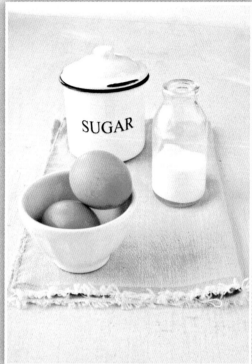

Narrow aperture and high f/stop results in deep depth of field. *(lower left)*

f/16, ISO 500, 50mm

Very narrow aperture and very high f/stop leads to a very deep depth of field, where everything is sharp and in focus. *(lower right)*

f/22, ISO 500, 50mm

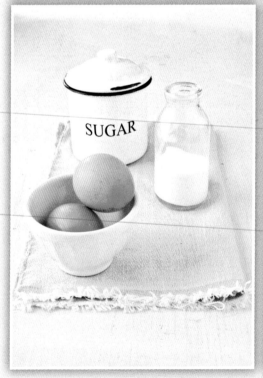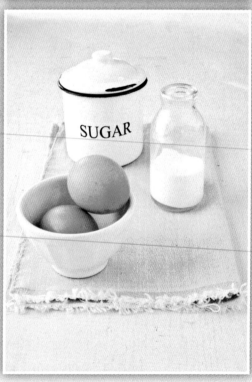

Notice in the set of images on the left—each photograph was shot at a different aperture—how much or how little is in focus depending on the camera setting. A small f/stop number (a large aperture) will generate a lot of soft focus throughout the image. It's hard to even read the word *sugar* on that enamel jar at f/1.8 (page 29). But as we gradually increase the f/stop number, it decreases the aperture of the lens and brings more of the elements in focus. The difference at f/2.8 (page 29) to f/22 (lower right on previous page) is striking in terms of visibility.

Using different degrees of shallow depth of field can be useful in telling a story through composition and styling. (See Chapters 5-7 to find more information on Composition and Styling.) Try placing the main dish in focus and blurring out other servings, props and ingredients to help convey a certain mood.

There is a soft quality to shallow depth of field that works really well, especially if you're shooting level with your food or three-quarters above the plate. If you're shooting from overhead, there is little reason to keep the f/stops low unless you are in low-light conditions and/ or there is a creative reason for a shallow depth of field.

This shot of a basket of pears was taken at a shallow depth of field. The low f/stop was used to hide the concrete and grass, which were not very pretty, and to create a soft feeling … as if the pears were floating.

A major drawback to using a very low f/stop is the narrow focus point that comes with it. Take this scenario: If you shoot a bowl of freshly cooked pasta at a low f/stop, then the focus point might be so narrow that only the tip of the noodle strands are clear in the image, instead of the full dish. I am exaggerating slightly, but you get the idea.

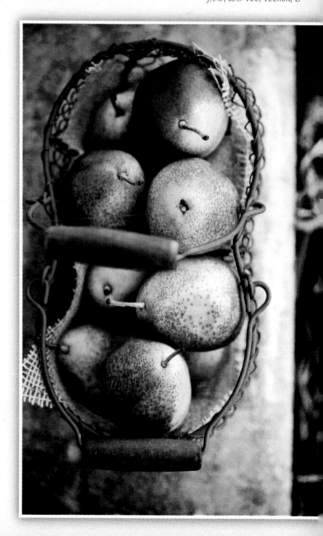

These pears were shot with a wide aperture and shallow depth of field.

f/3.5, ISO 100, 100mm, L

What's the right DOF?

So how do you choose the right aperture and focus point to get the depth of field you want? It really depends on what part of the dish you want to feature. Is it the whole plate, the whole table, or maybe just the tomato perched on top of a salad?

Ask yourself what you are trying to say with your image and how much you want to reveal ... versus suggest.

I know that a lot of food photographers aim for shallow depth of field, but it is far more likely that a reader will get excited about a pie if (s)he can see at least half a slice in focus versus only the tip of the crust.

Another thing to keep in mind when shooting in Aperture Priority mode is how to use the exposure compensation button (*EV* or *Exposure Value* button) on your camera. Since being in this mode necessarily means you are not in Manual—and thus cannot adjust the shutter speed to give you proper exposure—learning how to turn exposure up or down can really help. Just remember, depending on your camera brand and model, the exposure compensation button might have a different icon or increment scale.

Each of the radishes photos was shot at the same ISO and aperture, but I started with an exposure compensation of -2 and went to +2 ... to show you how easy it is to under- or over-expose your shots. Practice to see which setting works best for you.

One last thing to consider when shooting in Aperture Priority mode is its limitations when trying to capture the movement of liquids ... or ingredients splashing into liquids. This mode does not focus on time, like Shutter Priority mode (described below) does.

Shutter Priority

As with Aperture mode, shooting in Shutter Priority mode lets the camera do part of the job to achieve a balanced exposure. Yet, when talking about the Shutter Priority mode, I always want to say that it's the mode you are least likely to use for food photography. But that's not entirely true.

In general, unless you want to capture hot chocolate sauce dripping from a spoon or pancake syrup as it hits a tower of pancakes and flows nicely down the sides—or unless you have a blog dedicated to flying food objects, liquids in motion or food fights—you'll rarely use the Shutter Priority mode for still-life photography.

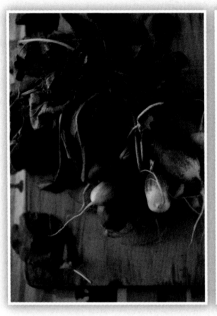

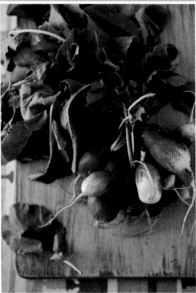

If your exposure is good to start with, setting the aperture compensation button at -2 generates a very under-exposed (dark) picture.

f/3.5, ISO 200,100mm, Macro L

If your exposure is good to begin with, setting the aperture compensation button at -1 will give you a slightly underexposed picture.

f/3.5, ISO 200,100mm, Macro L

When your exposure is good to begin with, you do not need to use the aperture compensation button.

f/3.5, ISO 200, 0-100mm, Macro L

If your exposure is good to begin with, bumping the aperture compensation button by one will give you a slightly overexposed picture.

f/3.5, ISO 200, 100mm, Macro L

When your exposure is good to begin with, bumping the aperture compensation button by two will create a very overexposed picture.

f/3.5, ISO 200, 100mm, Macro L

Shutter speed of 1/25 second: water and splashes are sharp and well-defined. *(upper left)*

f/2.8, ISO 320, 24-70mm, L

Shutter speed of 1/13 second: water and splashes begin to lose definition. *(upper right)*

f/4, ISO 320, 24-70mm, L

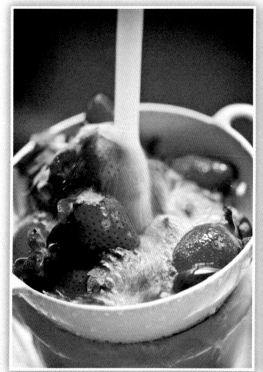
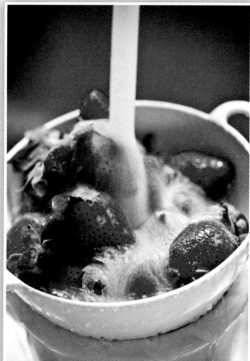

Shutter Speed of 1.3 seconds: the water becomes soft and cloud-like. *(lower left)*

f/18, ISO 320, 24-70mm, L

Shutter speed of 5.0 seconds: the water is very soft. There's almost no defined streaks of liquid or splashes. *(lower right)*

f/32, ISO 320, 24-70mm, L

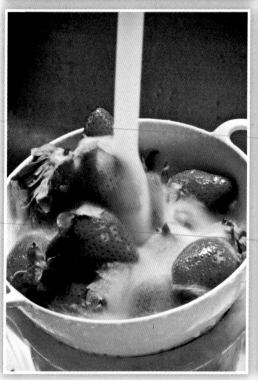
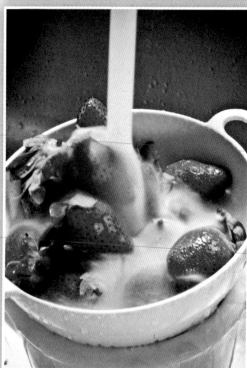

In the photo series of strawberries under water, see how the decreased shutter speed gives the water flowing out of the faucet a very soft, almost cotton-looking quality. This effect can be helpful if you're trying to focus on the object rather than the liquid itself. But by using a faster shutter speed, you can freeze the movement of the water. Notice the bubbles and ripples that are created as the water hits the berries and flows out of the bowl.

That said, the ability to capture movement is not the only benefit of the Shutter Priority mode. This mode also allows for deep depth of field to be achieved through small apertures and long exposures (slow shutter speeds). It can be extremely helpful when shooting in natural light, in situations where very little actual light is available. You'll definitely want to use a tripod in this case to keep your camera as steady as possible.

As you can see, there is not one right way to shoot … or even a best way to get the shot you need. The right setting for your specific circumstance is the one that produces a picture that make people say, "Wow" … and not "Ewww." Practice, practice, practice.

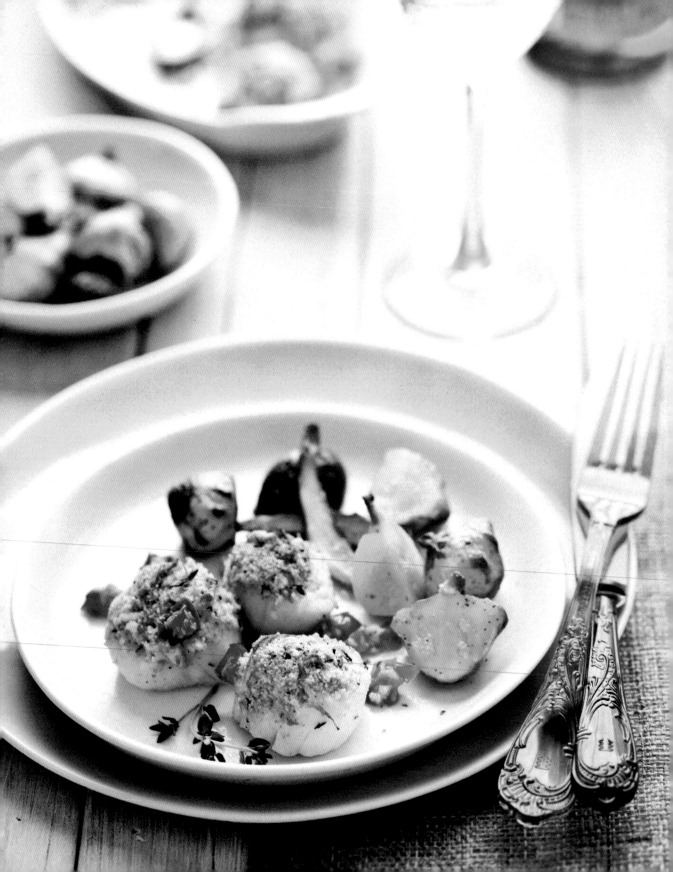

3 ✦ Natural Light Photography

When I first started taking pictures for my food blog, I thought that all light—in whatever shape or form it came—was good light. It was *light*, wasn't it? How could it not be good for my purpose?

Well, if you've been photographing for a while, I can nearly see that little smile on the corners of your mouth. And if you're self-taught like me, I can also bet that it took you a lot of setups and experimenting with light before you understood how to manage light to get the shots you wanted. I'm hoping this section will explain the different aspects of natural light and help make your photography work more enjoyable.

Yes, I am primarily a natural-light photographer. I don't have anything against artificial lighting, but there are several reasons I prefer to shoot in natural light … and make the most of existing conditions whenever possible.

I had very little photo equipment when I began photographing food. I started much like most other novice food photographers. That is, I was taking pictures in the kitchen and quickly realizing that the yellow light in that space was not ideal. And even with white balance manipulations—See Chapter 2 (Camera Settings and Modes) for more on setting your white balance—my photographs moved up to *okay*.

So I moved to the coffee table that was positioned right in the middle of the living room, between two windows. It's here where I learned about the effects of natural light and practiced ... and practiced a lot ... to grow my understanding of various lighting conditions and make them work for my images.

In the southeast region of the United States, where I currently reside, good weather and lots of sunshine prevail over rain and dark days. So I take full advantage of this good photo lighting throughout the year. Bright, clean and crisp skies are perfect for capturing soft-lit frames and setups for food—with the proper preparation, of course, which is described later in this chapter.

But I've come to love all light situations and take advantage of dark and rainy days as well. These days allow me to exercise my creativity in different ways. The lack of natural light during bad weather produces dramatic shadows and strong silver highlights, which impose a different set of challenges and decisions from the photographer, as we will explore in this chapter.

Of course, now that food photography is my full-time job, I work on other people's schedule and dime. This means I don't always get to choose my time and place for shots. So I now carry an artificial light kit in case I find myself on a job at a time when the weather and bright skies are not cooperating. It happens ... like when shooting a cookbook in the middle of a rainy week in February, it wouldn't be acceptable to call the artistic director to say you can't do the job because the light isn't right. No, you need to get it done—correctly and on time ... even if it means resorting to a light kit.

I'm not going to hide that this would be my last resort, as I really prefer natural light photography whenever possible. So I suggest that you try using the settings on your camera (e.g., exposure compensation, long shutter speed, etc) to address low-light situations before using artificial light. Artificial light produces fantastic results, too, but it's another learning curve altogether ... as we'll cover in Chapter 4.

Hard Light vs. Soft Light

Both *hard light* and *soft light* refer to the quality of the luminescence of your scene, and each has its purpose in photography. Direct sunlight is an example of hard light, and it' s known to produce harsh shadows and high contrast.

Conversely, indirect or *diffused* (scattered) light is an example of soft light. One is not universally better than the other; yet one will be more appropriate than the other for a given image, based solely on the artistic effect you wish to achieve. What is the story or mood you wish to convey with your photograph?

Hard Light

Hard light is stronger than soft light, and it illuminates your subject in a direct way that accentuates shadows and contrasts. Hard light can help you create dramatic effects, such as sharp highlights in the background or glossy casts on liquid surfaces.

In the picture of carrots, I did not diffuse or bounce the light coming from the back of the setup. This allowed a lot of contrast in the scene, which accentuated the colors and shapes of the carrots against the dark surface on which they sat. The hard light also added highlights to the tiny water beads, which would have been lost in a softer light situation. Keeping the water visible conveys that the carrots were fresh from the field!

These carrots were photographed in hard light to render their vivid colors.

f/3.5, ISO 200, 100mm, Macro L

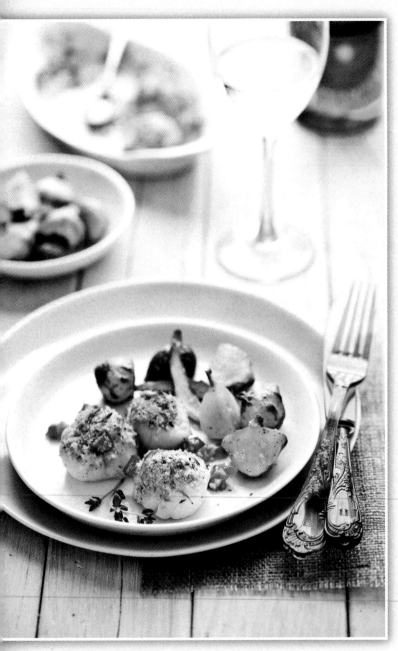

A plate of roasted scallops is placed in soft light to create an airy atmosphere.

f/3.5, ISO 250, 100mm, Macro L

Soft Light

Soft light can come from multiple directions, angles and sources … or from a single broad source. Light softens as it is becomes diffused and reflected. Soft light appears gentle and smooth; it illuminates areas evenly and appears to embrace your subject. Diffused light is also broader than its undiffused counterpart, which means it reaches more places in your frame.

In the picture on the left, the scallops are placed against back light, which is diffused with a bed sheet. A white foam board was positioned at four or five o'clock to bounce light back to the front and side of the plate … not only the side. The result is a soft and airy look that supports the "light luncheon" message I was trying to convey.

While you won't notice abrupt transitions from light to dark areas with soft light, soft light can be just as powerful as hard light. The closer your light source is to your subject, the more powerful it is—hard or soft. The ultimate feel and aesthetics of your photograph will be affected by:

❋ Size of the light coming through the window

❋ Size of the window through which light is coming

- Intensity of the light
- Proximity of the subject to the window

A nice little rule of thumb here is that light will appear soft if the size of the source is half of the distance of the source to subject. In my studio, for instance, the light coming through a 30-inch window will appear soft if it's about 60 inches from the subject.

Diffuse and Reflect

Learning how to diffuse and reflect light, and do it well, is key to photography, especially in natural light. The concept of diffusing allows for light to come through your frame in a softer and ample way than raw light allows. And reflecting light (commonly called *bouncing*) is yet another way to add dimension and visual interest to a photo. It allows you to fill in darker areas of a scene that may otherwise be heavy and distracting. Diffusing and reflecting techniques offer more ways to get the shot you envision.

Diffusers

Placing a diffuser between your main light source and subject allows the source to remain close to the subject and serve as strong soft light—see, *strong* and *soft* don't have to be opposites—even if the source is small to begin with. So if the best light in your house comes from a tiny window, don't assume you have to use it as it comes.

There are many things you can use to diffuse window light—from professional scrims and silk screens to thin white bed sheets. Yet all essentially perform the same duty. Diffusers simply filter and soften the light that comes through it.

Don't laugh. This is one of my best "equipment" tips. For most of the pictures I shoot in my studio, I cover the main window with a long satin sheet draped on a regular curtain rod. Pretty DIY, but it works great for the strong light that tends to blaze through this window. I wish I had something more sophisticated for you, but there you have it.

And really, it's best to have two or three different kinds of diffusers at your service—of varying thickness—to handle different lighting conditions. Double up your bed sheet if more diffusion is needed.

On the Go

When I go on-location to shoots close to home, I like to take a 40x60 multi-panel screen that attaches to a stand. It functions as both a reflector and a diffuser. Diffusers come in all sizes and price points, so evaluate your actual needs and budget before shopping around for this.

To use your diffuser, position it against the window or near it. The nuances are small, but where you position your diffuser can affect your image; it changes the intensity of the light shining through.

Yet diffusion isn't the only way to acquire soft light. You can also reflect, or *bounce* light off a surface and let it fall softly on your subject.

A small 22-inch white panel can be used as a bounce or diffusing panel.

f/3.5, ISO 800, 24-70mm, L

A large 40x60-inch white diffusing panel/ bounce can save the day in many different lighting circumstances.

f/3.5, ISO 800, 24-70mm, L

Reflectors

Along with a diffuser, you may want to add a reflector to your photography toolbox. Reflectors come in all shapes and sizes and are relatively cheap.

A small 22-inch reflector can be quite helpful in many situations. Usually held in place by two clamps, this reflector has both a silver and a gold surface for reflecting purposes as well as a white one that can be used as a bounce or a diffuser, if needed.

Another handy accessory is a large circular or rectangular panel that is also comprised of three surface options: silver, gold and white. These are great for large setups, and even come with a stand!

Also consider getting a piece of white foam board (cost is less than $1) to bounce light back onto subjects. And keep in mind that light can be bounced from walls, ceilings, towels, plates and other surfaces as well.

Experiment … especially because the type of bounce you use might affect the color tone of the light that's cast on the subject. And almost everyone has a strong opinion about what colors they like best. Play with all the options to find which ones work best for the type of dish you are photographing.

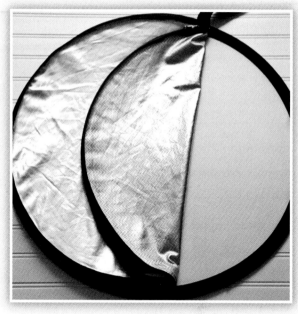

Silver and gold reflectors offer different options for reflecting light into your scene.

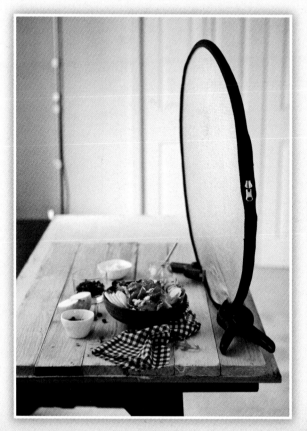

A gold reflector was used for this dish.

f/3.5, ISO 1000, 24-700mm, L

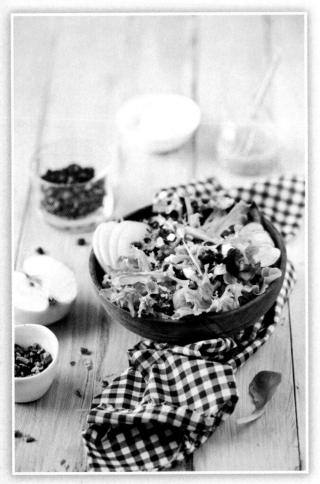

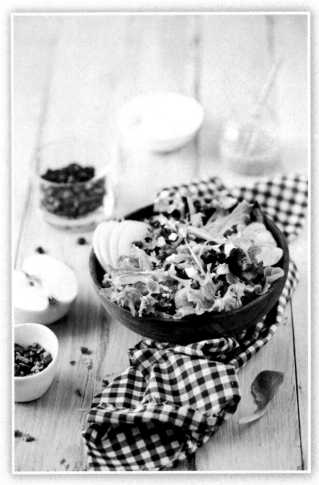

The gold reflector used in this salad shot cast a golden color onto the dish. The golden hue on the green of the salad and the radishes makes the image look slightly outdated.

f/3.5, ISO 250, 100mm, Macro L

Using the silver side of the reflector made a small ... but to some, important ... difference in the overall color tone. The green of the salad is vibrant and the whites of the radishes are more natural.

f/3.5, ISO 250, 100mm, Macro L

These images were shot with a setup that included a small reflector, which was used to bounce light back onto the dish. The light in this scene was coming from a window on the left, and I bounced it on the right. I don't often use the gold side of my reflector ... just a personal preference, but it's important to figure out your own preferences by shooting the same subject with each side of the reflector (and even without a reflector) to see which one works better for the dish you're shooting.

Go Big

Depending on your available space and the image you need to create, it may be worthwhile to invest in a large reflector. They come mounted on a stand, which gives you greater freedom of movement. The stands are lightweight and the reflectors fold flat, making them easy to store and tote around. Also, a larger reflecting surface bounces more light in a broader way, which is usually quite beneficial.

Decisions about how much or how little of the light to bounce and with what—a reflector, card board, mirror, etc.—will depend on the ultimate effect you're trying to achieve. Examining your pictures and playing with different setups will help you decide which bouncing situation works best for you.

Also, keep in mind that the distance between your bounce and the subject will affect how much light makes it back to your subject and fills the darker areas. I suggest positioning your subject as close as possible to the bounce and then moving the reflector away in small increments until you find the right distance. Notice that shadows become stronger as you position the bounce further from the subject.

The setup for this shot of the salad is the same as the one used for the previous photos, except a larger (40x60) reflector, mounted on a stand, reflects even more light onto the dish.

f/3.5, ISO 1000, 24-70mm, L

Options for Diffusing and Reflecting

To illustrate how diffusing and bouncing works, let's go through photographs that were created with different bouncing and diffusing setups.

I placed a few radishes on a table with light coming from the back. I did not diffuse this light or bounce it in the image on the left below. The incoming light creates visible and long shadows around the radishes, which is a bit distracting. They take away focus from the radishes.

The only thing I changed to the setup for the second shot was to diffuse the light by hanging a bed sheet over the window. This immediately reduced the strength and length of the shadows on the radishes. It also softened the overall light in the frame and brought focus back to the radishes, although the right side of the vegetables are a bit dark.

In the final picture of the radishes on the right, I kept the diffusing bed sheet over the window and added a white foam board to the right side of the scene to bounce the light. This evened out the light throughout the frame and

The light was coming from behind the radishes. It was left undiffused and unbounced, which created distracting shadows.

f/3.5, ISO 800, 24-70mm, L

The light was coming from behind the radishes. Here, it's diffused but not bounced. This reduced the strength of the shadows.

f/3.5, ISO 800, 24-70mm, L

The radishes were still back lit, and the light was diffused. It was also bounced from the right side to reduce the strength of the shadows and add more natural light to the picture.

f/3.5, ISO 800, 24-70mm, L

diminished the dark areas around the radishes. This was the picture I used for the article I was working on.

Now, I'm not saying that every shot needs to have diffused and bounced light. The use of this and any other photography technique depends on a variety of factors, including:

- The type of food you are shooting
- The quality and quantity of light available
- The overall effect you're trying to achieve

Here are more examples of the effects you can achieve by making the decision to bounce and/ or diffuse the light you have available—or not.

I wanted to play with the messiness of the cut-open pomegranate—a fruit known to be juicy and messy. I also wanted to play with the strong shadows and highlights given off by the light to help convey that messy feel.

The pomegranates were shot with side light, which was not bounced or diffused.

f/3.5, ISO 290, 50mm

The light was coming from a window on the left, and I intentionally did not diffuse it … in order to take full advantage of the dramatic effect it was already rendering around the fruit. The shadows emphasized the feel of messiness coming from the composition.

These ice cream sandwiches were shot in side light that was bounced and diffused.

f/3.5, ISO 400, 24-70mm, L

I tried to add a bounce on the right side to fill in the dark areas and lighten the red color of the fruit. But I realized that I liked how dark red it was, so I decided not to bounce the light after all. I wanted to keep everything around the pomegranate very highlighted and almost blown out so the eye would focus only on the fruit.

Unlike the moody shot of pomegranates, the intent for this picture of ice cream sandwiches was to keep the light soft and balanced throughout in order to let the two-color elements in the shot (the striped straw and chocolate cookies) really stand out. And to retain a feeling of "creamy and airy" for the ice cream, I diffused the incoming light. I then bounced more light onto the sandwiches by positioning a silver reflector on the right.

Finally, one of my personal favorite images for talking about light and storytelling is the one of Provencal Stuffed Squash on the next page. It was such a terrible day for a photo shoot when this was shot. The rain was falling hard, so the light was terrible—low and foreboding. Yet the shoot continued.

The photograph shows a popular dish of Provence in France. It is true comfort food and a traditional item for Provencal families—

Home Goods

A lot of reflector/ diffuser kits like the ones I use start around $30-50. However, money invested in photo equipment can tally up fast. Thankfully there are plenty of items that you already have on hand to get you started in the world of diffusing. Use bed sheets or any cloth you may have for diffusion and small mirrors, glass bottles, white dinner plates and foil-covered cardboard for reflection.

The Provencal Stuffed Squash was photographed with side light, and it was not bounced or diffused.

f/3.5, ISO 400, 24-70mm, L

the kind of dish that makes any gloomy and rainy day feel a bit less drab. I chose to use the dark ambient light instead of enhancing it with artificial lights so that the image could convey the cozy feeling of preparing warm soup on a dark or rainy cold day. The composition supports this feeling as well.

The natural light was not diffused, because I didn't want to interfere with the very specific silver … almost electric … quality that natural light takes on during a rainstorm. This led to greater highlights than would have appeared with diffused light, but these highlights add a pleasing drama to the frame. Nor did I bounce the shadows on the right. This was to retain the feel of moodiness in the shot.

Natural Light Sources

Photographs shot under natural light, whether from the sun or through a window, are usually more natural to the human eye that those created with lighting setups. But natural light sources are not constant; the light changes by the hour and with the seasons, and it's different according to the weather and your location. Each of these variables alter shapes, tones and colors.

For instance, in Western Europe and North America, wintry days bring about hazy or crisp blue skies with silver tones, whereas summer days produce a warmer light with more pronounced golden and green hues. If you were to stay in a single position while shooting throughout the course of a full day, you'd see that the direction of the light changes as the sun moves, and this alters the shape and texture of the subject you're photographing. To achieve the look you want, you need to know what effect different light orientations produce.

To select a natural light source that will best enhance the dish you want to photograph, here are some things to consider.

Outdoor Light

As a beginner, I figured the light on my outdoor patio would be the best. I mean, it was the sun and the sky! What broader and more readily available light can we find, right? Well, unfortunately, in most instances, you'll find that shooting outdoors does not mean that you will automatically have the proper light for your photograph. Just because the sun is out there and shining strong doesn't mean that light will work with the photograph you're trying to create.

Strong direct sunlight is actually quite a challenge for most photo situations. It's hard on your subject, and it creates strong shadows and equally strong highlights. Colors are more pronounced in this kind of light, and whites tend to become blown out more easily. All of this makes your job as a light whisperer that much tougher.

The picture on the right was shot as an outdoor snack board. It was the middle of a very sunny summer day when this composition was created, but I decided to wait for the latter part of the afternoon to take pictures. Among the benefits of waiting was the softer shadows produced by the afternoon light (versus the high contrast produced by strong noon-day sun). This helped me keep the subject well-defined and not masked by large dark areas.

The sun was on my left, and I chose not to bounce the light on the right with a reflector. This is why dark areas remain under the egg bowl in the background and the fig basket in the middle ground. Yet this works because the cheese plate on the far left is very highlighted due to the sunlight, creating a nice balance.

I love the feel and mood of this setup—a little afternoon spent relaxing on the deck—but the challenges presented by direct, non-diffused/ non-reflected light can be difficult to manage. Fortunately, the colors in this shot were muted, so only the whites threatened to become overpowering. I controlled this by keeping whites to a minimum. The three places they appear in the frame (cheese, milk and sugar) are separated, so they do not become one large source of white.

If this setup had included strong colors, such as bright reds and oranges, it would have been even more difficult. Indeed, the sun would have made them even stronger, distracting the eyes away from the rest of the elements. If this had been my shooting situation, I would have tried to diffuse the light first and, if that didn't help, I would have considered shooting at another time of day. I may have even moved this whole scene indoors.

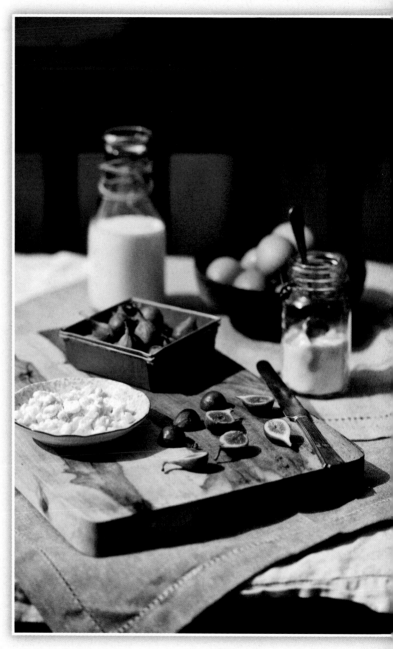

A table-setting shot outdoors one late afternoon presented a few challenges due to that gorgeous sun!

f/3.5, ISO 100, 100mm, Macro L

This outdoor dessert table is evenly lit on an overcast day.

f/5.6, ISO 100, 100mm, Macro L

Cloudy days provide a terrific environment for photography. The clouds create a natural diffuser for outdoor light, which leads to softer shadows and less blown-out edges. The light on an overcast day will wrap around your subject and fall more evenly than they do under strong direct sunlight.

There are so many different textures and heights that appear in the dessert table image. The soft quality of the light helped keep the look very smooth without dramatic highlights. And the inclusion of different heights and shapes keep the image from appearing stale. This visual variety adds movement to the photograph and breaks the even nature of the light. Find more information on setting up your scene in Chapter 5 (Composition).

If you don't have a diffuser (or even a homemade stand-in, as described earlier) and need to soften your outdoor light, try setting up under an awning, a deck, a parasol or a porch.

I was working on an outdoor summer party for a magazine feature when I shot the blueberry sorbet on the next page. Yet it was the middle of winter! So I tried to capture the feel of summer by shooting on a bright sunny day. To help me manage the changing light situations

throughout the day and filter the light coming directly from the sun, I set up most of the shots under the patio awning. The light in that location was nicely diffused and fell evenly in the frame, minimizing shadows and reflections in the glass.

No matter where you choose to shoot, remember that outdoor photography during daylight hours will enable you to keep your ISO relatively low (try 100 to 250 and up to 400 if the weather is overcast). Also remember to set your white balance appropriately when outdoors: usually Daylight or Cloudy. And pay attention to the season. The quality of the light will be different in winter than it is in summer, so be sure to make the proper adjustments as covered in Chapter 2.

Window Light

When not diffused, direct light coming through a window on a clear and sunny day can be just as strong and harsh as unobstructed sunlight outdoors. Even if you set your exposure properly, you'll notice that direct window light creates dark shadows and strong highlights. And perhaps this is perfect for the story you're trying to convey. But if you prefer a softer light with less contrast, try shooting under early morning or late afternoon light, which tends to be gentle and easy to manage.

This blueberry sorbet was photographed under a balcony, where there was nice, even light.

f/4.5, ISO 100, 100mm, Macro L

The soft light of an early Fall morning is coming through the window to cast an atmosphere of openness.

f/3.5, ISO 640, 100mm, Macro L

This cupcakes image was set up indoors in a place where light streamed directly through the window on the left. The light was undiffused to create lots of highlights in the scene and even blow out some of the whites. To me, this conveys an airy mood … light-as-a-feather cakes on a cold winter morning. The shadows were very strong, and to reduce their impact and retain the lightness, I bounced the light with a silver reflector that was positioned on the right.

Remember, diffusing light coming through your window evens out the quality of the light. This diminishes the hard contrasts and softens shadows. As a result, diffused light makes it easier to set your camera for a proper exposure, which can be key when time is an issue—such as when you are photographing food that melts or wilts quickly, or when you have a very hungry family waiting on you to finish photographing their dinner!

Even after diffusing the light, you may notice that shadows and highlights are still too strong. In these cases, you need to decide if and/ or how the available light can work with the frame you're trying to shoot. If you want to incorporate a dramatic dimension to your picture, leave it as is. Or, consider bouncing the light so it hits your subject from the opposite side as well. This may help fill in some of the dark spots.

Here you have it, my favorite diffuser is actually a recycled bed sheet!

f/3.5, ISO 320, 24-70mm, L

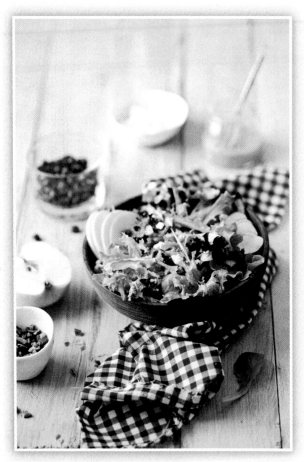

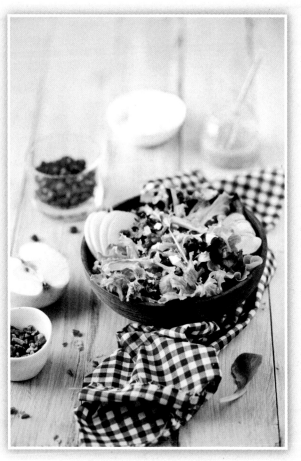

The setup for this photograph of a salad featured light coming from the left side, diffused with a bed sheet and unbounced on the right.

f/3.5, ISO 250, 100mm, Macro L

This is the same salad with the same left incoming light, which is diffused with a bed sheet. But this time, a white board bounced the light from the right.

f/3.5, ISO 250, 100mm, Macro L

In the pictures of the salad bowl above, the light came in from the left. I used my bed sheet diffuser to soften the direct window light, and I did not bounce the light to illuminate the other side of the bowl in the photograph on the left. Therefore, shadows naturally fall at the bottom of the bowl onto the table. They're not ugly, but they make the overall composition a bit stern. By using a simple piece of white foam board for the image on the right, the light bounces back onto the bowl, filling in the dark areas.

Depending on the quality and quantity of the light coming through your window, you might find it necessary to make some adjustments to your camera settings. That is, it may be helpful to bump up your ISO or decrease your

Golden Hours

During daylight hours in a well-lit area, you'll probably notice that low-light adjustments are unnecessary. Prime natural light is typically available for an hour or two after sunrise and an hour or two before sunset. This is known as the *Golden Hours*.

Of course, *hour* should be perceived loosely since the photographer's location in regard to the Equator will affect the duration of the amount of time that this soft light is available. Close to the Equator, less time is available for Golden Hour light. As you get further from the Equator, this superb lighting lasts longer.

If you cannot shoot your images under this prime natural light, then you'll probably need to use longer exposures or adjust your ISO to accommodate the light you have.

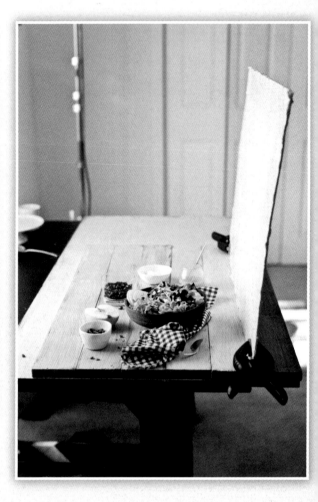

Among my most precious pieces of photo equipment is a 99-cent piece of foam board that I use as a bounce to fill in troublesome shadow areas.

f/3.5, ISO 250, 100mm, Macro L

f/stop to allow in more light. Or, if you don't want to compromise grain quality by increasing ISO, think about setting your camera on a tripod and using longer exposures (slower shutter speeds) to prevent camera shake, which would result in a picture that's out of focus or blurry.

You might also want to adjust the white balance depending on your window orientation, the time of the day you're shooting, and/ or the season. (The light carries a warmer tone in the summer than in the winter, for example.) Refer to Chapter 2 for examples of white balance adjustments.

Your ideal light orientation depends on your location and personal preferences. The irony … and interesting quality … of natural light is that it's never the same from one day to the next or from one location to another.

Where I live in the southeast US, I very much prefer a south-facing window, because I prefer the many variations of light that this orientation offers throughout the day. But I know other photographers who love northern light above all other options. So if you intend to shoot as long as possible throughout a given day, observe which part of your house or locale receives the most light and for the longest time. Or, if you're more concerned about color casts and contrast, try different window orientations to find the one that meets your needs.

Northern light is known to be soft and consistent. This is its upside and downside. Southern light, on the other hand, offers a variety of strength and shades of light. This requires a photographer to be aware of and prepared for these variations. Start with one orientation, move to another. See how one light source affects your subject versus another. Play and practice.

Just keep in mind that things change with the season. During winter in the Northern Hemisphere, the sun is positioned low, near the southern horizon, so more direct sunlight may come through your south-facing window at this time. In the summer, the sun is oriented higher in the sky, so this affects the angle of light striking that same window.

Light As Story Teller

Above and beyond the props, color palette and styling of your photo setup, light—the lack or abundance of it and your manipulation of it—is integral to creating images that reflect the mood, the ambiance and overall tone, you envision. As emphasized so far in this book, thoughtful management of light helps you to draw and hold the attention of your audience. A picture is worth a thousand words, yes; let the first one be *Wow*!

Whether you choose to photograph in direct sunlight outdoors or with a natural or homemade diffuser indoors, always photograph with intent. Some questions to help define purpose:

⬢ Why are you outdoors (or next to this window or in a corner) anyway?

⬢ What are you trying to convey about this food with your image?

⬢ Can the hard light and highlights of direct sunlight help enhance your dish by adding texture and shape, or will it completely ruin the tones and colors you're hoping to capture?

⬢ Will high beams of sun help to tell the story of your dish?

When managed appropriately, the quantity, quality and direction of the light will enable you to tell your story in a visual way. Some light situations will be more useful to you than others.

As already mentioned, the first step is to choose your light source and then decide whether or not to diffuse it and/ or bounce it. Then, think about the direction of your light. Where is it coming from? And is it appropriate for your shot? Let's explore the impact of the direction of light.

Finding Direction

For a photographer, trying to manipulate a natural element as fundamental as light is a constant. You simply must know where the light comes from and understand how each direction impacts your shot. It impacts the overall look of a picture tremendously. Natural light changes all the time, keeping you on your toes and your creative juices flowing.

Front Light

When a photograph is shot using front light, the photographer is placed with the sun to his/ her back so the light falls on the subject from the front. Front lighting produces a rather flat light which makes it relatively simple to set the exposure. By the way, a light is said to be *flat* when it produces very little contrast, which reduces the multi-dimensional nature of a subject. You don't have to worry much here about shadows and highlights.

Yet this is said to be one of the main drawbacks of front lighting: the light is rather dull. This kind of lighting won't bring forth the textures and shapes of the food you're photographing. To help, try standing further away from the subject— and maybe use a telephoto or macro lens. This will let some of the sun beams go right above your shoulders and fall onto your dish.

Back Light

When you use back light, the light source is directly in front of you, behind your subject. I know, this goes against the first bit of photography-lighting advice you probably ever received. At least in my case, when I was a kid playing with my first camera, I was told to never shoot with the sun directly in front of my camera. Doing so would produce strong highlights and silhouettes instead of people.

It's true, back light tends to have a strong effect, no matter what its size. And even diffused, back light can be tricky. When handled well though, back light produces beautiful highlights and contrasts. Use it when you want to accentuate

the shine of liquid surfaces, such as beverages. It also works well when photographing jellies or chocolate, because it helps hide some surface flaws and casts a nice silver shine on chocolate items.

To accentuate the gloss of the gel surface in the picture below, I used back light. And to ensure there wasn't too much going on in terms of shadows on the sides, a silver bounce was positioned on the right. Finally, a white foam core was placed right in front of the glasses to reduce shadows. This kept the main focus on the top of the subject.

For the photograph of the chocolate tart, I used back light to hide my setup challenges. The tart had been frozen because I wasn't able to photograph it

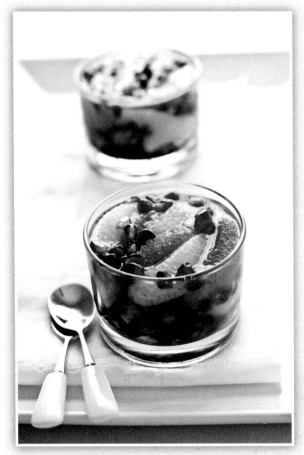

A back-lighting situation helped to enhance the shine on the top of this Citrus Tea Jelly dessert.

f/3.5, ISO 290, 50mm

This Chocolate Tart was backlit. The light was diffused but not bounced, which resulted in pronounced shadows against the pie plate.

f/3.5, ISO 400, 100mm, Macro L

The strong highlights created by the light coming from the back of these onion flowers helped draw the eye to the one in the center of the frame.

f/3.5, ISO 100, 100mm, Macro L

right away; and when I let it thaw, little beads of condensation formed on the chocolate. To minimize this, I sprinkled some cocoa on the top and used back light to accentuate the shine, which smoothed out the surface visually.

Back light is also great for frames that include minimum styling and props. The strong highlights coming from behind the subject tend to swallow background shapes and textures anyway, so back light naturally flatters the foreground of a composition.

The light in the photo of onion flowers was very strong, even though it was diffused, and this created a shallow depth of field. The back lighting blurred out the shape of the bowl in the background and minimized the stem of the onion flower. This worked well here, because these elements weren't too visually appealing. And with everything so highlighted, the overall feel of the image is gentle. Yet the foreground subject pops.

When using back lighting, bouncing light back onto the front and/ or sides of your subject will often be helpful. It will help you maintain a nice balance of lighting while retaining the benefits of back lighting … without having to increase your ISO too much.

One thing to remember about back lighting is that it can create *lens flare*, a term that describes the hazy look and/or polygonal shapes in a photograph caused when uncontrolled light (like the sun, the moon or artificial light) hits the lens at sharp angles. Lens flare is sometimes used artistically for portraits and lifestyle photography—think: picnic setting on a sunny summer day—but less frequently (if ever) for food photography.

One easy way to avoid lens flare is to use the hood that came with your lens. Think of it like the hat you put over your head to protect it from the sun. If for some reason, your lens did not come with a hood (they are brand- and model-specific), then I recommend that you purchase one. They are an inexpensive and can be easily found online or at any good camera store.

Side Light

When light comes from the side of a subject, it's known as *side lighting*. To visualize placement of side light, imagine a clock. If a subject is positioned at the center, then side light comes from the space between two o'clock and four o'clock … or eight and ten o'clock.

Side lighting adds dimension to your images by bringing forth the shape, textures and shadows created by the

The crabs are positioned with the main light source coming in from the left side at an eight to two o'clock angle.

f/3.5, ISO 320, 24-70mm, L

Ingredients for s'mores are
dynamic in natural sidelight.

f/2.8, ISO 125, 100mm, Macro L

food and props. Since the light falls primarily on one side in this setup, shadows on the other side are accentuated. Depending on the time of the day, you might find that the shadows are too strong for your liking. This is where reflectors, bounces, flash fills and other lighting accessories can really help.

In the picture of s'mores ingredients, the table is positioned between *two* large windows (instead of one), which provided more light to work with than I usually have. To convey an autumn feeling, I wanted lots of light in the composition … with sun beams coming through the room. The longer shadows and the golden glow from the sun splashes helped me create a Fall mood in this image.

The window on the left took a secondary lighting role, but it kept good light on the foreground of the composition. The other window, positioned at a side angle, provided the primary light for this image.

If you're new to food photography or photography in general, I suggest starting with side lighting. This is probably the most dependable orientation for light during

Be Quick

I was shooting for my blog when I captured the image of eggs and asparagus, which were indeed our brunch following the snap. But when I shoot for a magazine feature, I may or may not eat the food I photograph. It depends on how long it sits out. If I *know* a dish is going to be eaten and time is short for getting my shot, then I like the reliability of side light.

—◦✥◦—

Side lighting, when diffused, provides a soft and reliable light that helped me take a good shot very quickly before brunch.

f/3.5, ISO 640, 24-70mm, L

most hours of the day. And I think you'll find that it's easier to control exposure, highlights, shadows and other lighting considerations in side lighting situations than when working with front light or back light, which typically require more thought and technique.

All I had to do for the eggs and asparagus photo was bounce the light on the right with a white foam core and diffuse the light on the left. In almost no time at all, we were able to enjoy a warm and satisfying meal.

If this had been something we could have refrigerated to eat later or if more time to capture the dish had been available, I would have photographed it in both side light and back light. I would've experimented with undiffused and unbounced light. Instead, I used the go-to side light to get the shot fast so we could eat.

The Lemon Flan was side
lit in late afternoon.

f/3.5, ISO 250, 100mm, Macro L

Here's one more example to remind you to move around your setup. I was glad this came to be, because when I began shooting the lemon flan, the main light source was coming from a window directly to the side of this dish. It was alright, but not great. So I adjusted different elements to improve the setup. But I just wasn't happy with the results. It was late in the afternoon and I realized that the light was just all wrong. It looked flat and gray—not very interesting.

I considered packing away the flan and starting over the next day, but … motivated mostly by my sweet tooth … I decided to take a step back and reassess the lighting situation before giving up. There was plenty of light in the room after all. And I realized that I didn't *have* to stay in the same usual spot.

I moved the table closer to another window in the room, where direct sunlight was coming through. Positioned at a ten o'clock angle to the light, this setup allowed me to use some of the soft sun beams coming in through the window to convey an inviting mood of tranquility, as if telling the viewer, "Come sit and have a piece of cake."

So remember that you don't have to wait for the light to be in a specific position to start shooting. You are a mobile entity. Don't be afraid to move around your subject or to move the subject

itself to acquire a different relationship with the light … to get the angle/ direction that you want. If you have the time to wait for the right time of day, a time when you like how and where the sun splashes across your setup, then wait it out to get what you want. Otherwise, just make it happen by strategically placing yourself and your food.

So while you may have a preferred lighting setup for your photography, your images will benefit if you can stay open-minded and ready to experiment once in awhile. Natural light is constantly moving and changing. Enjoy the variety of effects it offers and use it to your advantage by moving with it.

In summary, when shooting with natural light, ask yourself these questions:

- Do I want to be outdoors or indoors?
- What mood/ feel am I going for? Do I want to bounce the light to minimize dark areas or do shadows add important visual interest to the shot?
- Do I want lots of shadows and highlights (direct light), or do I want to keep the light soft and gentle (diffuse it)?
- Do I want the light to come at my subject from the front, back or side?

Can you tell that I love natural light?! It's pretty amazing to me how much possibility it offers. There are so many ways to use what's out there. Just remember that tools, such as bounces and diffusers, can help you manage light. And your camera settings, such as aperture and shutter speed, enable you to harness and use as much natural light as possible.

There's a never-ending combination of tools and camera settings that offer you an ability to make photographic magic. Practice … and explore the creative possibilities available with natural light.

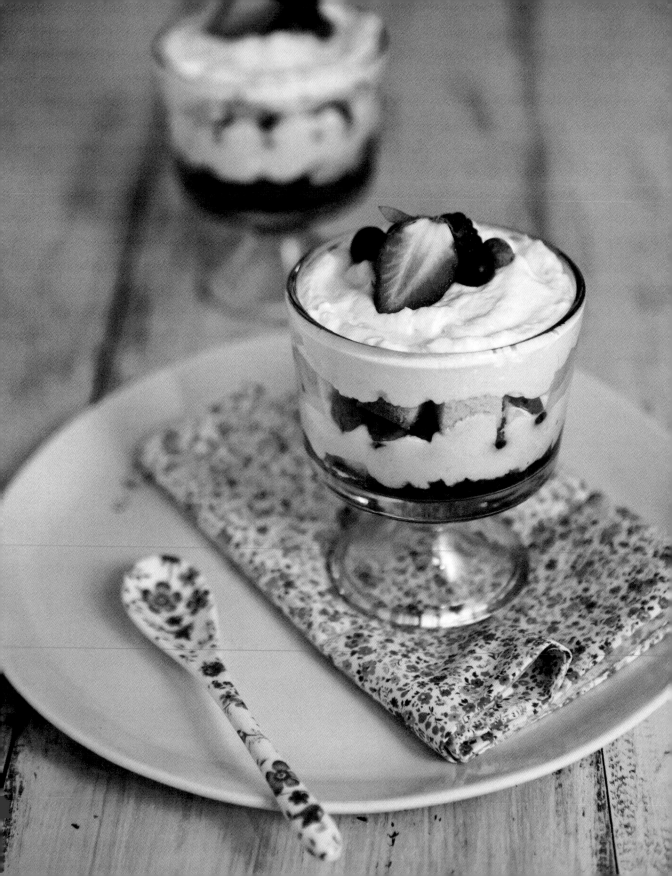

4 ✤ Artificial Light Photography

Despite my strong preference for working with natural light (versus the artificial variety), I must admit that I've found myself in places and circumstances that simply didn't have enough of it to create a good picture. So rather than pack up and postpone a shoot until another day, I learned how—in a pinch—to supplement the available light with different artificial light sources and equipment.

When it comes to collecting and using these tools, things can add up fast in terms of the amount of gear you'll need and the skills needed to maneuver all the technical settings. But one of the great things about artificial light is that the possibilities are endless.

Didn't I say that about natural light? Yes. And here is why both offer possibilities: They provide *light*. So, to create photographs that you enjoy, what's really important is that you know what to do with the light you get. And there's a lot to consider—no matter what light source you have. This chapter covers the basics.

TIP

The photographs in this chapter illustrate different lighting situations. All were shot with studio light as the primary source. Various types of ceiling light (each with different luminosity) were used as well to ensure visibility during the shoot.

Lighting Gear

Equipment for artificial light can get pricey, and some options offer a slew of complicated settings and adjustments. So I suggest, especially if you're just starting out on your photography adventure, that you start with some basic gear and work with them for awhile. You'll see quickly that each new tool opens a whole world of possibilities when natural light is not available.

Well, why not just use a table lamp and shade to light a food subject, you might ask. I encourage you to test this option. But I don't think you'll be completely happy with your results … because the quality and quantity of the light matter much more than the form in which it comes.

See, photographers don't walk around with artificial light setups because it's cool. There are specific reasons for artificial light systems, and none of them are to make you spend more money on photography … or to make you to haul more gear. Rather, they exist because the quality and quantity of light matter so much to photography. And the right light for my work will never be created by my bedside table lamp … even if it holds the best bulb I can find.

To select the best artificial lights for your particular setup, think about your budget, the time you are willing to spend on setting up your shots and the space in which you typically work. Talk to other photographers; do your research; and find a setup that makes sense for you.

Studio Kit

If you have a dedicated space for food photography, at home or at work, the basic studio kit is a nice setup to get started. It will include a light stand, halogen bulb and a lighting umbrella. This type of set is called a *hot light system*. Most people, when they begin working with studio light, find this kind of set easier to control than strobes, and it achieves lighting that's close to natural light.

Strobes offer one big source of light, often overpowering other light sources. Conversely, hot lights allow one to see where the light is directed, and they provide ample light for shooting in small spaces. This is ideal for most food bloggers, foodies and beginner photographers. Yet even as a pro, I love my hot light set as a supplemental source of light when needed.

A bigger space will require more lights and umbrellas, but when you plug in a single bulb on a studio kit, your first reaction will likely be, "Wow! That thing is bright!" And yes it is! Depending on the intensity of your home lights, you may need dim them, especially if your home light is bright. This will help you avoid an added yellow/orange color in your photographs.

Lights

The umbrella lights that come with most kits on the market nowadays have strong halogen bulbs, commonly ranging from 500W to 750W. Depending on the angle of the umbrella, these bulbs can emit a very powerful light from far away. You can start with a 500W halogen bulb, but I recommend getting a 750W right away if your light kit does not come with it already. It makes a world of difference.

But be careful! These tiny halogen lights are really powerful … and extremely fragile. It just takes one little bump against the wall to knock out your bulb. And if you're on a deadline …well, that could be a real problem. Consider purchasing a few extras each time you replace a bulb. They're reasonably priced, so this shouldn't be too painful.

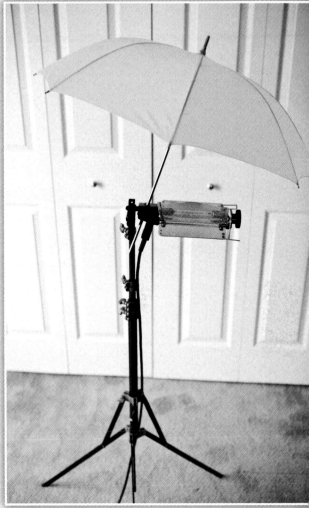

A basic studio light kit includes a stand, umbrella and halogen bulb.

f/4.5, ISO 250, 24-70mm, L

Another thing about halogen bulbs is that they get *very* hot … very fast. There are special types of umbrellas/light modifiers made specifically for hot lights. Normal strobe umbrellas should not be used, because they are not made for the higher temperatures. And I know this well. One time, I failed to secure my umbrella tightly in the open position, and it slowly started to close as I was busy taking pictures. I didn't realize what was going on, until … Yeah, the smell of burning fabric can be quite distracting. I now have a silver umbrella

The Halogen Option

If you don't want to mess with studio kit lights, you can purchase halogen construction lights that are either mounted on a stand or easily attachable to one with sturdy clamp. These have the same quality of the kit studio lights and are very sturdy, but they're a bit on the heavy side if you need to move them around.

with a hole in it that took only seconds to form. Lesson learned.

To avoid the heat issue, think about using "cool lights" instead. These are fluorescent bulbs that don't get hot. They put off a color that's similar to daylight, so they can be used while there is still natural light in the room as an added light boost. Like halogen lights, the strength of fluorescent bulbs is determined by the number of watts they have.

When it comes to fluorescent light bulbs, there are many variations in color temperature, which will affect the look of your photo if you shoot in Auto or Fluorescent white balance. If you opt to use fluorescent light, consider doing a custom white balance on your camera (which is well-explained in all camera manuals) before you take the picture. In my opinion, these work great as a light supplement but less well as a dominant source of light.

Umbrellas

A photography umbrella looks no different from a regular rain umbrella, but of course it has an entirely different purpose. It opens and closes like a regular umbrella, but a photography umbrella has a reflective inner lining. Yes, even white photo umbrellas have a reflective quality to them.

These umbrellas are used to diffuse light. To use a photography umbrella, shine the halogen bulb directly through it, and then position the umbrella to point toward or away from the subject to obtain different effects of shadows and highlights. Moving the umbrella closer to the subject will broaden the light source, allowing it to reach more places in the frame. Moving it away from the subject has the opposite effect.

Different types of umbrellas will produce different effects.

- A white umbrella generates a soft diffused light, but since these are not 100% opaque, some light is lost. These umbrellas generate a flattering light.

- An umbrella with a black coating on the outside allows virtually no light to pass through, which means that all of the light is bounced back onto the subject.

- Umbrellas with a silver lining are similar to the white ones, but they are a bit more reflective and can put off strong shadows.

As with nearly every piece of photography equipment, *best* is a matter of preference. The nice thing about umbrellas is that they are relatively inexpensive (starting around $20-30), which makes it do-able to get a few to use for various types of projects.

Scrims

Diffusing is key when it comes to artificial lighting, and if you have an umbrella with your studio kit, chances are you already have good diffusion. (For a closer look at diffusing, please refer to the Diffuse and Reflect section in Chapter 3.) But there might be instances that call for another diffusing tool, like a scrim, which is a translucent gauzy type of material that's fastened onto a frame. Scrims can be hand-held, if small enough, or attached onto a stand.

Scrims both diffuse and reflect light without changing its color or quality. They come in different strengths, which depends on the tightness of the fabric weave on a unit. Scrims are available in single and double strengths, which means they can reduce light by a half (single) or a full (double) f/stop.

Professional-grade scrims are not cheap, but you can mimic the effect at home by stacking sheets of vellum together or using different thicknesses of opaque papers that you can pick up at a craft store. The opaque diffusers that come with reflector kits (like the one that came with my 40 x 60 reflector or the little 22-inch round) also work really well with studio lights.

The studio system I use at home is nothing grand or outrageous, but it's proven to be reliable in situations that require artificial lights. I use the studio kit a few times per year—to photograph something on a deadline when it's dark outside or to comply with the art direction on a specific project.

And I still use the first system I bought: a Lowel Tota Pak that runs about $210. Setup is simple, and the kit is easy to operate and store. Most importantly though, it gives me reliable light for my work when natural light is insufficient. There are hundreds of studio lighting kits available, so take your time to study and compare different models to find the one that's best for you.

Stand Down

An important thing to know when using a studio kit: stands fall. Because these kits are designed for indoor use, the stands are not very sturdy. They can easily fall to the floor, but they won't usually break from these falls. Consider weighing down your light stand with bags of sand, and keep children and pets out of the area when your stand is set up and in use. Upgrading to a sturdier stand may be a good idea, especially if you use your system more than a few times a year and/ or outdoors.

Balance!

Don't forget to adjust your white balance settings before using artificial light. Since different types of bulbs have different color temperatures, you need to be sure to select the appropriate white balance for your setup. In my experience, the Tungsten setting is most reliable when shooting food with artificial light. It tends to require minimal adjustments in post processing. But don't take my word for it. Play around with the options each time you shoot, and find the one(s) that work best for the effect you're trying to achieve. Refer back to Chapter 2 for more information on Camera Settings and Modes.

The photo on the left was shot with Auto white balance, a common setting for natural light conditions. Notice the orange/ sepia color. For the second picture, I changed the white balance to Tungsten. This reduced the sepia tone. There is still a pink cast to the image, but this can be fixed in post processing. See Chapter 8 (After Capture) for more information on photo editing.

Auto WB, f/3.5, ISO 640, 100mm, Macro L (left)

Tungsten WB, f/3.5, ISO 640, 100mm, Macro L (right)

Equipment Setups

Once plugged in, you can position your lights and umbrellas in different ways to achieve different effects. When working on your setup, notice how the position of each element affects the softness of the light as well as shadows and dark areas. Note, too, how the use of a bounce changes the light in an image.

Keep in mind that I work from RAW files, so the only post processing that was required for these photos is a bit of sharpening and contrast enhancement. No editing was performed on the lighting, exposure or white balance of these images.

Studio Lights and Umbrellas

When it comes to light, one thing you must do is *take charge*! It's much easier to do with artificial lighting, since you move the light sources yourself. But as shown on the next page, there are as many ways to approach the same item as there are results.

The photo on the right shows the setup for shining the light source through the umbrella, and both are pointing toward the ceiling. One thing to appreciate about directing light to the ceiling is that it takes away a good bit of the glare coming off the white porcelain plate. This positioning is also referred to as *bouncing light off the ceiling*. It's something to consider if you shoot in artificial light for scenes that include regular china. Glare can be quite distracting, and it takes away focus from the food.

Setup: The light is shining through the umbrella, and both the light and the umbrella are pointed toward the ceiling with a bounce.

f/8.0, ISO 800, 24-70mm L

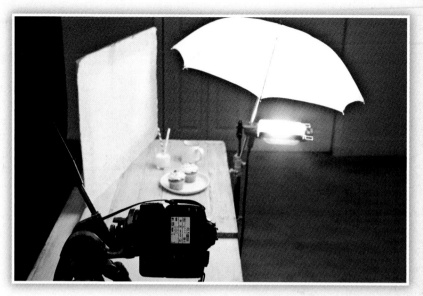

Here, the white ceiling onto which the light is directed bounces the light back onto the cupcakes, adding a bit more power to the light as it falls down and over the subject. In addition, a white board bounces the light coming down on the cupcakes. This fills in what would have been dark shadows on the left. Adding a silver reflector to this setup would have further diminished these shadows.

This is the setup to use to reduce as many dark areas as possible while using as much of the light as you can.

Keep in mind that the size of the board has very little effect in this situation, because the subject is relatively small. When shooting a whole table composition, a larger board would better cover the larger scene.

This image was shot with a setup like the one shown above. Notice the soft even light and minimal shadows in the scene.

Tungsten WB, f/3.5, ISO 640, 100mm, Macro L

The Versatile Umbrella

Most umbrellas in basic lighting kits are best used as *shot into* umbrellas—rather than *shot through* ones. Shoot into the umbrella by directing the light and umbrella away from your subject. This way, you use the umbrella as a reflector. When you shoot through an umbrella, you use it as a diffuser.

Distance Matters

When setting up your lighting equipment, pay attention to the different effects of various distances between your light(s) and your subject. When using bulb lights to supplement natural light, the light stand can be set further away from the subject. When your bulb lights are the dominant source, it may be better to close this gap. Check your setup and take a few test shots to determine how far away from your subject to position your lights.

To achieve the same level of lighting in the pictures on the next page, which were shot with the umbrella directed at the food (and the light shining through it) as I got for the images on the previous page (shot with the umbrella directed away from the food to reflect the light), I bumped up my exposure compensation by a half stop in Aperture mode before pressing the shutter button. Be quite sure to check your camera settings and modes to verify they are set appropriately for your shooting situation.

In the photograph on the lower left (next page), the light is soft, because it's been diffused through the umbrella. However, shadows and dark areas remain because the light was not bounced. This soft feel works great to emphasize the creaminess of the frosting.

Set up your equipment based on the food you're shooting. This soft look of the cupcakes may not work as well for a bowl of beef stew or a pizza, which may turn out better if the umbrella and light are pointing at the ceiling for extra light. Test out a few different setups to see what works best for your dish.

Diffuse with Scrims

I admit that one of my favorite ways to shoot with a studio kit is the one shown in this last set of pictures (on the next spread): through a scrim without an umbrella. I like it because the light is diffused softly but remains powerful. I tend to use either the diffuser of my 40 x 60 reflector kit or, if working on small items, the one that came with my 22-inch one. I find that these scrims do a great job at diffusing the light without being pro-graded units. This is very similar to my method of diffusing natural light coming through my window with a bed sheet, as described in Chapter 3.

Setup: The light is shining through the umbrella, which is pointing at the subject. (upper left)

f/8.0, ISO 800, 24-70mm L

These cupcakes were photographed with an umbrella and light directed at them (using a setup like the one shown on the left), without a bounce. Notice the shadows on the left side of the scene. (lower left)

Tungsten WB, f/3.5, ISO 640, 100mm, Macro L

This photograph of cupcakes was also shot with the umbrella and light directed at them, but with a bounce. The left side of the scene is more illuminated now, and shadows are reduced. (lower right)

Tungsten WB, f/3.5, ISO 640, 100mm, Macro L

This picture on the upper right shows the setup I use when shooting with a large white panel and the studio light. The light bulb being quite powerful, I decided to move it slightly away from the panel, and this had virtually no impact on the amount of light being diffused. My main concern here was that the light would burn a hole through the panel if it was too close. I used the Tungsten white balance setting and bouncing board in this setup, which shows the positioning of equipment that I used for these cupcake photos.

The light in the lower left photograph was diffused through an opaque panel. As it is diffused, the light falls softly on the subjects without shining harshly on them. The effect is similar to a photo taken with the flash pointing at them. It's fine as is, but I took a couple more shots to test the effect of light being bounced back on the cupcakes.

For the photo on the lower right, the only thing I added to the setup was the white board on the left side, which was used to bounce light back onto the cupcakes and minimize the shadows. The shapes of the cupcakes became really well-defined without those shadows, and the whole picture retains a crisp look. The orientation of the light in this photograph is similar to what would be coming through a window, as explained in the Window Light section of Chapter 3.

Diffusing and bouncing are really important aspects of lighting—no matter if it's artificial or natural. As you now know, I mainly use a white board to bounce light. I call my silver reflector Big Bertha, because I only use it when I need a more powerful reflector than the white card. I encourage you to try different reflectors—gold, silver, white—to figure out which one you like best.

Built-In Camera Flash

Whether you're using a P&S or an entry-level dSLR, your camera probably comes with a built-in flash. Although, for a dSLR, it's referred to as a *pop-up flash*, because it pops up when you turn on the Flash function. Whether or not you need a separate flash unit is completely up to you. It's a matter of personal preference … like wearing green on Saint Patty's day. You don't *have* to, but it will probably make your day more pleasant.

If you happen to have a professional camera, you'll notice that the major manufacturers have removed the pop-up flash and installed a hot shoe for your separate flash unit. I guess they assume people using pro cameras have explored the limits of camera-mounted flashes and know enough

Setup: A large white panel is used in this setup instead of an umbrella. (upper left)

f/6.3, ISO 800, 24-70mm L

These cupcakes were shot with light diffused through a large white panel but without a bounce. Notice the shadows on the left side of the scene. (lower left)

Tungsten WB, f/3.5, ISO 640, 100mm, Macro L

This shot of the cupcakes used light that was diffused through a large white panel and bounced on the opposite side. The bounce minimizes the shadows on the left and makes the shot look more crisp. (lower right)

Tungsten WB, f/3.5, ISO 640, 100mm, Macro L

Ooh, ooh ... Hot Shoe!

A hot shoe is a mounting point on top of a camera. It's where a flash unit can be attached, and it looks like a squared inverted U with a metal point in the center. The flash unit will have a matching adapter on the bottom, which lets the flash slide into the hot shoe. This adapter has a metal point that connects to the hot shoe mount to fire. To fire the flash, the hot shoe mount and the flash metal point are shorted together through a circuit in the flash unit. Some flash units have a little securing band or belt to tighten the flash on the hot shoe.

about the flashes' limitations to get serious with separated flash units. Consumer models provide the option of using a pop-up flash or a hot shoe, which is a great feature for those who want to gradually explore flash-lighting options.

There's a lot you can do with built-in camera flashes, but once you get serious about artificial light photography, they can quickly begin to feel quite limiting. To get decent photographs with a pop-up, treat the flash as a separate light source and not as an extra setting on your camera.

What I mean by this is, if nothing else, do not point your flash directly onto your subject. Direct light casts harsh shadows and highlights that are quite unpleasant, and this startling light setup creates an unnatural scene.

Of course, this is difficult to avoid with a built-in camera flash; because in most cases, it's not possible to rotate the flash head in order to bounce the light off the ceiling or the wall ... or to diffuse and soften it. So I recommend using little techniques to diffuse and bounce the light of your pop-up flash. They're covered later in this chapter.

The photograph of the shrimp salad on the next page (upper left) was shot with the pop-up flash of a Rebel XTi camera, which was in a vertical position. The flash was aimed toward the salad and positioned slightly off center. The ceiling light in the room was on, too. Notice the strong highlights on the salad in the foreground as well as the hard light coming from the pop-up flash. Check the Hard Light vs Soft Light section in Chapter 3 for a refresher on these terms.

But before you rush off to buy a *speedlight*, which is an off-camera flash unit (described in the next section), know that there are a few easy ways to better use a built-in flash. I suggest you try these, because speedlights are pricey and require a tad more studying and practicing.

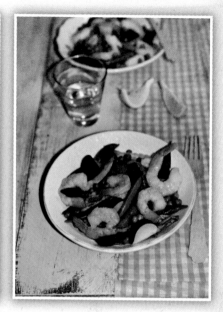

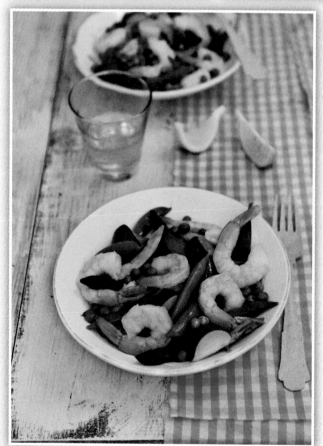

The shrimp salad was shot with the pop-up flash aimed toward it. Notice the intense brightness and strong highlights on the salad in the foreground. (upper left)

f/3.2, ISO 400, 24-70mm L

This was also photographed with the pop-up flash aimed at the shrimp salad. The flash was covered with a white piece of paper. Notice the softer appearance of the scene and the toned-down highlights. (upper middle)

f/3.2, ISO 400, 24-70mm L

This was shot with the same setup as the previous photos in this set, but the flash was covered with a soft pop-up diffuser instead of a white piece of paper. (upper right)

f/3.2, ISO 400, 24-70mm L

This image was shot with the pop-up flash aimed at the shrimp salad. The ceiling light was on and the flash was partially covered with a white piece of paper. The light was bounced with a white reflector. (lower left)

f/3.2, ISO 400, 24-70mm L

The first very easy and very cheap way to diffuse the harshness of the direct light of a pop-up flash—on a P&S or dSLR—is to take a piece of white paper and hold or tape it to the front of flash. Once taped onto your camera flash, you are freehanded to angle the paper in different ways to further manipulate the light coming from the pop up (explained below). You can also use a reflector next to your subject(s) to bounce more light onto the scene.

The paper diffuses the light a little, so highlights are diminished. This gives the elements in the shot a little more definition. Yet the white paper, placed flush with the flash in the upper middle photograph on the previous page made the light slightly too soft. The image could be improved by bouncing the light.

To further improve on this idea, I used a nifty trick in the picture on the previous page (lower left). The same white piece of paper was placed over the pop-up flash, but I angled it away. The paper functioned as a small but powerful reflector next to the pop up. This allowed the light to bounce off the paper, adding plenty of light to the scene. And a reflector placed next to the shrimp salad further brightened the frame. This is a great way to use the harsh light of a pop-up flash to your advantage.

If you're using a dSLR, the last workaround is to use a soft pop-up diffuser, such as Opteka or Gary Fong ($8-20), which comes mounted on a band that you simply secure onto your pop-up flash with a rubber band. Note that these are more see-through than a white piece of paper, which means they produce less of a noticeable improvement.

The third picture on the previous page (upper right) was shot with a soft pop-up diffuser over the camera's built-in flash. The highlights are softened a little by this small device, and this small bit of diffusion improves the overall intensity of the light. It's an improvement over the first shot of this series, which was created with the pop-up flash alone.

I like the effect produced by a white piece of paper attached to the flash (lower image on the previous page) more than that of a soft pop-up diffuser. And you'll find that a white piece of paper works especially well when your flash is used as a supplemental light and not the main light source.

Never feel intimidated to use what you have available. You can get good shots with your in-camera flash by using little tricks, like the white paper approach, or inexpensive diffusers. But when you're ready to step up your game, a separate flash unit will make a world of difference.

Remote Flash

The most commonly used off-camera flash units on digital cameras are *speedlights*. Other units, such as *thyristor* flashes, exist; but their technology is not ideal. They can easily damage the camera with their unregulated use of high voltage.

Off-camera flash units can be set in the hot shoe of your camera or on separate stands or tables. Operate speedlights directly through the hot shoe and flash setting of your camera. (Models vary, so please refer to your camera manual.) Or connect them to radio triggers or another type of remote-control device—either while they're in the hot shoe or away from it.

The extreme portability of these light accessories and their built-in power source make speedlights a favorite tool among photographers of all levels and fields. Starting around $300, they are not cheap; but they will be your best long-term photography investment. And as long as you downgrade or upgrade your camera over time within the same manufacturer's line, you won't have to replace your speedlights when you switch out other gear.

But there are other options to consider, such as larger strobes … although it's important to know that these are a bit more difficult to master than speedlights. Strobes are covered in more detail later in this chapter.

Some two-light strobe kits that come with soft boxes, a carrying bag and two light stands can be purchased for less than $250 from B&H in NYC. Just understand that, at this price, these kits are not top quality. But for photographers starting out on a shoestring budget, they're a viable stepping stone. In fact, this inexpensive option may even yield a better light for food than a single speedlight due to the size of the lights it includes. But remember to diffuse strobe light to make it more appealing.

Again, since each camera brand has different models and nomenclature, I recommend using a flash that's made by the same brand as your camera. It is possible to use a flash from a different manufacturer, but it will not utilize the metering to its full capacity. This is because the technology used inside the flashes are proprietary and made to work to their maximum potential within their brand. Sticking with your primary brand ensures that your equipment is fully integrated.

Remote Flash Settings

Like your camera, your off-camera flash unit has different modes for you to use. In general though, the most common and easiest speedlight setting is *Through the Lens*, or TTL. This is a good one because your flash works with your camera to calculate the correct exposure and flash output. That is, when you press the shutter button, your camera tells your flash to send a signal to the subject to be photographed. It will record the amount of light reaching the camera sensor and determine how much flash output is needed. This information is sent back to the camera to be processed in order to coordinate the flash output in relationship to shutter speed and aperture. The camera then fires the flash to take the picture. And all of this happens in microseconds!

You can choose to use your off-camera flash in Automatic mode, but it will be like using your camera in Auto mode. This mode tells your equipment to calculate everything for you. In a way, this assures that you'll get the shot, but it takes away your creative input.

There's also Manual mode to consider; but here, you are *completely* in charge and must become the brain for the camera. This means you'll need to adjust your f/stop to match the output of the flash for appropriate exposure. When shooting in Manual, it may be especially helpful to use an *incident light meter*, which provides the information needed to set the f/stop and shutter speed in relationship to the ISO. This external device, unlike the meter in your camera, will not rely on the reflected light but rather on the actual available light that's hitting your subject. An incident light meter is particularly helpful in high contrast situations, where your camera light meter will average the reflected light—almost always incorrectly—for exposure.

There are as many light meters as they are camera models out there, so please research your options and priorities before purchasing one.

Not-So-Remote Flash

I know I just said that off-camera remote flashes are better than those that are built into your camera. Yet I'm now going to explain how to use speedlights *on* your camera. I know. Stay with me; there is a method to the madness.

One advantage of working with a speedlight directly on your camera … with it slipped into the hot shoe … is that you don't have to worry about setting it somewhere—on a tripod or table. Doing so would require a sync cord or a set of radio triggers. (See more on this below.)

While it's mounted on your camera, the head of the speedlight can be easily maneuvered into position as needed. Rotate it away from your food and up; move it sideways; or even swivel it toward the back of the camera. The ability to rotate the head gives you more options to soften, diffuse and play with the light. Bounce it off a white card placed to the side to reflect the light, or place a white card over it to diffuse the light … just as you would with a built-in flash.

On the next few pages, we'll explore some easy applications for using a speedlight mounted on your camera. But first, take a look at the image on the right. A speedlight was aimed directly at the subject. The light was not managed at all. Therefore, there is nothing flattering about this shot. And there is very little anyone could do in post processing to fix the harsh shadows and highlights.

Note that in these pictures, the speedlight is used as a dominant light source and the ceiling light was left on to enable me to navigate around the room.

Metering

To use the simplest of incident light meters, just hold it next to the subject and fire your flash. The meter will register the amount of light hitting the subject and give you the appropriate f/stop and shutter speed relative to the ISO. You can then manually set your camera according to that reading. Of course, some models are more complicated. Refer to instructions for specific meters for operation information.

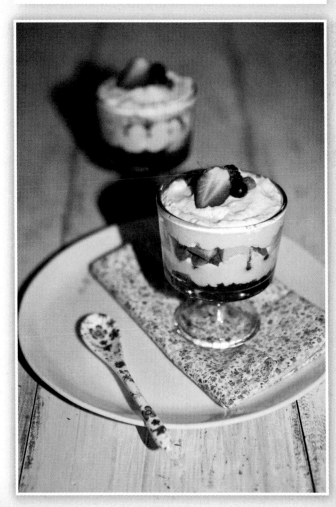

When creating this image, the camera body was positioned vertically, and a speedlight was aimed at the trifles. No diffuser or bounce was used to soften the light. The result is harsh shadows and unflattering light.

f/3.5, ISO 400, 24-70mm L

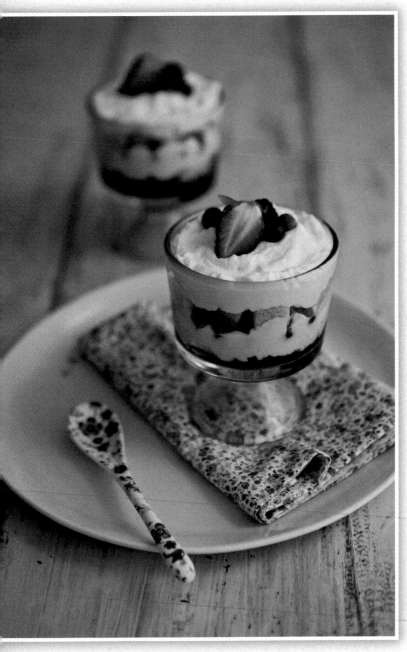

Fortunately, the terrible image on the previous page can be improved easily by simply pointing the flash off the subject … to the right or toward the ceiling, as shown (respectively) in these two pictures.

Because it is directed away from the subject, the light is less intense in the shot on the left. This helps reduce the harsh highlights and strong shadows.

Keep in mind that there is always some amount of natural bounce taking place, even if you don't position a bouncing device in your setup. The light from your flash will automatically bounce off other things in the room. This is not a bad

The trifles were shot with the flash head pointing toward the right, away from them. Without a bounce though, the left side of the scene remains slightly too dark.

f/3.5, ISO 400, 24-70mm L

thing for food photography, because it softens the light until it reaches your subject. To bring more light to the scene, especially to the left of the trifles, a reflector or white board would have shortened the travel distance required for the light and better illuminated the whole frame.

In the shot on the right, the flash was pointing at the ceiling—which served as a bouncing surface that diffused and softened the light. As a result, the light now wraps around the trifles and falls softly toward the back. It also minimizes the shadows on the left side. Find more information on using soft light in the Hard Light vs Soft Light section in Chapter 3.

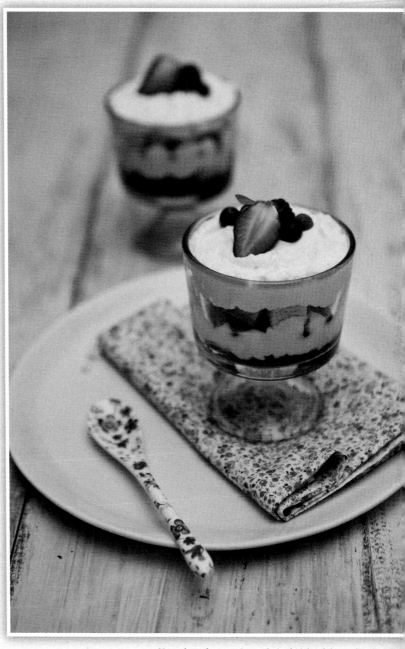

Here, the trifles were shot with the flash head directed at the ceiling, which serves as a bounce. This softened the light and reduced the strength of shadows on the left side of the scene.

f/3.5, ISO 400, 24-70mm L

85

Setup: The flash is pointed to the
right and bounced off a 40 x 60 white
panel that's attached to a stand.
(upper left)

f/6.3, ISO 800, 24-70mmL

This photo was shot using a setup like the
one shown above. (lower left)

f/3.5, ISO 400, 23-70mm L

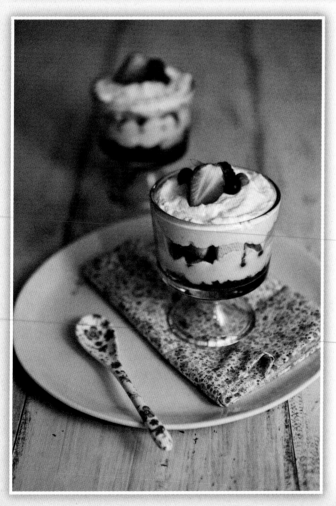

Bouncing the light from your speedlight
off a white surface helps you get lots
of lighting bang for minimal effort. To
achieve more bounce than the ceiling
can provide, you can use a piece of
white poster board held down with
clamps. Or you can use the thick
white diffuser that comes in the basic
3-in-1 or 5-in-1 diffusing kits. Just
remember that the larger the bounce
the more difficult it becomes to position
it securely. A tripod with a mounted
bracket or arm will make your life a lot
easier in this regard.

In the photo on the left (bottom),
the bounce is positioned close to the
subject, so there is a good amount of
light falling on the front right side. Let's
see if we can further improve on this.

Yep, we can! By adding an extra bounce
to the setup, this shot improved a lot.
The second bounce further increased
the amount of light hitting the trifles on

Setup: The flash is pointed to the right and bounced off a 40 x 60 white panel that was attached to its stand. A small white board is positioned as a second bounce. (upper right)

f/6.3, ISO 800, 24-70mm L

The photo of trifles was shot using a setup like the one shown here. The effect of two bounces is softer light that flatters all the elements in the scene. (lower right)

f/3.5, ISO 400, 24-70mm L

the left side. And this helped to create a more pleasing depth of field. The subjects in the foreground are sharp and the rest of the scene is somewhat out of focus. Try this for your photos. It only takes an extra two minutes to set up a second reflector, such as a white board, and it really makes all the difference in the world. For more examples of the benefits of bouncing light, take another look at the Reflectors section in Chapter 3.

So, we've seen that a separate flash unit provides added flexibility for your photography—even if it stays anchored to your camera. Some other flash accessories to consider for your artificial light projects are additional speedlights, radio triggers, sync cords and optical controls. These accessories are covered next.

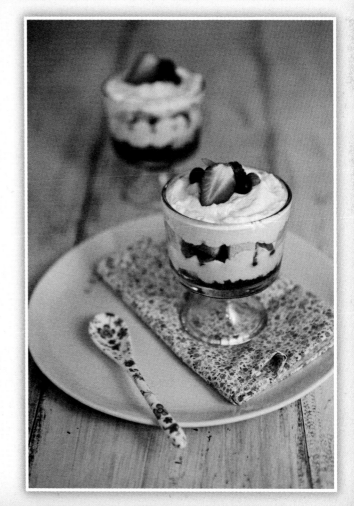

Radio Waves

Once you start playing with speedlights to improve your artificial light photography, you might want to go a step further. That is, take them off your camera and operate them remotely. One of the most popular—and most reliable—ways to do this is with wireless radio triggers.

If you want to go the wireless route, consider optical control (infrared or communication devices) or radio signals. Most speedlights have a Slave mode that allows you to control them wirelessly. Just set one in Master mode and the rest in Slave mode.

To learn more about the adjustments used to output light from your specific brand and model of speedlights, consult your manual. Also, take a look at some of the books I recommend in the appendices to learn more about working with speedlights and artificial lighting accessories.

Radio Triggers

Radio triggers are very popular with photographers who want to either take their flash off the camera body or add more than one speedlight to a studio setup. With radio triggers, the photographer can place his or her speedlight anywhere in the room but remain close to the camera while remotely triggering the flash. It lets the speedlight function as a dominant light source—from anywhere near the scene.

But why would you ever be away from your speedlight, you may ask. Well, you might find yourself in a situation where you need to diffuse your artificial light with a large scrim. The light source needs to be behind that scrim while you and your camera need to be in front of the food to capture it at the right angle. Or maybe you need to use a large bounce, and the flash head, if it stays on your camera, would be in an awkward position for the shot. Radio triggers offer a great deal of freedom to move. And this gadget is so popular because it's easy and reliable.

Radio waves are omni-directional, so you don't have to worry about aiming the trigger straight at your flashes to fire them. And they are accurate when it comes to firing multiple flash units at the same time.

Wireless triggers, such as Radio Poppers and types of Pocket Wizards, convert the light data contained in the master unit into a radio signal that is then sent to a receiver unit, which translates that information into a light signal. The speedlight reads that light signal and fires.

These tools are not cheap and prices vary depending on the brand and model; so please, read reviews and shop around to find out how different options work with your camera. It's pretty much a matter of budget and personal preference … and compatibility with the gear you have. But no matter what brand you choose, be sure to add a few extra battery packs in your cart, because they do consume a lot of power.

Radio triggers are especially helpful for setups in which your only light is your speedlight. Treat the speedlight as you would a studio light with an umbrella. A radio trigger will make it easier to use scrims and reflectors than trying to attach an umbrella to your speedlight. Just take the speedlight off your camera, position it behind the scrim and go anywhere you want. Set radio triggers to remotely fire your speedlight when you're ready.

To use a radio trigger to fire your flash(es), try mounting the trigger on the shot shoe and connect the receiver to the flash. This setup enables you to be at any distance desired from the camera and the subject … and still trigger the flash.

Of course, studio lights and flashes, either mounted on the camera or operated wirelessly by radio triggers, are far from the only artificial light sources out there. The number of lighting options you have—even on a tight budget—is proportional to your imagination … and the time you're willing to spend making them work.

Filler Flash

If you're interested in challenging yourself to go one step further. Experiment with using your flash with *natural* light. Set on TTL, your flash might be useful as a light filler. It can help you avoid too high contrast in scenes with harsh shadows, and it can help brighten dark areas in, for example, a scene that's backlit.

In this setup, the radio trigger transmitter is mounted on the hot shoe while the receiver is connected to the flash with a cord. This allows you to remotely fire the flash.

f/2.8, ISO 800, 50mm

Free Standing Light & Soft Boxes

When shooting space, your photography budget and setup/ breakdown limits are an issue, it's helpful to have a set of free-standing lights, bulbs and/ or soft boxes. For instance, I have a couple of friends who love to record their cooking prowess, but they must do it at night. They simply can't have their children running around their photography equipment and possibly stumbling on tripods, breaking stands. During the winter months especially, when sunlight is less available, many photographers appreciate being able to rely on easy-to-use light supplements.

Free Standing Lights & Bulbs

One extremely popular free standing light system is the Lowel Ego Light. It looks like a simple rectangular flat box with a light bulb inside. From what I've seen, this product can get really close to mimicking natural light … if you use the appropriate camera modes and settings and make full use of bouncing white cards, if necessary. One light retails for around $90; and a two-light system, which usually comes with a set of differently colored backgrounds, runs about $200.

A Lowel Ego Light System
©Lowel Light Inc.

I know people who've opted out of the full system and settled instead on a couple of Lowel Ego fluorescent bulbs. They affixed these bulbs to a small lamp with a plain white lampshade and are really happy with the results. Note that the thickness and material of the lampshade will affect how much light is diffused and thereby change the quality of the available light.

No matter what, in no circumstance whatsoever, never place a piece of paper over a light bulb! Paper will catch on fire quickly; and, left unattended … even for a short while, it can literally burn your house down. No. Paper. Diffuser!

Soft Boxes

Another popular artificial lighting option is a simple soft box. Purchase a soft box or make one for yourself. But keep in mind that there are two kinds of soft boxes. One is used in a tabletop setting (described later) and one is used directly on your camera.

On-Camera Soft Boxes

Soft boxes that operate on a camera are usually a plastic cover (shown in the image on the right) or a funnel-type piece with a flat front. Both varieties attach to your flash. The diffusing strength of the plastic cover is not as good as the funnel-shaped model, but it's a bit easier to operate. Both have pros and cons, so read reviews before deciding which—if either—you'll use.

The plastic cover option is a small soft box attachment that covers the actual light unit. This device diffuses and softens the light much like a soft pop-up diffuser (covered earlier in

Steamy Kitchen Blog

A good friend of mine, Jaden Hair, writes the popular blog Steamy Kitchen. She wrote a detailed post on how to use the Lowel Ego Light System and what to expect from it. I have to say, I was impressed with the quality of this light and the ease of setting it up and putting it away. Read Hair's article at http://steamykitchen.com/266-lowel-ego-lights-for-food-photography.html.

A soft diffusing box is mounted to a speedlight.

f/4.5, ISO 200, 50mm

this chapter). It attaches directly to your flash unit and does a great job at diffusing your flash light output. It also softens the light and reduces glare. But yes, that means you need a speedlight. This device does not fit on a pop-up flash. It retails for around $10.

Some people find that the size of this on-camera soft box is too small to make a big impact. So they use a larger model or create their own. A small pop-up soft box like the one described above measures 3.5 x 5, but I've seen studio setups with ones as big as 20 x 28 (around $40) and larger. Some DIY flash-mounted soft boxes can take on crazy dimensions and will require you to set your flash on a heavy duty light stand. Go crazy! Go wild! But remember to pick equipment that is appropriate for you—in terms of budget, difficulty of use, ease of set up and break down, your available time and space, etc.

❋ Tabletop Soft Boxes

The other popular and efficient soft box option sits on a table or other flat surface. It looks like a three-panel tent most of the time. Because of this, it's also known as a *light tent*. It's made of nylon fabric and opens toward the front. Just set your food inside the box and position lights (preferably fluorescent or halogen bulbs) on the outside. These soft boxes range from $40 to $100 and beyond, depending on the size and brand you choose.

These units are so easy to create that some people have taken it upon themselves to make their own … for as low as $10. This might be something to consider. It's inexpensive; you can complete it over a weekend; and it actually works! It's not perfect, but it does a fair enough job at diffusing harsh light to produce quality images.

You can create a tabletop soft box out of a recycled card box. Use cloth to cover the sides and place a white poster board in the back to serve as a reflector. You can also use a black poster board or other color to add variety

DIY

There are several sites online with DIY instructions, but I think the most downloaded and comprehensive post about how to make your own soft box comes from the famous Strobist website. Find it at DIY $10 Macro Photo Studio: http://strobist.blogspot.com/2006/07/how-to-diy-10-macro-photo-studio.html.

to your backgrounds. In any case, this type of soft box is perfect for close-up shots of your food or small single items. It is not made for large table setups and complicated compositions.

Whether or not you decide to use these accessories and DIY ideas, remember the fundamentals of light management: *diffuse* and *bounce*. Whether the light you're using is natural or artificial—or both, these qualities stand true:

- Light comes from different directions.
- Light varies in quality and quantity.
- You have to manage light properly to achieve the photo results you want.

I often joke that my studio is a giant soft box, since there are opaque sheets in front of each window … but it's the truth! Artificial light will give you light … even decent light, but it's different. And you need to remember to diffuse and reflect it to properly manage it … just as you do with natural light. Large artificial light sources, such as big strobes and studio lights will help, but an investment in this equipment is only worthwhile if you're very serious about your photography work and frequently need to rely on artificial light.

If this isn't your situation, know that you can get good light for your photographs by combining strobes, a large diffuser and a soft box. This studio setup will require more "studying" on your part, and I recommend reading books dedicated to artificial lighting when you are ready to go in that direction. (See the appendices for suggestions.)

No matter what, always consider *how* you are going to diffuse the light source— by directing it away from your food. Explore different ways to bounce the light to reduce shadows, and see how much or how little you want that effect in your shot. Discover techniques of your own to manage the light around you. Never stop exploring!

5 ✦ Composition

Composing a photograph of food is so much more than setting your dish and props on a work area, holding your camera and taking pictures. I don't mean it's much more difficult or more daunting; it's actually much more exciting!

Once you realize how many different ideas and decisions can come into play to compose your shot, you'll literally feel like a kid at a candy store. Your imagination will fill with possibilities for creating various moods, for establishing the right atmosphere to translate your vision and tell a story through your photographs of food. This abundant world of creativity is truly your oyster.

This chapter covers the basic guidelines of composition. Keep in mind that these are guidelines—not rules. You may decide to try them all (hopefully not at once!), or you may focus on one technique and then move to another. Just be sure that you understand the fundamentals of photography (exposure and light) before diving into composition and styling.

Tomatoes positioned in the center of the frame

f/3.5, ISO 400, 50mm

Subject Placement

The process of composition begins as you are cooking your dish (if you are both the cook and photographer) or as you read through your call sheet (if you aren't the one preparing the food). Before you physically set up your shot, think about where you'll shoot, what props and linens you'll use, the direction of the light you'll be working with, the shadows and other considerations for the scene. You'll need to decide how you'll convey the sensory appeal and emotion of your subject.

To get started, think about where you want to place the dish in your frame. Do you want your subject off center or centered in the final image?

Off-Center

Imagine the following situation: You are about to photograph a nice salad. You have all your camera settings and modes adjusted, and you're happy with the way you've lit the shot. You're wondering if you'll get a nice photograph if you place the salad right in the center of your frame and start pressing the shutter button.

I say, "Yes! Sure!" But don't stop there. Try moving the salad around the frame to see if there's a better angle, a more interesting view or more striking point of interest.

Sometimes placing a subject off center or shooting it from a different angle allows you to convey more artistic expression and creativity. It also helps to change sight lines to one your audience *doesn't* see every day. This gives your photographs more visual weight and staying power than every other pasta shot, so to speak.

You don't need to come up with crazy setups and lots of propping and arranging to add interest to your photos. Many times, an off-center subject can do the trick. In the two pictures on this spread, the use of props and colors is minimal. To add interest to the cluster of tomatoes, I simply moved the plate and bowl to the right side of the frame. This provided a sense of movement without adding another element to the frame.

Tomatoes positioned off center

f/3.5, ISO 400, 50mm

If you compose your photographs with a lot of the same dishes or the same colors and textures, then shooting off center may help to break the monotony of things. Another bonus of off-center placement is that it can be a great "hiding" technique. This is helpful for shoots that involve an item with a portion that doesn't look very good or situations in which you don't have enough subject to fill the frame nicely. Placing a flawed subject off center can naturally crop it in the frame to hide flaws or scarcity.

In the picture of kumquats, I didn't have enough of the fruit to fill the bowl in a nice manner. My solution was to push most of the kumquats toward the front of the bowl and position it off center. This naturally cropped the area that was empty and less attractive.

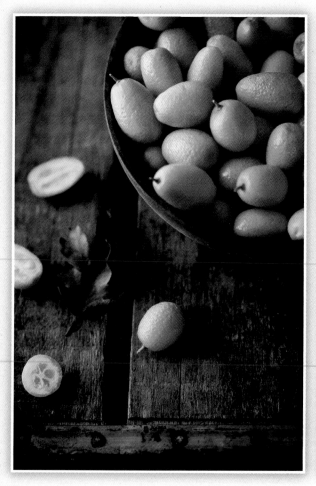

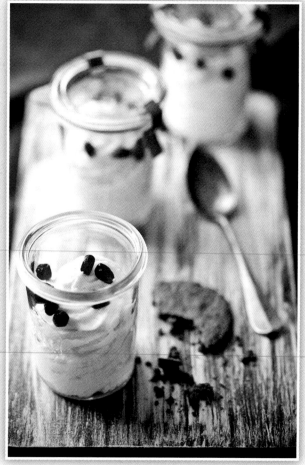

The kumquats are positioned off center and toward the top right of the frame to enhance their presence in the bowl.

f/3.5, ISO 320, 100mm, Macro L

Three ramekins of mousse are positioned off center in the frame to create visual interest and movement in the image.

f/3.5, ISO 800, 100mm, Macro L

The picture of mousse shows how to add movement to your image by placing the subject(s) off center. Depending on your composition, you don't need to crop your main subject to make it work off center. Just take a step back from your initial setup if things appear too stiff, and start moving things around to create visual interest in the composition.

I placed the donuts off center to attract viewers to the front view of the subjects, particularly the top one. I did not like the look of the frosting on the other two. I played with the off-center position to slightly obscure the view of the subjects and minimize all the little things I did not like about them.

A potential issue associated with shooting an off-center subject is focus. Your camera may hone in on a part of your dish that doesn't necessarily represent the area you deem most interesting. Fortunately, there's easy to fix for this:

1) Aim your camera toward your subject and position it in the center of the viewfinder.

2) Push the shutter button halfway down to lock in the focus.

3) Continue to hold it down (halfway) as you move your camera back to your preferred composition.

4) When ready, press the shutter button all the way down.

5) You can also take the lens of your dSLR off Auto focus and use Manual, aiming it at your subject, adjusting the focus, and then moving your camera back to the frame you created.

6) On a point-and-shoot camera that lets you choose between Manual and Auto focus, you can get the same result by taking the camera off Auto and using Manual.

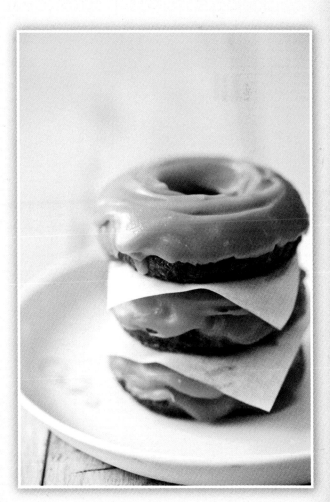

The donuts are placed off center, toward the right side of the composition.

f/3.5, ISO 320, 100mm, Macro L

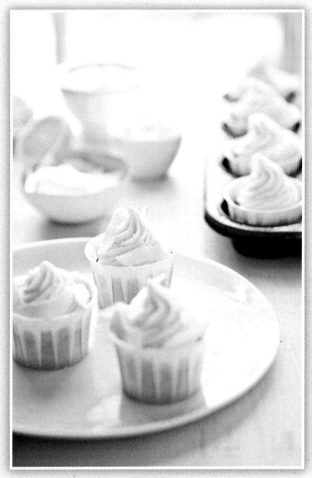

The focus in this shot of the coconut cupcakes was set on the middle, leaving the front cupcake completely off focus.

f/3.5, ISO 640, 100mm, Macro L

Here, the focus was set on the foreground, bringing the front cupcake in focus and blurring the middle and foreground subjects.

f/3.5, ISO 640, 100mm, Macro L

When shooting the two pictures above, in which the cupcakes are a bit off center, my camera wanted to focus on the cupcake toward the back of the plate instead of the front one. Technically, there's nothing wrong with leaving the focus like that; but this was going to be my opening shot for a blog article, and I wanted all of the front cupcake to be visible—from wrapper to frosting. Therefore, I refocused my camera to achieve the second version of this shot.

Centered

I can imagine you now looking around for objects to shoot off center. Go for it! But keep in mind that, just like an off-center subject can bring interest to your pictures, there is value in centering subjects in some shots to emphasize their full beauty.

An obvious reason to center a subject is to make it crystal clear to viewers what the main element of interest is. If your composition is busy with different elements (e.g., foods, props and other items) or part of a broad setting where the main subject might be lost, centering the prime subject can help direct the viewer's eye to it. This spares you the "What am I supposed to look at here?" reaction.

Here, the main ingredient was crab, so I placed one right in the center to emphasize it among the high volume of other elements in the frame.

In this frame, the crabs are arranged in different areas to scatter the composition and allow focus to rest on the main crab positioned closer to center.

f/4.5, ISO 400, 24-70mm, L

The pumpkin pie in this photograph is placed in the center of the frame to keep the eye focused here and not on the background, props, linens and other food items.

f/3.5, ISO 500, 100mm, Macro L

The bowl of onion soup is placed in the center of the frame to put the emphasis on the quality and look of this dish with toasty bread and cheese.

f/3.5, ISO 800, 100mm, Macro L

If you are composing frames with one main plate/ dish and sides or supplemental ingredients, place the main element in the center with the sides off center to clearly point the viewer to the primary element.

With one well-centered object, you can add impact to your photograph. Leaving small amounts of negative space on all sides/ corners of the main subject is an easy way to quickly add visual impact to a simply styled dish.

Negative Space

When it comes to composition, most artists refer to the main subject as the positive space and everything around it as the negative space. Visual impact will come from the positive space of an image as well as from the negative, untouched … uncrowded spaces of a frame. Remember Chapter 3, when we covered how use of light and dark areas conveys a mood or a feel to your capture? Well, think of this principle when you play with positive and negative spaces in your composition. It's not necessary to fill every nook and cranny with props, linens or food to make a visual impact. Thoughtful placement of empty spaces can often make an even stronger and pleasing impact.

I deliberately left the eggs. in the center of the frame, because I did not want to add many props or linens. I left some negative space around them, so the viewer's eye would be directed to this delicate subject.

f/3.5, ISO 320, 100mm, Macro L

Rule of Thirds

I've always found it amusing to listen to photographers talk about the Rule of Thirds. Usually, they'll go through its principles and applications and eventually end the conversation with, "It's a good rule to learn and forget."

I agree. It's important to know the Rule of Thirds—what it means and how to use it. But put it in the back of your mind. Chances are, your eyes and mind are already trained to apply the Rule of Thirds … if only by the materials you've seen over the years—cookbooks, portraits, ads, magazines, etc. I don't set up all my shots according to this rule, but I can see that it's become second nature for me to apply aspects of it in many scenarios.

To implement the Rule of Thirds, divide your frame into three parts, both horizontally and vertically, like a tic-tac-toe board. Now, place your subject along the lines or at some point they intersect. The purpose of the Rule is to help you achieve lines and placement of objects that are naturally appealing to the human eye.

Composing with the Rule of Thirds helps you achieve an appealing composition.

f/4.5, ISO 200, 100mm, Macro L

In the picture on the left, the windows in the background help illustrate the lines that appear in your mind when you mentally divide your frame horizontally and vertically. I placed a plate of cherries in the center of the bottom tier of the frame. To add movement and interest both in shapes and heights, I added a bottle along one of the vertical lines on the right and shorter glass along the opposite vertical line. In addition, I placed a clear glass behind the cherries at a different distance than the other glass, and this added another height level in the final composition.

I agree that the resulting effects of the Rule of Thirds are pleasing to the eye, but I don't usually feel like standing over a frame, trying to apply perfectly straight lines. That's why being too strict about applying it is not very practical in most situations. Plus, it can take you away from having fun as you compose and shoot. Focusing on applying this Rule can prevent you from seeing other interesting angles. This is why most photographers will tell you to learn it and then tuck it away in the back of your head. Retain spontaneity while using its composing qualities.

In the picture of cherries falling from a basket, I deliberately placed the basket on the upper right tier of the picture and let some cherries move through the frame randomly, not checking to see where they dropped vertically and horizontally. This allowed the image to appear natural—not contrived to meet requirements of the Rule of Thirds.

One major benefit of this Rule is that it encourages the viewer's eye to move naturally from one item to the next, depending on the placement, heights and distance of each item from each other. It helps you compose a shot that seems natural. And it's especially helpful if your subject is monotonous in color or texture.

The Rule of Thirds facilitates emphasis on an idea or look as well as on an actual dish, and this is really useful for shots that contain fully set tables or lots of plated items. Arrange a multitude of items along those six lines, place clusters of items where the lines intersect, set plates near the lines. Just remember to retain the patterns of lines and distances when showing a whole table setting. Of course, you can follow the vertical and horizontal lines of the Rule of Thirds on a small scale, too, with just one or two items.

Cherries falling from a basket produced an unintentional Rule of Thirds composition.

f/3.5, ISO 200-100mm, Macro L

A whole table setting is created with a loose application of the Rule of Thirds. Food props are placed in a pleasing manner.

f/3.5, ISO 250, 100mm, Macro

In the picture on the left—for which I did not think deeply of the Rule of Thirds—the tart hits most of the major cross points of thirds in the frame. Initially, the eye lands on the bottom left third of the frame. The eyes move then to the middle tier of the frame and fall on the second tart. Finally, a viewer's focus lands on the top left corner to the last piece of tart. The flow is dynamic. But since the colors and tones are pretty neutral, this shot would have been bland if the main subjects had been placed in a line instead of according to the Rule of Thirds.

One of my favorite things about the Rule of Thirds is that it serves as a safety net for challenging situations. It can save a shot when you're limited by time or space or even lighting … by allowing you to be efficient while remaining creative.

So during shoots when you're on vacation or on location at a client's request, where the lighting is different from the conditions of your home base and you're working with someone's else tables, counters, linens and props, etc.—or when you have a very small window of opportunity to get a good shot—

Set brightly colored items against dark backgrounds to instantly define their shape and texture. In the image below and on the left, the camera angle and the dark background direct the viewer's eyes to the kumquats in the little saucer.

In pictures with lots of elements, attract your viewers' eyes to your primary subject by using a narrow focal point. This leaves the rest of the image open to exploration.

There are times when it's difficult to pick one center of interest or focal point. One such occasion is when you're trying to describe an entire scene with just one shot, as in the dessert tables pictured below and on the next page. In busy settings like this, select a focus point toward the middle, so it includes more than one specific item.

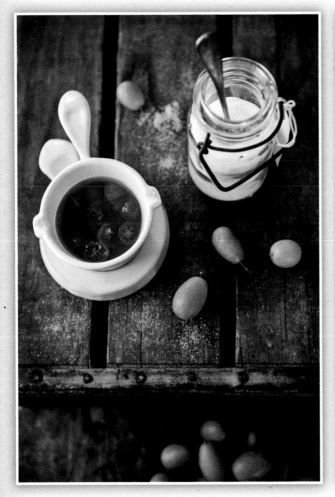

f/3.5, ISO 320, 24-70mm

f/3.5, ISO 320, 100mm, Macro L

picture is worth a thousand words. Don't mumble them.

Sometimes the item to be photographed is that center of interest. For example, a serving of pie might be the focal point or center of interest for a food blogger who wants to tell the story of a grandmother's recipe. On the other hand, if you're talking about the quality of the crust and topping of the pie, you might focus instead on those parts of the pie.

In the picture of the little rhubarb tart on the left, all the focus is on the top of the tart, which has a really good golden brown color, great shape and a nice crispy look to it. I kept the background and props minimal with woods and whites, so the eye would not veer away from the tart for too long. Textures and backgrounds can help your viewer find the main attraction of a picture quickly.

Setting the donut (in the image on the right) against a rustic off-white surface made the melting chocolate jump out more than if it had been resting on a dark background. The simplicity of the composition— the minimal props and center placement of the donut—also helps direct the viewer's eye to the melting chocolate.

f/3.5, ISO 400, 100mm, Macro L

The focus in this shot was placed on the top of the rhubarb to showcase its texture.

f/3.5, ISO 125, 100mm, Macro L

When setting up a shot, always ask yourself if your composition ideas add or take away from the story you want to tell in your image. As the word implies, *guidelines* are intended to give you a sense of direction and a safety zone when you need some help. They're guides to broaden and sharpen your composition mindset, and they should never hinder the spontaneity of your creativity. Learn the guidelines of composition, apply them deliberately a few times, and then loosen up and avoid being too strict about them. The most important thing for you to do is enjoy the process of taking pictures. Curves and diagonals are just as good to work with as cross sections and verticals.

Focus

When it comes to visuals, nothing is more frustrating to an audience than a jumbled image with no primary focal point or center of interest. So, before you start composing, determine which element(s) will be your dominant point. You can have more than one center of interest, but the scene needs to help a viewer understand your message and not make his eyes wander aimlessly. Remember that a

applying the Rule of Thirds can guarantee you'll get a few good shots before you break some rules of composition and rearrange things as you like.

With shooting the picture of pancakes, I was working for a new client at the art director's house. I had been told that most of the props and linens had already been selected by the art team and that the recipe developer would have the dishes cooked and ready for me. I literally had no idea what I would find.

Using different props and having no control over the preparation of the food were not the main issues. That was different and fun. But I got a bit worried by the weather, which was veering toward rain and threatened the good natural light I needed to stream through the window in order to comply with the art director's instructions. I had to be quick and efficient.

Yet I didn't want to rush through setting my exposure properly, styling the food appropriately and composing the frame well. Rushing is the best way to forget something important. Knowing that using the Rule of Thirds would produce a good shot gave me some peace of mind, so I could focus on the other things I had to do.

These pancakes and props are positioned along the vertical lines of the Rule of Thirds.

f-3.2 - ISO 1000, 50mm

Depth of Field

Depth of Field refers to the amount of space in a scene that retains acceptable focus. I use the term *acceptable* here, because what constitutes an "appropriate" or a "good" depth of field is very subjective. The right level of depth of field varies depending on a photographer's individual style and the desired effect for a particular image.

A photograph with a shallow depth of field shows elements in the foreground in focus while the background is blurred. This is a good effect to make a subject in the foreground pop. A deep depth of field is clear throughout. This effect allows viewers to clearly see the full environment of your scene.

An image's depth of field (DOF) depends of three factors:

* Aperture
* Lens focal length
* Distance between camera and subject

Basically, the smaller the aperture is (high f/stop), the deeper the depth of field in your image will be. Likewise, the larger the aperture is (small f/stop), the shallower your depth of field will become. Note that these statements assume that the distance from subject to camera stays the same.

f/3.5, ISO 100, 100mm, Macro L

These persimmons were shot with a shallow depth of field.

f/2.8, ISO 500, 50mm

Short focal length produces a deep DOF. And as distance from camera to subject grows, so does the depth of focus in your image. An example of a short focal lens is a 50mm, which requires you to be physically close to your subject for a close up. A long focal length will let you get a close-up shot even when you're far away from your subject.

One very common misconception regarding DOF is that only a shallow depth of field will enable you to create a strong visual impact. While it's true that keeping your f/stop number in the lower ranges and blurring elements in the background create a "wow" effect that also helps your viewer pinpoint the center of interest of a picture, a deep DOF can be just as beautiful and powerful if you make good composition choices.

And be careful not to equate DOF only with the f/stop number you pick. A very small f/stop will indeed create a shallow DOF, but it can also hurt your effect by narrowing the focus point too much. You may get a photo that sharply focuses on a crumb on top of your grating, for example. You can achieve beautiful DOF with high f/stops if you use the right distance ratio with your subject. Don't shy away from moving around, if you can, to achieve the effect you want.

I used a shallow DOF here to keep the focus on the persimmon going from whole to cut. The rest of the persimmons in the background are very out of focus, but I needed the color pop they provide for balance.

The image just to the right has a very shallow DOF, which keeps the focus on the chocolate piece. It's chocolate. It makes people want more. It's also an American icon, highly recognizable by its shape and wrapper, so I really didn't

need to add more. But I wanted to keep a piece in the background, very out of focus, to make the viewer feel hungry and more interested.

But there are times when a medium DOF is preferable. This effect keeps the emphasis on the dish as a whole instead of presenting only one element. It also maintains a sense of balance, which is pleasing to the eye. Since we don't usually see things in the real world with a very narrow or a very deep DOF, a scene with medium focus can seem more natural.

Here, the squashes in the back of the pan are neither completely out of focus nor completely in focus. This keeps things balanced and inviting. There is no reason to pick one extreme over the other, which is why I went with a medium DOF.

A shallow depth of field emphasizes this chocolate kiss.

f/3.5, ISO 400, 100mm

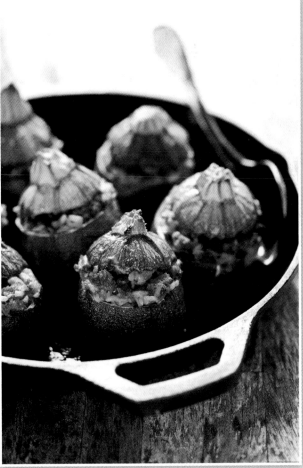

This image of stuffed squash shows a medium depth of field.

f/3.5, ISO 250, 100mm, Macro L

113

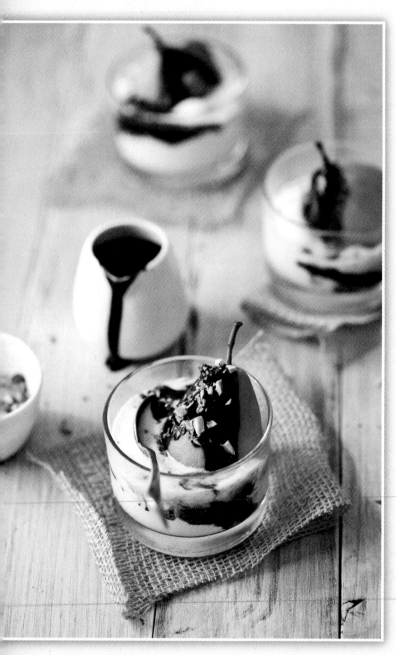

Use depth of field to minimize composition or styling issues.

f/3.5, ISO 320, 100mm, Macro L

There are also instances when keeping a medium to shallow depth of field can help you keep certain flaws out of focus. You may like a certain plate, but you'd rather people not see the chip it has. Or, maybe out of the three slices of pie you plated, one really took a beating as you lifted it off the pan. To avoid attracting the viewer's eye to this slice, you'll likely put it toward the back of the frame. Using a medium to shallow depth of field, you can increase the focus on the perfectly plated slice in the foreground.

Keeping the DOF in a low to medium range helped minimize the fact that even though I took all the necessary steps, one of the ice cream cups melted a little too much for a beauty shot. This effect allowed me to direct focus to the front, yet give life to the scene by keeping the melted ice cream in the frame … but away from the main focus area.

Yet, I admit, there are times when the only thing I want to do with a specific item is to photograph it with a deep depth of field … and keep everything nice and clear. Not so much with stews and brown foods, which tend to look less appealing than cupcakes; but with the proper

camera viewpoint, choice of subject and prop placement, the full view of a deep DOF can be the perfect effect.

In the picture of the macarons (right), I wanted to convey a sense of strength and impact, because the flavors in the food are intense. I picked dark props and set them off center to repeat some of the movement in the shells. The image was shot from overhead to minimize the visual impact of the varying heights of the elements (e.g., macarons and plates). A medium focal length (70mm) helped me get close to the subject and capture as much of the center of the frame as possible while using a relatively low f/stop.

We all have our preferences. Mine over the years has shifted to all different levels of DOF to help tell various types of stories with pictures. Try to think of what story you want to tell. That will help you figure out how and what kind of focus you want … and how shallow or deep to take your DOF. Don't be afraid to mix it up a little, too. Sometimes exploring a different DOF than the one you initially used for a shot will end up being your favorite.

These macarons were shot with a deep depth of field.

f/3.2, ISO 320, 24-70mm, L

Perspective

I want to say that picking a perspective for shooting your dish is just a matter of personal choice, but sometimes that's just not the case. Before pushing your shutter button, take a moment and ponder whether to photograph your subject as a close-up, macro or wide shot. It's not always obvious which will produce the best image for you.

For instance, I understand the interesting and appetizing factor of melted cheese, but I don't necessarily need to have my eye in it when I look at photograph of a grilled cheese sandwich or a plate of gooey lasagna. Lots of budding photographers think that a macro setting will help get their point across more clearly. And while sometimes that's true, in many cases the image produced is nearly grotesque.

With food, it's difficult to get deep into a dish without losing its shape and texture. Say you're photographing a plate of lasagna, for example, and you want to focus on the dish. You might want to keep a wider perspective to be able to capture more of the cheesy top and its texture and to show how big the lasagna

f/3.2, ISO 320, 100mm, Macro L

pan was—instead of honing in on the insides of the lasagna. But, if you want to focus on the variety of heirloom tomatoes that you used in that lasagna dish, then you might want to get a closer perspective and use a more macro approach.

Starting with a medium range of distance between the dish and your camera can help you create visual interest without giving away every detail at once. Sometimes it's nice to let viewers discover the composition little by little.

In the image of rice pudding (left), I wanted to convey that we could not resist eating this chocolate treat. But I didn't want to show a dirty cup of half-eaten pudding or a completely empty dish. Even partially eaten items are hard to pull off, so I took a middle-of-the-road approach and focused on the remaining half portion rather than showing the full dish.

I picked a tighter setting for the shot of ravioli to show the texture of the filling and shape of the final item. I didn't want to get any closer, because shredded cooked meat just doesn't usually look very appetizing … and it's only one part of the finished dish.

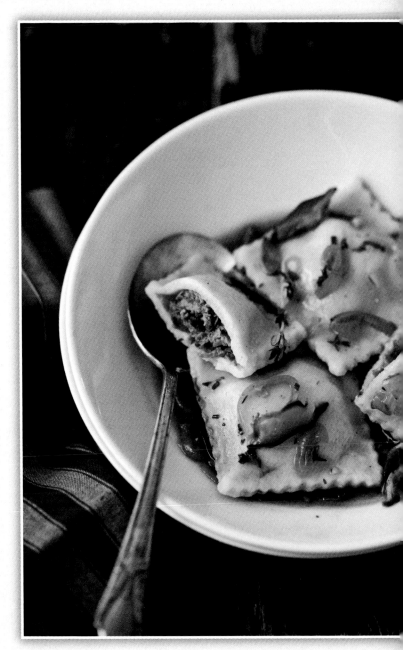

f/3.5, ISO 500, 100mm, Macro L

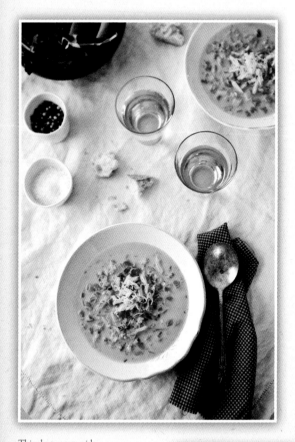

Sometimes a wider setting can help you set a mood or a scene. For example, I'm very fond of table settings that suggest a gathering of people. So, in some shots, I'll use a wide setting to suggest that there are more than one or two people gathered at the table. Sometimes I'll take an even wider approach to include more of the furniture around the food. This gives a dish a sense of space, allowing the food to be *part* of the context, not *the* context.

The shot on the left uses a wide perspective to capture a whole table setting that conveys a sense of sitting down to dinner around a hot bowl of crab soup.

In the picture of kumquat cakes, room elements are included in the frame—the edges of the table, the back of the chair and the floor underneath—to show the dish in context rather than a stand-alone plate. It helped set the scene in a natural way.

This shot uses a wide perspective to capture a whole table setting.

f/3.5, ISO 320, 24-70mm, L

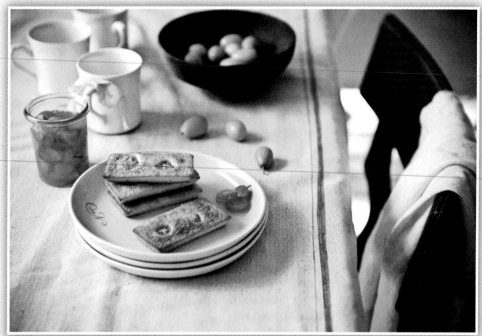

Use a wide perspective to show the food in relationship to a larger area.

f/3.5, ISO 320, 100mm, Macro L

Other times, perspective in a shot is a matter of personal preference, and you have to make an executive decision on which option you like best … and for what purpose. In the images below, I went with a somewhat broad perspective at first to convey the story of an afternoon snack—casual and simple. I then took the same setting and got a bit closer to focus on the shape and texture of the inside of the cake itself.

When making decisions about perspective, as with any other photography decision, always try to remember what you are hoping to say in your image. Play around and experiment with your options by going in close and moving away from your food subject. Macro shots lend themselves perfectly to compositions that feature textures and shapes, while larger settings encompass more of the surrounding atmosphere and offer context for your subject.

On a side note, you'll see that I use my macro lens a lot, but this has very little to do with a constant desire to get close to my subjects. I use this lens because I absolutely love it. I have a lot of room to work with it in my studio, and this allows me to put large distances between my camera and the food I'm photographing. I love the quality of this lens in all sorts of light situations and angles.

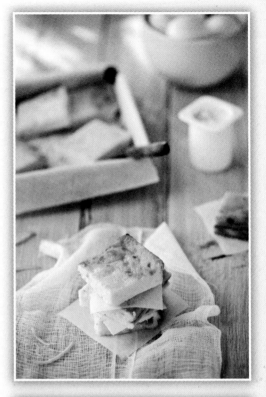

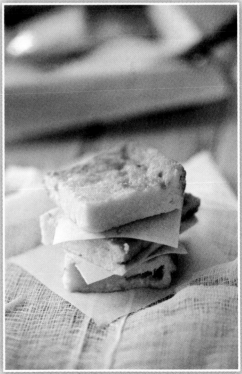

A wide perspective is great to show more of the scenery surrounding the item being photographed. (upper)

f/3.5, ISO 250, 100mm, Macro L

A close perspective on the same subject allows you to hone in on the item itself. This is ideal if you're describing the shape and texture of a dish and are less concerned about placing it in an environment. (lower)

f/3.5, ISO 250, 100mm, Macro L

119

Angle

Add interest to your composition with minimal effort by moving around your subject and exploring possible viewpoints from which to shoot. Interesting angles will keep things fresh for you and provide your viewer a new way of seeing what might be a familiar scene. Consider your subject from all sides to observe texture, height and shape. Walk around it, move it around the table.

Even though I shoot in my studio with my camera on a tripod 80% of the time, I tend to move the tripod around the table to find the perfect angle. I love long exposures, but my hands are not steady enough to prevent camera shake without the tripod. But when I feel like I'm getting stuck, I'll go free-handed and give myself more mobility.

You might find that the amount of available space in your shooting location dictates the camera viewpoint you'll use, and that's fine. There's always a way to make the most of your shooting conditions.

Eye-Level

Shooting from an eye-level position seems to be the most natural choice for many people who are just getting starting in food photography. This angle allows you to isolate a subject in front of your eyes. You can position yourself close to the food to be photographed to get a close-up perspective. Or you can step away and include more of your frame. This works well with whole shapes, but you will lose details.

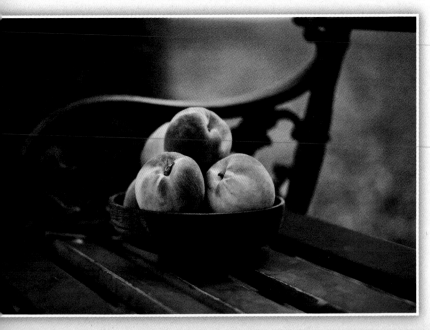

The photograph of peaches (left) shows that the distance and perspective worked great with whole fruits. But if I had used only sliced peaches in the bowl and positioned myself at the same distance and perspective, the image of the fruits would have lost detail and shape. The peaches would likely have appeared as a shapeless pile.

These peaches were photographed at eye level.
f/2.8, ISO 100, 100mm, Macro L

Overhead

I am quite fond of overhead shots (also called *High View Point*), but this doesn't work for every kind of shot. High View Points tend to minimize strong elements by putting textures and heights on a more level plane. Yet this perspective lets you show other dimensions and offers new options for depth of field. For instance, you can use shallow DOF to focus on the top of a dish that's especially pretty (a frosting rose, for example), while suggesting the cake underneath. This angle can also help you minimize height issues if you're trying to get elements of all sorts into one shot and your space is too limited to fit them in with a traditional forward-orientated shot.

The cookies in the image above were essentially flat, but both cups beside the plates were high. When I moved around my frame to pick a viewpoint, I noticed that the different heights minimized the presence and appeal of the main subject, the cookies! The overhead viewpoint also made it possible to capture the cocoa nibs inside the cups without having to sprinkle them everywhere to enjoy that element.

The shot of clementines on the right is another example of capturing several levels with an overhead shot. Imagine putting a box on a table and setting a plate on it. Then say you place an item on the table itself. By angling your camera appropriately, you can capture both the top of the box and the tabletop. This creates a nice image and shakes things up a little. Similarly, I placed the plate with clementines on top of an inverted crate that was set on a table. I used the different heights to create different points of interest and depth of field in my image. It was a nice change from straight overhead shots and it made me think differently. In photography, it is really key to keep playing around with your perspective.

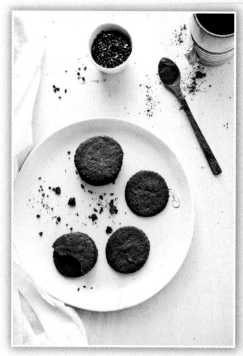

These cookies were shot from overhead to flatten the plane.
f/2.8, ISO 100, 100mm, Macro L

These clementines were also shot with High View Point.
f/2.8, ISO 100, 100mm, Macro L

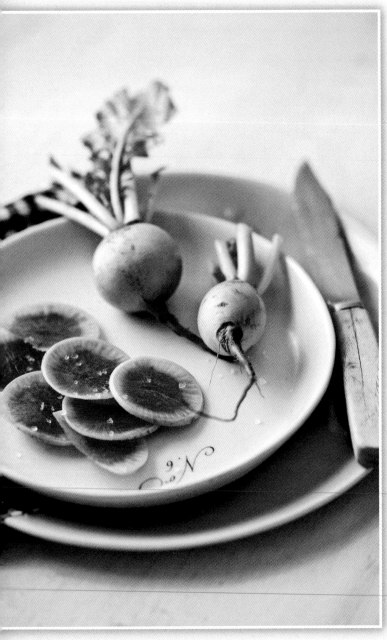

f/3.5, ISO 250, 100mm, Macro L

Three Quarters

Another common camera position in food photography is often referred as shooting *three quarters*. Here, you're not quite overhead and not quite eye level. It almost brings out the best of both worlds.

Shooting at three quarters is convenient in most situations, because your subject's textures, heights and shapes are nicely displayed, and scales are easy to respect. It's also a good position, because it works well with most focal lengths you choose.

Both the radishes (left) and salmon appetizer (right) could have been shot in any of the camera viewpoints described in this section. But the three quarters viewpoint was the best option based on the location and available light.

I know … I haven't covered a low camera viewpoint, because it simply doesn't work for most food shots. I mean, imagine yourself aiming your camera upward at a dish, as if you're on

the floor shooting toward the sky. Would the food even show up in the frame? If so, would it look very appetizing? This is just not something I see often. However, if you find yourself working on a high-design shoot for a food ad, maybe it'll be your winning solution. Who knows?

Eventually, we all develop a sense of our own style. Or maybe you'll develop many styles and just hold on to certain preferences for your shoots. But it's always helpful to understand the guidelines and principles of photography composition—even as we learn new tips and tricks.

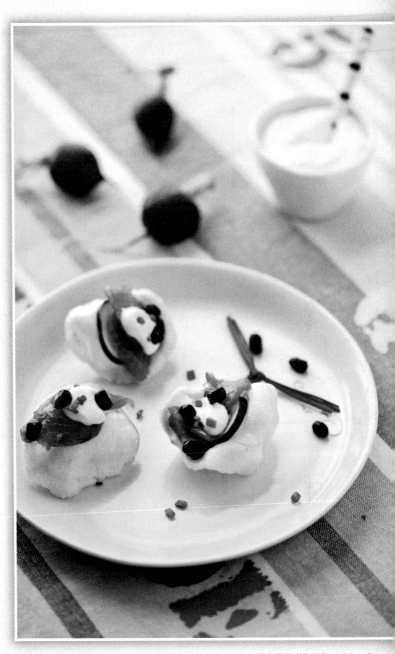

f/3.5, ISO 400, 100mm, Macro L

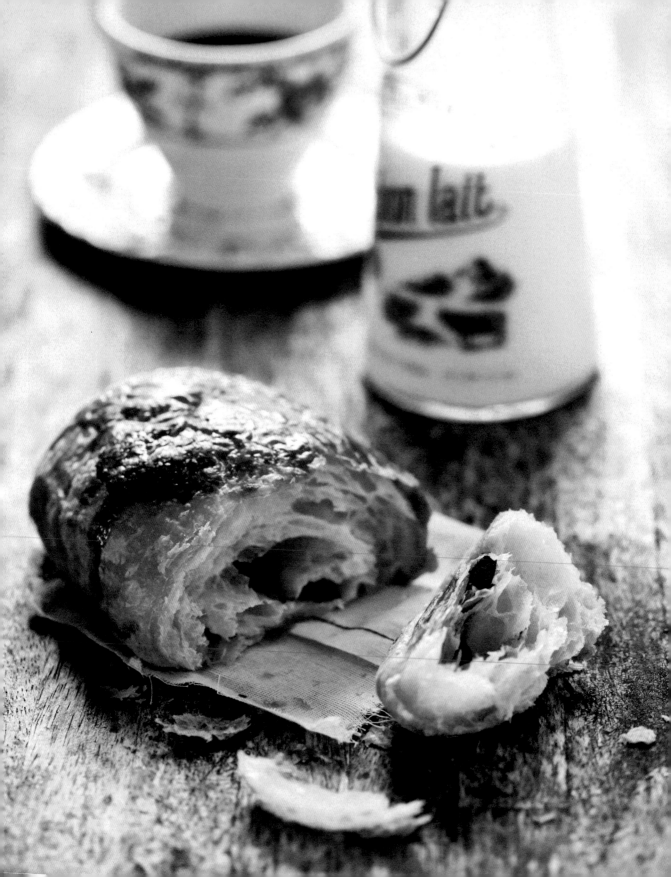

Storage within Reach

When I first started taking photographs of food … on that little coffee table … I used my family's everyday plates, cups and flatware. And as I got more and more into it, over time I started collecting other props to enhance what I already had. I still don't have a huge collection of props, but I have favorite pieces that are used only in photos–not for actual dining.

To store these items, I cleared space in a closet near my camera setup. One side hosts my dishes, the other the linens. I also created some extra shelving space in the closet for camera bags, lens sleeves, cords, light bulbs, batteries, etc. I've found that having a dedicated drawer, box or bin for such items saves me an incredible amount of time and stress. It's nice to know where to access my equipment quickly.

A third bin could be PLATES & FLATWARE if you wish to reserve these items for pictures and not have them handy for everyday use.

The amount of surface space you need to shoot your images depends on whether you prefer macro shots or whole-table setups. As shown in the bouncing and diffusing setups, my work area is nothing more than a large piece of wood (48 x 36) set on sawhorses … even though my studio is a large room.

No matter what size surface you choose, be sure to position it so you can circle it. Since light comes from different directions at various time of the day, and different viewpoints offer different effects, you'll likely need to use all sides of your surface—eventually.

My table, for example, is pushed against the wall that holds the window. I never like the way my pictures look when I have the sun coming from behind me. Remember, this is called *front light*. (See Chapter 3: Natural Light Photography for information on the impact of light's direction.) But I like to be able to use the light as back light sometimes or side light, depending on the atmosphere I want to create.

I also advise you to clear your work area of clutter. An open space will allow you to move freely … and quickly, if necessary.

I can never stress enough that your camera does not make the pictures you get. Along with the available light, your subject and surroundings, your camera is but a single element in the creation of a photograph. So it's important to understand how lighting, framing a scene and other fundamentals impact an image. Because ultimately, your creative outcomes depend on how and where you put this understanding into action. Develop a functional space to achieve your best work. Then, start planning.

The key is to observe and make use of the opportunities available to you based on the circumstance you face. Being flexible because of space or schedule constraints is just as important as being organized about that space. (See content below for my thoughts on accessibility.)

If you have tripods, flashes, softboxes and other lighting equipment, consider setting up in an area with minimal risk of kids or pets tripping over cords. As much as I like the company of my dogs when I work, they are more concerned about rushing to the front window to bark at passersby than avoiding my equipment cords.

Kids are (a bit) different. When your children are old enough to understand what you're telling them, enlist them as your assistants and stress the value of your photography equipment. Let them help you set up and break down. Who knows … they just might get the photo bug, too.

Of course, if you do a lot of on-location shoots, roaming pets and children will probably not be an issue. Just make sure to pack and pad your camera bags appropriately … and label them FRAGILE … so that people around you pay attention.

Accessibility

If you spend a lot of your time taking pictures, or if photography becomes your full-time job, you might want to consider a separate room for your work—spare bedroom, den or perhaps just a part of a room—to create an area that will be yours. This will enable you to keep your gear and props nearby.

For any props that are dedicated to your photography—and not used regularly by your family—you might want to create shelving or drawer space, and keep everything handy and organized. Place linens on one side, plates and glasses on another. Use large tumblers to store special silverware that you use for pictures.

Yet if your food photography is a minor part of your life and you can't … or don't want to … let it invade on your space, consider creating a simple and portable setup. That is, find a nicely lit area that's good for photography (read more below), and then invest in some storage bins. One could be labeled GEAR for your reflectors, bounces, lenses, etc.; another could be LINENS for your favorite tablecloths and napkins.

Taxes

If your photography becomes a business venture, be sure to learn about tax laws in your area. Find out about working from home as a small business.

Location

If you take photographs with natural light, locate the best source for it in your house. Try different light orientations (e.g., north- or south-facing windows) to decide which works best for you. You may find that it's not your kitchen or your living room. My studio is what used to be a big guest bedroom. The light in there is fantasic.

Start with the obviously convenient locations for shooting food subjects: the kitchen, dining room, breakfast nook. And observe the light in these areas. Find the place(s) where natural light is abundant, keeping in mind that this will change with the season. You'll just want to make sure you have plenty throughout the day to work with—to diffuse, reflect and bounce—depending on the effect you want to achieve. See if you can clear a space in this area to take your photographs.

If nothing works next to the kitchen, try to find enough space in a sunroom, office or bedroom. Anywhere that provides good natual light and has a spot for you to set a plate down and take some shots will work. Of course, I'm not suggesting that you re-assign the entire family to new quarters, but if your style of photography requires an easy setup and break down, then a folding table or some desk space may be quite enough for now.

See the Light

Even if you do most of your work at a time or place that requires artificial light, there is still value in learning where the best natural light is in your house ... and establishing a work area there to use it. On days when you are able to use some natural light, even if partially, you'll know where to go and how to manage the light. Whenever possible, try to use artificial light as a filler instead of making it your primary light source.

❧

And if you find that the best light is in the bathroom, then it's time to renovate! No, no … I'm not being serious! Don't do it! But this space could be a lifesaver one day, when you need to add a shot that doesn't require much styling or composing. Which reminds me of a story …

I was about to send in a number of photographs for a magazine feature, and it dawned on me that a picture of some of the ingredients in the recipe would add a nice touch to the the story. I didn't feel like loading up a tray and going upstairs to the studio, so I set out a simple white napkin on the bathroom floor—where the second-best light source is at my house—and I snapped a few overhead shots. Of course the bathroom is not an ideal location for food photography; but in a pinch, it might serve a "quick fix" purpose.

my camera. And since my hands shake naturally, I needed to start using a dedicated tripod rather than setting the camera on a cookie jar, hoping for the best.

Our little coffee table did just fine for more than a year! And for the type of food photography I was shooting, my point and shoot was all I needed in this small space. I used boards and linens to change surfaces, and our black leather sofa served as a natural backdrop. Although sometimes I'd drape a cloth over it to change things a bit.

My light streamed in from two large windows. So when I discovered the impact of bouncing light, another world opened for me. Indeed, I was quite the happy camper in the living room for a while.

Eventually I realized that my food photography work was a lot more than just a hobby. So my camera gear began to evolve—as did the amount and the quality of dishes and flatware I began using for props. Yet my studio still does not look like the storage room of Crate&Barrel or Pottery Barn.

Here are some tips to help you get a setup you can use for successful photography.

Before anything else, start this process by figuring out what type of photography you want to do. Figure out how much time you'll spend taking pictures and how much space you're going to need. Much like the process of buying real estate, always keep *location* and *accessibility* top of mind.

A table, some props and the food …
My kind of super production!

f/3.2, ISO 2000, 50mm

©*Taylor Mathis*

Establish a Photography Work Area

Right off the bat, let me tell you that a giant space and work table are not
required for the type of food photography we're exploring in this book. As
you can tell from Chapter 3: Natural Light Photography, my workspace
is pretty simple. Although I now have more room to maneuver and store
things, my workspace isn't too different from what it was just a few years
ago when I was make-shifting in my living room.

When I first started taking pictures of food, I lasted about three days
in the kitchen. It wasn't long before I was moving my plates to a small
wooden coffee table in the living room for photos. As much as I tried to
keep a small space on the counter—conveniently located for light and
tools—our lifestyle just doesn't allow for that space to remain clutter-free.

Plus, being a former chef, I spend long hours in my kitchen. It's the center of
our family life, and I am far too much of a worrier to risk flour or grease on

6 ✤ Setting Up for Capture

A lot of people, especially budding food photographers, seem to think that the first steps to creating great food photography is composing and styling. As I mentioned in the previous chapter, it's helpful to start thinking about these two important elements before you begin your set up, but composition and styling should not come first in your planning. Nor should they come last.

Composition and styling are on the same level of consequence to a photograph as the quality, quantity and orientation of the light; your choice of camera modes and settings; the camera viewpoint you use; and the food you're featuring. And all of these elements come into play before you're ready to press the shutter button. I know it seems like a lot to manage, but a bit of planning and organization will make your work much simpler … and enjoyable!

Plan the Shot

When it comes to preparing for a shot of food, much of the work begins before the dish is cooked—whether you're the one cooking or not. Below are some steps you can take to facilitate the composition and styling process.

Explore your Recipe

Especially if you are responsible for cooking and styling the dish you plan to photograph, be sure to take a look at the recipe before you make decisions about your shot. At a minimum, be aware of the ingredients involved and try to visualise how the ingredients will look once cooked. To examine this step, let's look at a recipe.

Sweet Potato & Black Bean Wrap (Serves 2)

For the dressing:

- 1/2 cup fresh cilantro leaves, packed
- 1/3 cup Greek yogurt
- 1 tablespoon milk
- 1 tablespoon freshly squeezed lime juice
- 1 garlic clove, minced
- ¼ teaspoon ground cumin
- 2-3 dashes of hot sauce
- Pinch of salt

- 1 cup sweet potato, diced into ½-inch cubes and cooked until tender
- 1 (15.25 oz) can black beans, drained and rinsed
- 2 scallions, finely chopped
- 2 (8-inch) multigrain tortillas

Make the dressing: Finely chop the cilantro and fold into the yogurt in a medium bowl. Stir in the milk, lime juice, garlic, cumin and hot sauce. Season to taste with salt. Reserve.

Cook the sweet potatoe cubes in a pot of boiling water until just tender, about 10 minutes. Drain and cool to room temperature.

To assemble the sandwiches, gently stir together the cooled sweet potato, beans and scallions in a medium bowl. Divide the mixture evenly among (the center of) each wrap. Divide the dressing between both wraps and roll, tucking in sides to firmly close.

Recipe adapted from *House Calls Magazine* Spring 2010

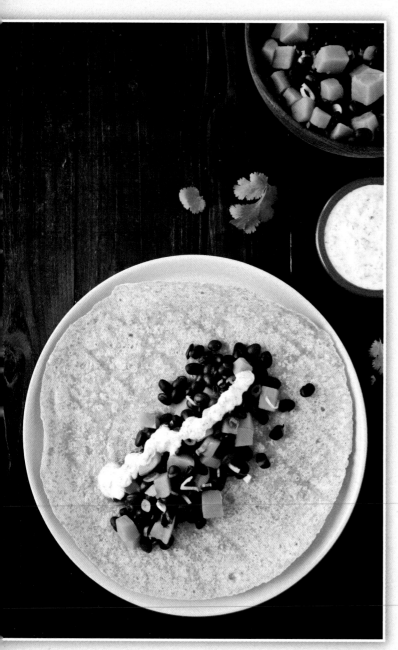

Sweet Potato & Black Bean Wrap: The open-face style lets you showcase the ingredients in the recipe.

f/6.3, ISO 200, 24-70mm L

While reading the recipe, I made mental notes of things that could help with the styling or provide ideas for composition. For instance, the dressing called for cilantro, so I set aside a few whole leaves to garnish the plate and stored them in water in the fridge. I also noted that the recipe (pretty much) said to avoid overcooking the sweet potato. We'll want to keep it tender but not mushy.

There's not much to consider regarding the wraps themselves, but there are enough differences in the textures and colors of the ingredients to make an interesting photo featuring this recipe. Being unsure of my folding ability, I decided to fill one wrap and take a picture of it open faced. So if my rolling and tucking ended up a catastrophe, at least there'd be a good photo of how the wrap looks on the inside. The viewer can easily imagine the rest.

Once that shot was in the can, so to speak, I gently rolled and tucked as the recipe directed … without being overly cautious or slow. I just tried not to pat or mush things down too much. But then I realized that my chopped scallions were no longer visible; they were engulfed under the weight of the black beans. Nevertheless, I could have stopped there and taken a decent photograph. But I took an extra five

minutes to chop half a scallion and sprinkle it on the wrap. I also dabbed a little more sauce on the wrap with the tip of a knife. Voilà.

The point is, considering the finer details of a shot doesn't take more than a few extra minutes; yet it can make something as casual as a wrap look extra delicious. Seriously, the chopping and dabbing didn't take *that* much extra work and it makes a big difference. It's like making sure that your socks match or that your scarf really goes with your outfit.

Stuffed foods are also fun. Let's look at crepes. A few months ago, I wanted to photograph one of my favorite desserts for my blog: gluten-free crepes filled with roasted persimmons slices. Mmm …

I took a picture of an unfilled stack of crepes. *Meh.* I took a picture of a filled crepe. *Better.* But I could barely see the slices of persimmons sticking out. And even though I knew that my readers—by reading the title of the dish—would know they were persimmons, someone browsing at random through my pictures may not. So I gently pulled a couple slices closer to the edge, positioned the crepe in the foreground to ensure it would clearly be the main focal point and then placed a serving of the stuffing, the

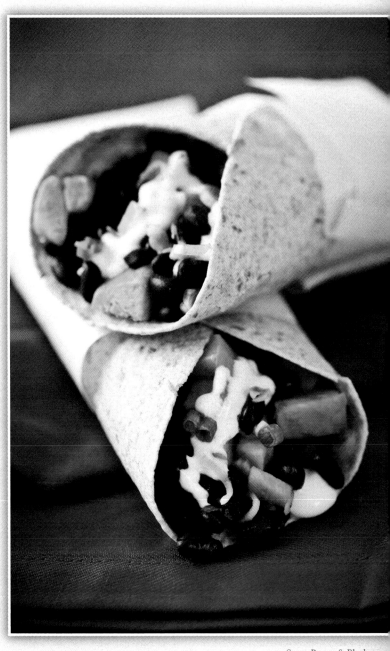

Sweet Potato & Black Bean Wrap: It's rolled and tucked gently to preserve the integrity of the ingredients.

f/3.5, ISO 400, 100mm L

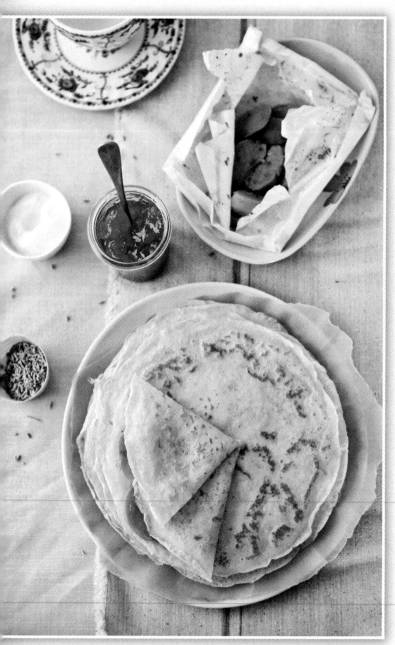

Stuffed Crepes with Roasted Persimmons: A sample of stuffing is used as a prop to show what's inside the crepes.

f/3.5, ISO 500, 24-70mm L

roasted persimmon slices, on the side. This allowed me to show the stuffing. It's in soft focus as a suggestion, while the final dish is sharp.

Use the same technique for photographing foods that taste fantastic but don't look very pretty when cooked. It can be a challenge to photograph crumbles for example. Before it is cooks, everything looks plump and the dish has interesting shape and texture. But out of the oven, it often looks flat. It's a delicious dessert but challenging to convey this in a photograph.

My family eats 99% of the food I photograph, and I want my pictures to show what a dish really looks like after following the directions for baking and cooling. So I always look for steps in the recipe that can help keep things look appetizing.

In the picture of Cherry Crumbles (right), I did not cover the entire surface of the dish with the crumble mixture, as the recipe instructed. Instead, I reserved about a quarter cup of it for styling. I also pulled aside the best-looking cherries to use as natural props. And, finally, knowing that the ice cream was another important component of the story I was telling, I placed some in a little container … just in case I decided to position some on the side. So when time came to compose,

style and shoot my photograph, I was ready with all the elements I needed—all a part of the recipe—to describe and enhance my dish! That allowed me to focus on the dessert, and it helped me to avoid cluttering my composition with extraneous props.

Whenever a dish you're photographing includes a stuffing that looks presentable before being assembled and cooked, think about reserving a small portion for your composition. Consider it a way to say, "You can't really tell what's inside once this is cooked, but it looks like this before everything comes together." It may not always work, but it's worth a shot. (Pun intended.)

Now, say you're the photographer and food stylist but not the cook. Let's imagine that you've been asked to photograph a few dishes at a restaurant. And you have some time to set up your camera, consider the composition and style the food before capture. Be sure to request a few favors that will help you create a nice shot.

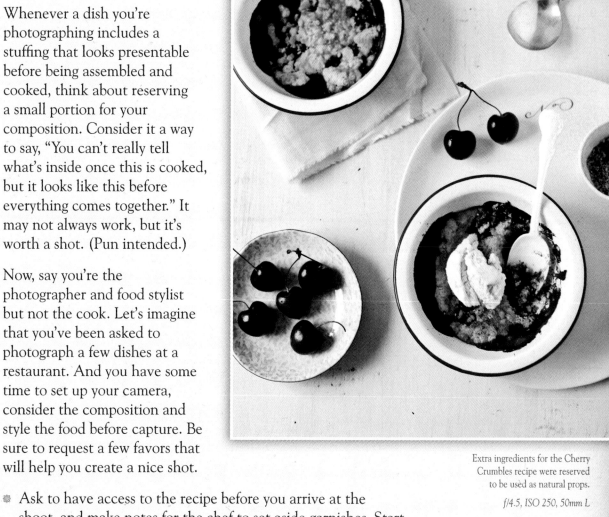

Extra ingredients for the Cherry Crumbles recipe were reserved to be used as natural props.

f/4.5, ISO 250, 50mm L

❋ Ask to have access to the recipe before you arrive at the shoot, and make notes for the chef to set aside garnishes. Start thinking of colors in the dish and what props, linens and other materials might complement these colors.

◈ Ask that the dish be made as fresh as possible for the shoot and that the ingredients are not overcooked. This will keep colors vibrant and textures firm, which will facilitate your styling process.

◈ If the dish is served plated, nicely ask the chef to hold off on placing the garnishes, so you can arrange them on the plate yourself.

You might encounter some resistance to these requests. So be aware that as artists, chefs and photographers alike have strong feelings on how their creations should look. Respond to any possible offense by mentioning that you simply want to keep everything on the plate as fresh and vibrant as possible for the photograph. Always explain what you are doing and why—whether you move a piece of fennel to avoid it catching too much light or you spritz some water over a dish to spruce it back to life. Respect the pride of the chef and let him/ her know that your requests are being made only to ensure that the food is represented as well as possible in the photo.

In the picture on the left, I was working on a magazine feature that focused on what chefs cook at home for themselves and their family. A week before the shoot, I asked the chef to send me the recipes he would be cooking. I wrote little notes for him:

Can you cook this right before picture?

Can you undercook the pasta just a little, so it won't fall flat right after plating?

Can you set aside some parsley for garnish?"

Pasta with Mushrooms and Fresh Herbs: Teamwork between a chef and stylist can enhance a photograph.

f/3.5, ISO 200, 100mm, Macro L

I showed up a little before the shoot, and I asked him to talk me through every recipe—what it was, the origin, the history, the significance. It was important to know if we were trying to convey a modern or a classical setting, a casual or fancy one … so that I could gather the right flatware, glasses, dinnerware, etc. It also assured him that I would be portraying the dish as the feature had been described to him.

I explained that everyone involved in the project—the art director, magazine editor, article writer, etc.—had been working on this project by holding pre-production meetings that began as soon as he was contacted to be featured. The magazine writer talked with him about the recipes and anecdotes that would be featured. The art director talked with me about location, props, styling and linens. As a team, we made lists of the items we would use from the chef's collection and mine, and we decided what color palette we'd use and what the general feel of the feature would be.

Look at the Menu

If you are responsible for the photography only, you probably won't have the opportunity to weigh in much on the preparation, cooking and styling of the food before taking your shots. That's okay. You can still get great photographs.

Say you're at an event and you are asked (or you simply want) to take pictures of the different dishes that are presented. If there's a menu, look through it and try to prioritize what you want to capture. Fully dressed salads are going to wilt fast because of the acidity in the vinaigretttes, so it might be a good idea to locate these first and fire quickly when they're presented. And anything coming out "fresh from the fryer" or "fresh from the oven" or "fresh from the grill"—like fries, pizza, burgers, chops—will lose the shine quickly, too. So always be aware of the kind of event you are attending (e.g., buffet, tray service, hors d'oeuvre stations) and be prepared to target and deploy to get the best results.

At restaurants or events, when you don't have control over styling … and composition is dictated by the surroundings … focus on getting your camera settings right. The rest will follow.

f/2.8, ISO 400, 24-70mm L

137

Say please.

When preparing to take photographs at a restaurant, be sure to get permission from the manager or owner. Verify that you are permitted to take pictures in the venue. And please, take your pictures quickly and effectively so that you do not ruin your own or your dining companions' experience.

If, on the other hand, you're at a restaurant where you'll start with appetizers and end with desserts, study your surroundings. What type of light is in the room and how much of it is available? Do you need to diffuse or bounce the light? Can you shoot in natural light alone or do you need a boost from an artificial source? Make a little checklist of sorts before deciding on your camera modes and settings.

Since the table props and look of the dish are out of your control in this situation, focus on your camera settings. Make sure your exposure is set correctly and that your ISO and white balance are ready for capture—before you receive the food.

Once you are presented with your dish, it's okay to take a few seconds to clean up a splatter and to remove or re-position a garnish, but try not to make it a long styling session. The chef might be annoyed if (s)he sees you tweaking a lot of what (s)he has prepared, and I am positive that your dinner companions are much more interested in talking with you than watching you play with your food and camera.

Think more about exposure, focal points and your camera angle when you can't modify plating and styling decisions.

f/2.8, ISO 640, 24-70mm L

Oh, one important last thing. When shooting frozen foods that melt quickly, it's important that you're ready to snap as soon as the food is set. I recommend getting ready for capture by using stand-in items to set up your frame and composition. To ensure your preparation is accurate, try to use stand-ins that are the exact same colors as the stuff you'll actually shoot.

If it's vanilla ice cream, crumple some white paper towels in the cone or cup. If you're going to shoot mango sorbet, use paper of a similar color. Set the white balance and exposure according to your practice setup and maximize your time with the real stuff.

Some people use an empty setup to prepare. And while this allows time to finalize the composition, it doesn't help you get your camera settings ready.

Use an ice cream stand-in to adjust styling before capture.

f/3.5, ISO 250, 100mm Macro L

Replace the ice cream stand-in with the real thing before finalizing styling.

f/3.5, ISO 400, 100mm Macro L

Pick Garnishes

From the feedback I get when I teach workshops, it seems that soup is one of the foods that people struggle with most when preparing for a photograph. So let's look at a recipe for Cream of Celery Soup. At first glance, it seems like it will end up looking one shade of green without much texture. Will it?

Cream of Celery Soup

Prep & Cooking Time: 30 minutes

- 1 lb fresh celery or celery root
- 1 medium Russet (or other starchy) potato
- 2 Tbsp unsalted butter
- 1 medium onion, peeled and roughly chopped
- 1 clove garlic, peeled and crushed
- A couple sprigs each: rosemary, thyme, parsley
- 5-6 springs fresh chives
- 1 qt vegetable stock or white stock
- Salt and pepper to taste

Cut celery into half-inch to one-inch thick pieces, depending on diameter.

Peel the potato and cut it into pieces about the same size as the celery.

In a heavy-bottomed soup pot, heat the butter over low-to-medium heat. Add the onion, garlic and celery and cook for 2-3 minutes or until the onion is slightly translucent, stirring more or less continuously. Add the fresh herbs.

Add the stock and the potato.

Increase the heat to medium-high and bring to a boil. Then lower the heat and simmer for 15 minutes or until the celery and potatoes are soft but not mushy.

Remove from heat and purée in a blender, working in batches if necessary. Return puréed soup to pot and bring to a simmer again, adding more broth or stock to adjust the thickness as necessary.

Season to taste with Kosher salt and white pepper.

Serve with slices of crusty French bread if desired.

As I started reading this recipe, I made a mental note of all the herbs going in the soup and thought about which ones I might set aside for garnish. This process has become automatic for me over time, because it is really the easiest first step for styling. And since, when I was first reading the recipe, I did not yet know how the final dish would taste, I saved some of each herb. I knew I wouldn't necessarily use all of them, but I needed to wait to see which ones would taste most prominent in the final dish.

I tend to do the same thing with spices. I make a note to set aside some of the whole form of spices—like whole black pepper, coarse salt, whole cumin seeds and cinnamon sticks—to use as natural props. They don't always work in the final composition, but whole spices are very convenient to have on hand.

And these natural props serve a dual purpose. Showing them allows you to visually tell a viewer what ingredients/ spices/ herbs are in the dish—which might be helpful if (s)he has no clue what a whole cumin seed looks, for instance. They also give you quick styling tools that don't require much fuss.

From the ingredient list of a recipe, pick out a few options you might be able to use as garnish for the final dish.

f/10, ISO 400, 24-70mm L

Styling begins with just a few items.

f/3.5, ISO 400, 24-70mm L

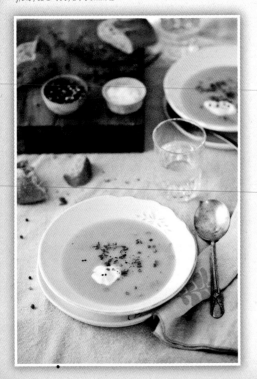

This is the final shot, created after another read
of the recipe and the addition of ingredients.
Some very basic props tie it all together.

f/3.5, ISO 400, 24-70mm L

I took a few pictures of the soup without the bread
and with only minimum props. Although it worked
fine, I felt there was something missing. My aunt had
written on the recipe *Serve with slices of crusty French
bread* for a reason. It's how we always ate soup in our
family. We also always added a dollop of sour cream
to our soups, because they would be served scortching
hot. Sour cream was a delicious and easy way to cool
them down.

So already, I had two natural elements to enhance
my picture, and they spoke truth about my family
traditions. Since I was imagining a casual Sunday
supper as the background story for the soup, I simply
added two water glasses … as if we were just about to
dig in.

One thing I had to address was the reflection in
the spoon of the tripod and camera, which were
positioned overhead. I simply changed my camera
viewpoint and that problem was gone. When I sent
the image to my mother, she emailed back instantly,
"That reminds me of Sunday suppers when you were a
kid." Bingo! Mission accomplished.

It's all about making mental notes. You move
from being the cook and eater to also being the
photographer and stylist. It's much like cooking for
someone special, when you pay a little more attention
to your gestures. Plating and serving a special dish
for a special occasion deserve a bit more care. It's not
about *mettre les petits plats dans les grands*, as we say
in France ("pulling out the finest china"), but about
focusing more on taking a plate from "Looks good!"
to "Wow! Look at that!"

Create a Scene

When listening to photographers recount their struggles with composing and styling, I most often end up asking them the same question: What is the story behind this dish? Right away, their eyes light up and they emit an enthusiastic explanation, like:

Oh! That's the dish my mom used to make for my birthdays when I was a child.

This is my grandmother's famous apricot pie.

This is the dish I ordered on my first date with my husband.

The simple act of verbalizing the inspiration of a dish gives direction to the composing and styling process. So if you decide to photograph a rendition of grandma's famous tart as a deconstructed modernestic fusionistic plated dessert, then you probably don't want to take the rustic, nostalgic route. You get the idea.

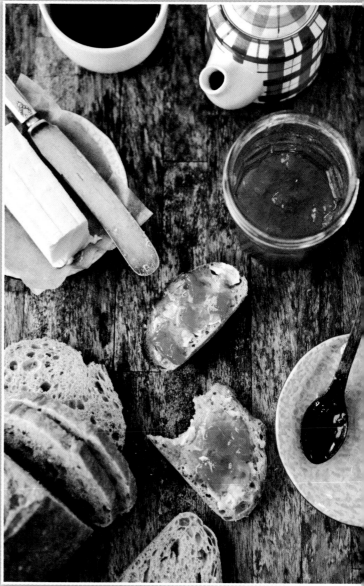

This image re-creates a typical Sunday morning at home.

f/3.5, ISO 250, 24-70mm L

In the picture on the right, my goal was to describe a breakfast scene as they happen at our house on lazy Sunday mornings. There's bread, butter, jam and coffee. At first, I considered a little fancier setting—a white tablecloth and finer china—but that's not us. Our table would never look like that on a casual Sunday, so I went with dishes that we use on a daily basis ... and my favorite wooden background.

143

There will be plenty of times when the occasion dictates the setup, as in the picture below (left). I really wanted to bake my husband a birthday cake. I wanted to recognize the bridge between getting a year older and being a kid at heart. After pondering how to incorporate that idea in one shot, I decided to keep the styling of the cake minimal and use a monochromatic tone. I added a little splash of color and whimsy with some cute straws in small milk bottles.

If shooting in natural light, it's especially important to make full use of the quality of the light. Let the mood of the light guide your styling. In the picture of the rhubarb tart, for example, (bottom right) I wanted to convey the mood of a casual moment spent having a bite of dessert on a stormy afternoon. The un-styling of the food and the props … combined with the unusual quality of the light, which was strong in shadows and highlights and featured tones of grey and

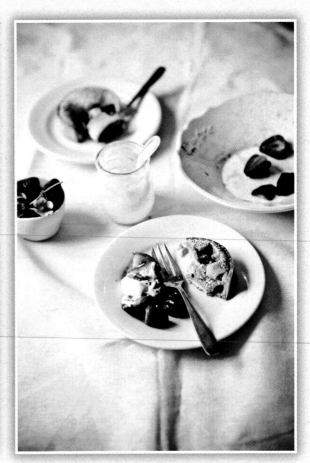

The birthday boy is a kid at heart.
Accessories set the scene.

f/3.5, ISO 320, 24-70mm L

This scene is all about having a bite of dessert
while staying away from the storm outside.

f/3.5, ISO 1000, 24-70mm L

silver … was perfect for portraying a casual scene. The only post processing I did to this photo was to desaturate the colors slightly. Ahh, a perfect stormy day with nowhere to go and nothing to do but dig in and enjoy.

Don't worry, it's not always so deep. There are times when I just cook something because it looks good and I want to make it for my family. If it's good, I like to tell my blog readers about it. No family history, no first date story, no birthday celebration to anchor the dish is required. Yet I always try to think of how I would want to serve food if my friends were coming to share it with us. Would I want to keep it casual? Make it elegant by pulling out my finest china? Is it a fancy-tea kind of dessert or a minimalist one?

I start that process as I'm cooking. Actually, sometimes I start thinking about styling my food as I'm shopping for ingredients. Never too early …

I baked the fig tarts in the picture on the right completely on a whim. No auntie with a great tart recipe, no romantic dinner plans on the horizon. I just saw these tiny figs at the market one day and thought they were too sexy to pass on. Yes. I don't know why *sexy* came to mind, but it stuck to me pretty much the whole time I was baking the

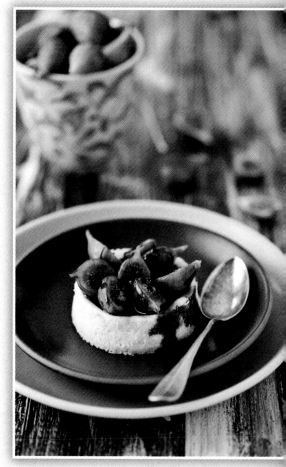

Setting up for a date night …

f/3.5, ISO 100, 100mm Macro

tarts. So when time came to compose and style these tarts for a photo, I picked a simple setting but kept everything on an intriguing side—dark wood, glistening balsamic vinegar and reassuring touches of blues, greens and whites. Much like seduction, this setup plays with what is familiar as well as what is not.

There are times, as a photographer/ stylist, when your job for a particular assignment is to capture someone else's dishes. The job is to make the food look appetizing while staying true to the idea behind each dish. There will be times when you find yourself in someone else's home, relying on the information they share to make styling decisions.

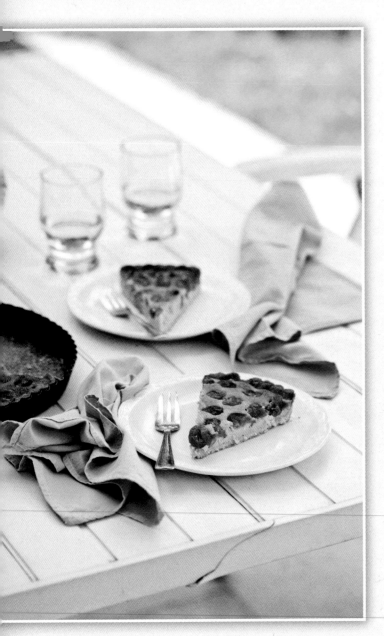

Here's to summertime and
Sunday suppers back home!

f/4.5, ISO 100, 100mm Macro L

By establishing a rapport with the person who made a dish, you'll hear messages that will help you make good choices for the assignment. Ask about the origins of the recipe, such as the country or era. This might help you pick out props and linens that the family already has and that tie the picture to the story it's telling. Is it a family recipe? Is there is an interesting story around it? Who knows, maybe it accompanied a marriage proposal, which may lead to a romantic setting for the photo. Perhaps it became a family tradition that you could portray—a vintage feel or a holiday mood.

These kinds of questions will help you create a setup that enhances the food. Probing into the history and stories of a dish will help you understand why it's important for the person cooking it. And this enables you to translate the emotional language of the photograph.

Show and Tell

Mood and story intertwine intimately when styling food. Whether you have a strong—or zero—attachment to the food being pictured, your styling will become much more organic and natural … picturesque … if you take just five minutes to think about the story you want to convey and the mood of it. Trust me, there is always a story to tell with a dish, even if it is somewhat boring. I'm serious. The story could simply be: *This dish was delicious, and you should consider making it.*

Indeed, it's never just about the food. As a photographer who creates images of food, you become part of the story.

In the picture on the left, I was going for a summer feel … when everything seems light and simple. I was visiting my parents back home in France, and it was just another Sunday supper. Nothing fancy, nothing different. So I used what my mother had available to set up this photograph. I rummaged through her linen closet to find colors that worked well with the oranges and yellows of the dessert. But that is the only executive decision I took regarding the styling. And, yes, I brought that vintage tart pan back to the US with me, but that's the story of a prop stylist!

Sometimes, you'll receive a recipe with some basic instructions for propping and camera angles … and instructions to "Make it look good!" I remember working on a magazine feature that focused on easy weekday dinners. One of the recipes was for a pork and vegetable chili. The styling started out really bare … with virtually no garnish and just some touches of blue to offset the oranges in the chili. (I will go over that color thing in the latter part of this chapter.)

That was really too bare—even though the message was *simple supper ideas*. So I took a look at the possible garnishes and decided to add some sour cream on top along with a sprinkle of the cumin seeds and a few sprigs of cilantro. Basically, I used ingredients in the recipe to make the image more appetizing.

Since I didn't know how casual or minimalist the art director wanted this to be, I took one final shot that was one level closer to minimal. It was a crisp, clean look that focused exclusively on the chili. All other color was removed. So which picture do you think they kept? They actually asked for both, because they each worked in a different way.

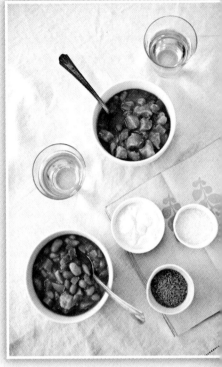

f/3.5, ISO 160, 100mm Macro L

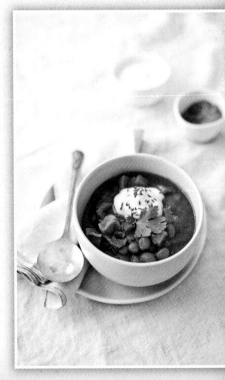

A simple change in props can change the mood in an image from classic to rustic, even when featuring the same recipe. Here, and above, it's chili.

f/3.5, ISO 160, 24-700mm L

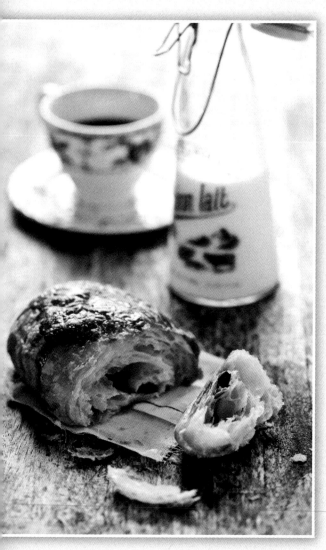

This shot of Pain au Chocolat with a milk bottle and coffee cup shows a minimal use of props.

f/3.5, ISO 200, 100mm Macro L

Feature the Dish

Photography is a constant stream of decision-making moments. Everything you do to create a shot—whether you're a blogger, foodie, pro photographer, cook or whatnot—brings together the scene you capture when you press the shutter button. So when making decisions about exposure, ISO, white balance, composition, camera angle and styling, always be sure to make *the food* the main element of the picture. After all, it's not about the objects surrounding it.

But, obviously, if your photograph centers on your grandmother's casserole dish, the actual cookware might be an integral part of the story. Just be sure to use props that help you set the scene. They should be the supporting cast for the food's leading role.

Props

In addition to making full use of the ingredients in a recipe by using them to style a dish, props can enhance the overall look of a photograph. Sometimes, the nature of the dish you're photographing will lend itself to the style of props you'll use. A plate of wings and a glass of beer rarely call for your grandma's silverware, unless your grandma ate wings that way. See where I am headed?

Your favorite bistro dish, let's say Croque Monsieur and a side salad, matches a simple, restaurant style and goes well with white plates and simple flatware. But if you're plating your kids' favorite macaroni and cheese recipe, you'll probably want to add some color. Find a touch of whimsy in a cute napkin, a favorite Flintstone tumbler, or another fun prop of this type. Help viewers of your photograph relate to the dish you're featuring by finding props that match its style.

No matter what kind of prop shopper you are—and whether or not you even like propping—when you look at your composition before capture, ask yourself if you're seeing the food or the props. And be honest. Think about props like makeup. The more you put on, the more people focus on that and the less they see of you.

When beginning the prop-selection process, start with one or two pieces. Maybe go with your favorite plate and glass and a pair of vintage flatware that will work well with the dish. Consider a bottle of wine to break up composition and lines. Then take a step back and reassess.

Some people really enjoy the propping part of food photography and seem to do it naturally. It's often a game of Try & See. For others, it seems to be the most difficult part. My best advice is to follow the story you're trying to convey. The rest will fall into place. And if you're really struggling with what to add in terms of props to set the mood, just keep it simple. Add a splash of color, a fun spoon or fork, a textured plate … and keep your focus on the ingredients.

A simple salad off to the side in complementary colors helps keep the focus on the main item, the quiche.

f/3.5, ISO 400, 100mm Macro L

I get the same two questions regarding props. They are:

- What are some good basic props to start with?
- Where do you find your props?

And I say, simple plates and flatware are always a good start, especially if you're on a budget. You can't go wrong with whites and pastels. Strong colors are a bit more tricky to work with. I have basic white bistro plates, and I have others with scalloped edges; but I tend to prefer matte whites and pastels, because they help reduce the amount of glare that's produced by the light.

149

There are lots of options for cupcake wrappers and other baking accessories to keep styling fun.

f/3.5, ISO 400, 100mm Macro L

I also have a few colorful pieces that I sometimes use in certain compositions to break lines or add another point of interest. Colorful bowls, polka dots, flower plates … these are great for certain shots, but be sure to ask yourself whether patterns and textures are highlighting your food or hiding it.

Fun accessories are good for certain setups. But you don't have to collect a crateful of them. A few select pieces can make a picture really pop. Fun straws are easy to find and add a whimsical touch. Cupcake wrappers never stop with fun new designs.

I also encourage people to think creatively when they're out and about. I can never look at an item and think only of its intended use. I see votive candle holders as perfect little cups for mousse. Small bud vases make really cute drinking glass, and shot glasses are terrific for making ice cream lollipops!

One of my favorite props is a galvanized metal tray with a set of eight planters in it. I picked it up at an antique store for less than $10. For photographs, I line the planters with parchment paper and bake cakes or souffles in them for a unique styling approach.

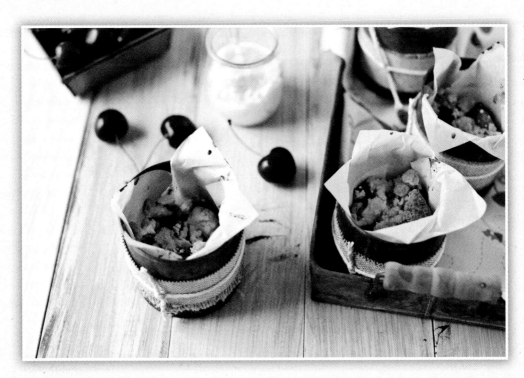

Thinking creatively:
Use vintage garden
planters as cake tins.

f/3.5, ISO 250, 50mm L

When asked where to find good props, I say *everywhere*! If you really need to be efficient though and find something fast, I suggest starting with eclectic stores like World Market, Crate & Barrel, Pier 1. They all have relatively inexpensive items that will give you a solid foundation to work with. And I'll add that even professional stylists shop at these places, so don't think the hot shots in this field are spending all their time in back alley antique stores!

But of course, if you have some time and enjoy browsing around, then antique stores and yard sales are perfect places to find one-of-a-kind items to add to your collection of photography props. For my work, I need to rotate props rather frequently, so my clients don't all end up with photographs showing the same plates and spoons. I also need to keep things very budget friendly. So I often shop little neighborhood vintage stores to find props. I love my five-cent knives and my one dollar coffee cups.

The Internet is also a fantastic place to find props … no matter how frequently you need new stuff or how you function as a photographer. I can pick up an entire set of vintage glasses for $10 on etsy.com and buy fun jadeite pieces on ebay.com. Google is your best friend. Trust me…

Here is a mix of styles and prices. Can you tell which are the five-cent pieces and which items cost $10?

f/4.0, ISO 400, 24-70mm L

Find what works for you—your budget, your lifestyle, your space. If budget and storage are problematic, know that you can't go wrong with timeless pieces such as white plates and basic silveware. You can always use your own tablecloth and napkins. Heck, I often borrow dishes and linens from my mother-in-law. She gets a kick from spotting her things in my pictures. Just keep your eyes and your mind open enough to recognize the possibilities in the items around you.

Backgrounds

No matter what props you use (if any) and how you position them, a fundamental element of your images is the background. This is a primary tool for styling a scene and showcasing your food.

Similar to the advice I gave for propping, it's important to think about the food first when choosing a background. Then determine whether or not the background you want to use will enhance or hide your dish. Be aware of the impact of the texture, color, pattern in the background—and even a lack of it.

I tend to stay away from my own dining room table when taking photos, because the wood is so varnished and shiny that it gives off some glare that always ends up bugging me. As much as I'd love to, I can't afford to buy or store extra tables—antique, metal, old or new.

But I do have a couple of tricks that I don't mind sharing. Most of them follow creative thinking and DIY concepts.

I love using wood surfaces as backgrounds for pictures; but as I said, I would need three houses to store all the tables I love. Instead, what I do is go to a home improvement store, like Lowes or Home Depot, and I buy simple planks of wood that I stain in the color I want at that moment. Since I can use both sides of each plank, I create two different backgrounds for less than $50—and that's if I buy fresh paint! I like to distress them a bit so they don't have that freshly painted look, but it really depends on their intended use. (See Appendix C for a resource on how to distress wood.) The tile section at home improvement stores is also a great place to find backgrounds. Pick four to six large tiles to make a neat textured surface.

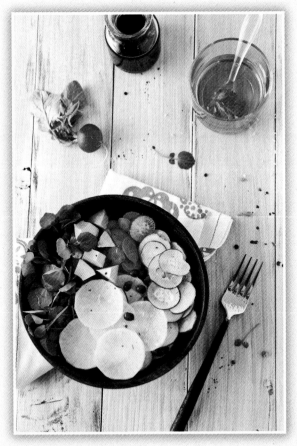

This salad is positioned on a wood board that was painted white and slightly distressed.

f/8, ISO 100, 24-70mm L

Here, a pomegranate sits on a wood board that was painted dark with white accents.

f/3.5, ISO 200, 24-70mm L

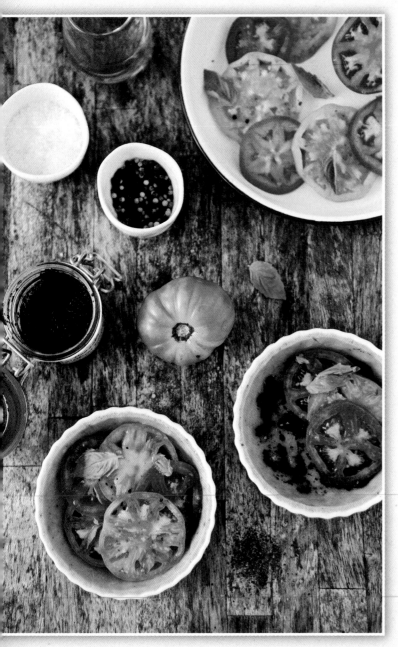

Hidden treasure: This recycled tabletop was found on the street and is one of my favorite backgrounds.

f/3.5, ISO 320, 24-70mm L

Other backgrounds I use are things I picked up at vintage stores or found on the side of the street. I'm not kidding… My favorite background, shown in the picture on the left, is nothing more than the top of a table that someone had thrown away on the curb. It was broken in two from being deeply weathered and left to its own demise, but it actually fitted half my regular table setup, so it's perfect dimension-wise for my work.

As I always like to say, "Think outside the box." Vintage ceiling tiles make great backgrounds for a very small monetary investment. My two favorite pieces were clearly not intended for food styling, but I just love their textured surfaces and how well they fit my style. I picked up a large distressed green metal ceiling tile at an antique store in North Carolina for less than $10 … and a tiny rusty one for about $2 a year later at the same place. Some of my best investments to date!

It's not that I'm a giant pile of tricks, but since food photography is what I do everyday—and because I must keep things fresh and different—I have to do this on a budget. That means I need to be creative and resourceful; otherwise, we'd be living under a bridge!

Think outside the box: Vintage ceiling
tiles make great backgrounds!

f/2.8, ISO 400, 24-70mm L

A vintage ceiling metal tile makes the perfect
rustic background for a simple soup.

f-7.1/ ISO 250, 24-70mm L

Surfaces and Linens

As with props and backgrounds, it's good to have a few timeless
linens. You can't go wrong with whites, off whites, a few solid
colorful ones and pastels.

I wish I could tell you some universal truths—something like,
large prints work better than smaller ones—but it all depends
on how the cloth affects the dish to be photographed. As with
anything, adding more pieces of linens to your collection of props
can become costly, even if you shop the sales bin. So would you
be surprised to know I have a DIY solution for that, too? I do!

Keep a variety of linens to showcase different colors, shape and texture.

f/4.0, ISO 400, 24-70mm L

My go-to place to vary my collection of linens without drowning the family budget is the fabric store. I pick up one or two yards of the fabric I want, and I always look in the remnant bins for small pieces I might use as napkins or coasters. The beauty of a fabric store is that all sorts of textures, colors and patterns are right there in one place—from hemp linens and smooth cottons to satins and silk. Dare I say that I've also recycled an old apron as a set of napkins. It never ends, I tell you!

Online fabric stores are also great resources, because they often feature designer fabric by the yard and offer great sales all year long. Yard sales and antique stores are good for picking up pieces for cheap. And I was also recently tuned in to painters' canvas drop cloths. The Cream of Celery Soup pictures were shot on a painters drop cloth. They make great rustic backgrounds for little money. These run less than $10 for a five-foot square! (See Appendix C for resources.)

Try to keep on hand a couple extra cutting boards, too. They are easy to store and use, and they offer another way to add interest to your shots. Cutting

A simple cutting board, painted over, provides yet another fun prop to use.

f/3.5, ISO 800, 100mm Macro L

This shot includes a plain cutting board that was painted white and slightly distressed.

f/3.5, ISO 200, 100mm Macro L

boards don't weigh much and they stack easily in a cupboard or against a wall. I invested in a couple of good ones—a nice rectangular one and a slate one—and then made up my own with plain cutting boards I picked up at craft stores in the wood hobby section.

Since the craft store boards are completely bare and unvarnished, they provide a perfect platform to create the look you want. I stained some white, some off white and some black. I let some remain bare. They easily add a point of interest without taking away from the dish you're styling.

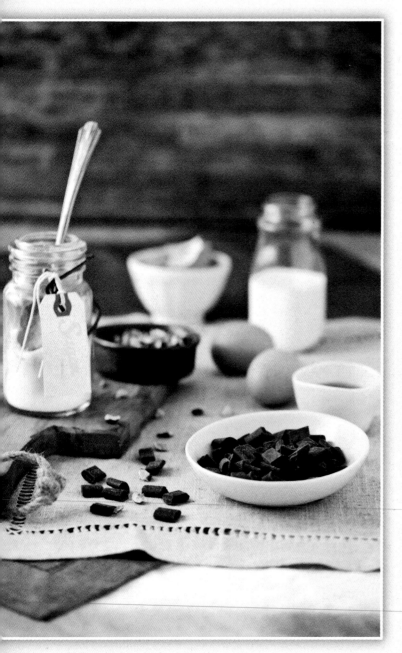

Use props of different heights to break up a composition and add interest.

f/3.5, ISO 100, 100mm Macro L

Use Height and Color to Accentuate and Complement

As you assemble your props, linens, backgrounds and other photo elements, think about how the various heights and colors of these items might impact your image. As you set up the scene for capture, try to mix and match pieces and play with your arrangement. See if your props and their placement add to the story you're trying to tell or distract from it.

Heights

When I was conceptualizing the picture on the left, I laid out most of the ingredients that would be used to make a chocolate cake. I wanted to keep the colors and tones monochromatic and use only different shades of brown and beige.

I expected this composition to be a bit bland, so I placed some objects on the table. Some of these items were perched on a board to give them more height. Some were low bowls alongside tall jars. And the objects were dispersed throughout the frame, so the viewer's eye moves from one object or ingredient to another due to the flow created by the different heights and shapes.

Another way to use height to add interest to a very simple setup is shown in the still life of figs and pastries on the right. I started this scene by setting the plates on the table. Then I manipulated the light and shadows to add more depth to the setup. I did not diffuse the light as it was coming through the window, which created strong highlights. And I used this effect to add a feeling of open space to the scene. Yet that decision meant that strong shadows would appear.

Instead of bouncing the light to minimize these shadows, I used them to add a more stern feel to the composition. I wanted a gender-neutral picture, so I used the strength of the highlights and shadows to balance out the more feminine flowers on the napkin and the little tea cakes. And that was nice, but it was too bland for my taste. So I placed a chair in the background to add an architectural element. Much better.

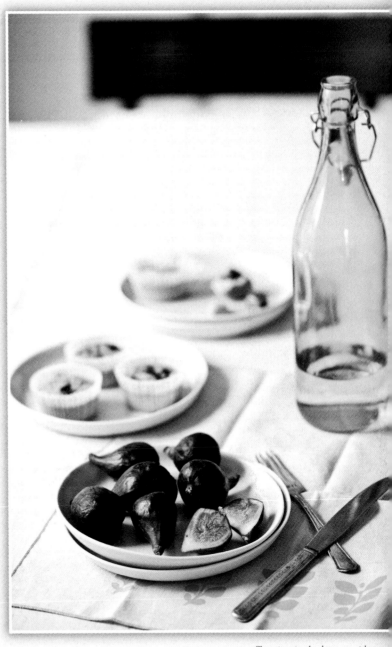

Try using simple elements with different heights, like a chair or a bottle, to add visual impact to your composition.

f/3.5, ISO 100, 100mm Macro L

The last thing I did to this setup was on a whim. But since a big part of composition is trial and error, I gave it a go. I picked up a long-neck bottle that was next to me and placed it next to a fig. I thought it might add a neat effect with the light nearby. And as soon as I looked through the viewfinder, I realized that the bottle had actually become an integral part of the whole setup.

159

Using a color wheel to pair or contrast color can help enhance your composition.

Colors

Having grown up surrounded by the notion of working colors, I have come to understand color pairing better and better over the years. I'm fortunate that my dad has painted watercolors as a hobby for as long as I can remember; and, a meticulous man, he's always kept his paint tubes arranged according to the basic color wheel. Over time, my brain has registered the concept of primary and secondary colors as well as complementary and opposite pairs. As a result, my dad's hobby helped me hone my eye for food photography. It's so important to see, capture and flatter the colors in the food without ignoring everything around it.

The color wheel identifies which colors are complementary and which are opposite. And this can help you make them work for you and the composition you're creating. The possibilities are quite endless, so let's look at a few basic applications.

Keep your compositions monochromatic sometimes, and play with the different hues in one particular color. Let's say you pick red violet as your main color in a

This smoothie image uses the hues in one specific color cone: red violet.

f/3.5, ISO 200, 100mm Macro L

setup. This means you have nine hues of red violet to work with … along with the invariable white. So call it ten. There's a lot of potential here!

In the picture of the strawberry smoothie on the left, I stayed within the red violet hues except for that little touch of green on the strawberry stem. Indeed, it's absolutely possible to stay within one set of hues when photographing food. But adding a complementary color, even a tiny speck of it, can also work well with composition.

Take a chance and work with complementary colors, too, by using colors that are opposite one another on the wheel, such as violet and yellow … or blue and orange. One of the most frequently asked questions I get is how to style baked goods, which are usually full of browns, oranges and yellows. My advice is to use a piece of blue cloth or a blue plate—a blue anything, really—in the frame. This tends to open the scene and add a bit of relief.

Another thing to consider is working with analogous colors. This means using colors adjacent to one another on the color wheel, like blue and blue violet.

Use complementary colors, like blue and orange, to take a ho-hum composition to wow.

f/3.5, ISO 1000, 24-70mm L

Try working with analogous color by selecting colors next to each other on the color wheel.

f/3.5, ISO 400, 24-70mm L

The white of the ice cream in the picture on the left works as the anchor for all the other colors, and different hues of blue appear throughout the image—notice the blue-gray wood background and the baby blue napkin. The adjacent colors are the violet hues in the spoon and the bottom of the shot glasses. These complement the color palette of the composition.

Don't get me wrong. I don't walk around all my setups with a color wheel in hand. But I do mentally reference it regularly. So if you're new to styling food shots and want to learn how to improve the way you put things together, check out a color wheel every so often and use it as a guide. I keep one in a drawer to either push myself out of my comfort zone with color composition or to help me when I'm struggling on a shoot.

Shooting Tethered

One last consideration for planning your setup is deciding whether to shoot *tethered*, or connected, to your computer. I say go for it!

The day I started shooting tethered, a new world literally opened up for me. I had heard other photographers talk about

its virtues; I had seen demos. And I was curious, but for some reason I always thought it would be more of a hassle than anything else. Was I wrong!

Tethering your camera to your computer allows you to see your composition—right away—on your computer monitor. So you can, in a few seconds, see how the picture is going to look. Viewing on a screen that's larger than your camera LCD screen makes everything so much easier to adjust right there and then.

Tethering works great in studio circumstances, where you don't have to move your camera and computer much. But I do not recommend tethering for on-location shoots at events, where the risk of tripods falling and computers hitting the ground are greater.

As a professional photographer, tethering enables me to check my work almost immediately to ensure I'm meeting project specifications. For instance, if a job requires that I shoot a picture that will be cropped to a seven-inch square, I can see right away on my monitor how the composition looks with this crop. I can adjust as needed … *if* needed. I don't need to photograph blindly, wondering if I'm in the right crop … to find

Be ready to shoot tethered.
f/3.5, ISO 400, 24-70mm L

163

Lightroom tethering functions

out later, when the shoot is over and I'm downloading images, that my frame is off, the food is in a weird place and I'm going to need to re-shoot. Or, if a do-over isn't possible … that I blew it.

As a food stylist, tethering allows me to look at a computer screen and see areas that may need a little adjusting. I can zoom in on a particular area and check for splashes, empty areas and other potential problems. So instead of shooting fifty frames to use for examples … and not knowing until I download if I had enough sauce on the stir fry … I can do it with ten.

In summary, tethering can make your work more efficient and save time in photo editing that can be applied to other jobs … or perhaps even a nap. While not all camera software lets you tether, more and more do. Lightroom does… and Aperture.

Most software will require you to connect your camera to your computer with a USB cable to start tethering; but since all cameras, software and computers work differently, please refer to the tethering menu of your specific program for details.

With Lightroom, for example, all you need to do to tether is connect your camera to your computer with a USB cable, turn on the camera and go to "Tethered Capture" in your "File" menu. Select "Start Tethered Capture" and the software will ask you to create a folder for your pics. Enter a name for your file, add tags and labels (see Chapter 8), press enter and start shooting. See? It always sounds more daunting than it really is.

No matter how much or how little you wish to do in terms of composing, propping and styling, setting up your environment for capture should be fun. There are countless ways to approach the food you're shooting. So whatever is driving you to photograph food, try to remember to "make it real." The entire idea is to make your dish look so appetizing that people want to eat it right away. So luckily, the next chapter is all about how to style food so it screams *Delicious!* without you having to say so yourself.

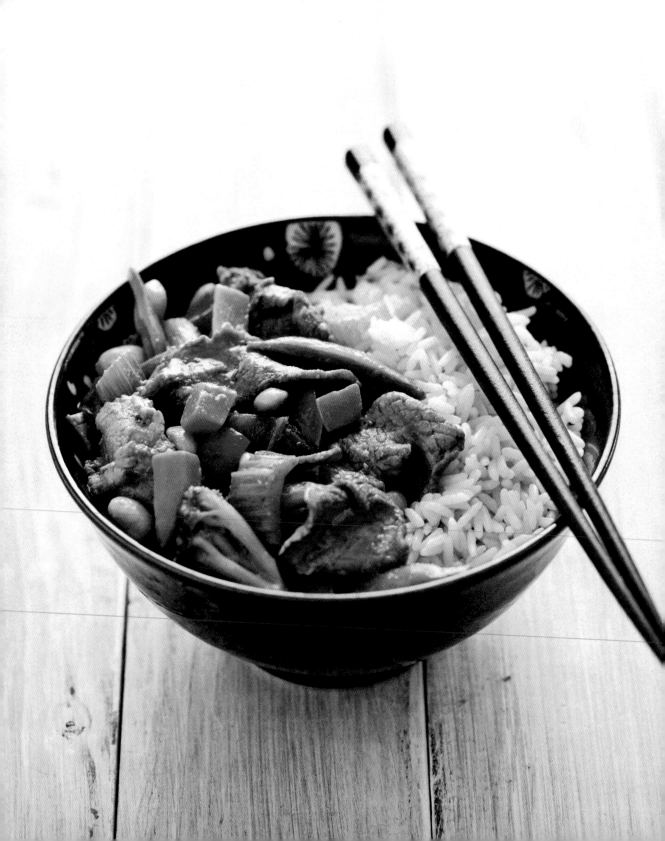

7 ❖ Styling

I recently sent out a Call for Struggles on my blog … to find out what foods and dishes were presenting readers with the most difficulty when they tried to style them for photographs. Yet as I read the submissions and examined example shots, I realized that most had good styling ideas and form. Folks were struggling to tie it all together. They were having a tough time managing the light and setting appropriate camera modes, exposure, white balance and depth of field.

That's exactly why this content on styling follows chapters on lighting, camera settings and other basics. It's important that you understand the fundamental techniques of photography before you dive into styling food for your images. It all works together. So while some aspects may seem less exciting than others, no part of the equation is unimportant.

Styling is the process of spicing
up your pictures. Oh la la!

f/13, ISO 100, 100mm, Macro L

This chapter addresses common styling issues. It outlines proven tips and techniques that can help you achieve beautifully natural shots. I encourage you to experiment with these ideas and find the processes that work best for you—in terms of the time you want to put into food styling and the look you're hoping to achieve in your photographs.

Thankfully, styling food isn't as complicated as building spaceships. Although some take it as seriously! So we'll focus on using materials and tools to style your dish that you probably already have. You'll get some easy techniques to enhance the appearance of your food while keeping it edible. From there, it's up to you to decide how much time you can invest in styling.

Whether you work on it for five minutes or thirty-five, the amount of effort you put into the details of your scene will make a big difference in the photograph you produce.

Herbs and Spices

As mentioned in Chapter 6: Setting Up for Capture, an easy way to enhance your composition and styling is to include herbs and spices from the recipe you're photographing. So if the recipe calls for ground thyme, you could place a few fresh thyme leaves or

sprigs in the scene. Set them next to the dish or tie a few sprigs together with kitchen strings to make a little bouquet.

The trick to using herbs, spices, bread crumbs and other ingredients to enhance your food shots is to present them in a coherent way. So if you're making ravioli with sage brown butter sauce, and sage is the only herb called for in the dish, please don't use basil as a garnish!

Keep herbs fresh by storing them between sheets of wet paper towel in a plastic bag in the fridge. When you're preparing your composition, place them in a bowl of cold water until you're ready to use them. Once everything is ready, pat them dry slightly and position them in the scene. If your photo session lasts longer than anticipated, either place the herbs back in water until you're ready to shoot, or spritz them with water to keep them vibrant. But if things start looking wilted or bent out of shape, just replace the item with another, fresher piece of herb.

At all costs, avoid using wilted or bruised herbs that have oxidized in the fridge. Basil, for example, does this quickly. It's much better to skip this type of garnish if your only option looks haggard.

Keep fresh herbs on hand to season your food as well as your photographs!

f/14, ISO 400, 100mm, Macro L

The oregano leaves are a perfect garnish for this roasted potato salad with herb vinaigrette.

f/3.5, ISO 125, 100mm, Macro L

Salt, colorful peppercorns and herbs are wonderful styling items.

f/3.5, ISO 100, 100mm, Macro L

In the image of roasted potato salad (above left), ground oregano was listed as an ingredient in the recipe. You can bet I jumped on the opportunity to use oregano leaves as part of my styling. After briefly considering chopped oregano, I decided to go with the fresh leaves. They look like pretty flowers to me.

Consider using coarse salt, as shown in this image, when styling savory dishes. There's sure to be salt in the recipe, so either sprinkle some right on top—especially if there's a nice beam of light; the effect is beautiful—or place a little container with salt somewhere in the shot.

Another idea is to use three-color pepper mix. Grind some between your fingers right above the dish. The specks of red and green peppercorns add a nice touch of color and don't demand much space in your scene.

Bread

Bread, crumbs, croutons, rolls … these
are enhancements that can really help
round out the styling of a dish nicely.
Whenever I style a soup or salad, I
try to use some bread in the shot. For
soup, it suggests a sopping action,
so look at the recipe to find out if a
specific type of bread is suggested.
When styling a salad, consider using
fresh croutons or vegetable chips.
Crumbs scattered on the table of
your setup is one of the easiest ways
to convey, "Pull up a chair and come
share with us." A viewer can relate
to this everyday scene, and the setup
is inviting.

The shot of pumpkin soup (right)
appeared on my blog when I covered
this dish a few years ago. It was actually
my first time using bread in such a
relaxed way. I had just finished a job
with an amazing photographer, Peter
Frank Edwards, and he had really
pushed my comfort zone for two days.
He kept saying, "Make me feel like
I want to dig in … not that it's too
pretty to eat." It was excellent advice.
And while I'm not suggesting that you
trail bread crumbs all around your dish
or create a messy scene, a few pieces of bread or croutons
in a basket or on the side can be a nice inviting touch for
a realistic setup.

Pumpkin soup and a bread basket
create an inviting scene.

f/2.8, ISO 100, 50mm

Make me feel like I want to dig in … not that it's too pretty to eat.

Peter Frank Edwards

Pistachios are a terrific addition to this thin Pear Tart.

f/3.5, ISO 250, 24-70mm L

Nuts

I love using nuts as a garnish. They can do a lot to boost the styling of your dish. Of course, choose nuts listed in the ingredient list of the recipe you're styling. That is, if the recipe suggests that you top your pastry with sliced almonds, then your nut garnish should be … you guessed it, almonds!

You get more freedom if the recipe suggests garnishing with nuts in general. For example, let's say a recipe for rice pudding says to use toasted chopped nuts as a garnish. This means you can use whatever kind of nut you prefer. You can use them toasted to golden brown to add oomph or use pistachios for a little color splash.

Of course, perhaps your recipe says nothing at all about nuts. That's okay, too. If, as you consider a dish or taste it, you think that a sprinkle of chopped nuts would be a good addition, then by all means throw some into the scene!

Pistachios were not part of the recipe for the pear tart shown here, but there's something delicious about pairing toasted pistachios with pears and cardamom. Since this was a picture I shot for myself, it was okay to take some liberty with the styling. If I had been working on a magazine feature, a cookbook or other

commercial project, I would have double checked with both the recipe developer and the art director to verify that it was okay for me to add the pistachios.

When using spices and nuts as garnish, start with a small amount and add as you go. It's easier ... and looks better ... to add chopped nuts to a mound of whipped cream than to remove them and start over.

Fruits and Vegetables

The color guard of food photography, fruits and vegetables bring a subtle—and sometimes elaborate—sense of refreshment to an image. Styling these foods is all about enhancing their simplicity in fresh and surprising ways.

To get started, explore the shape of the food once the recipe is executed ... whether it's cooked or raw ... to see how they appear in the final dish. It may be helpful to reserve a small portion of a fruit or vegetable that's used in the recipe to help you style your final dish. For instance, let's say you're cooking a gumbo. Well, reserving some okra for the final plated dish may improve the presentation, especially if some pieces have fallen to the bottom of the plate and are no longer visually prominent.

If a recipe calls for a cooked vegetable or fruit, it's usually best to use that cooked form in the dish you're styling. The shapes and structure of cooked vegetables and fruits are so different from their raw form that using the different version might appear forced to a discerning eye. But if the ingredient becomes unrecognizable once cooked, place a few raw ones in the scene to help viewers identify it.

Even when styling purées or chopped vegetables and fruits, make extra effort to keeping the food as appealing as possible—raw or cooked. For example, if cooked broccoli is a side dish accompanying a steak, be sure to keep the color and texture of the broccoli as appetizing as possible. It will help the steak look even better. And if a fruit or vegetable is the main player of a dish, keep in mind that you have one shot at making the viewer want it.

My best advice for working with fruits and vegetables in your shots is: Handle with care!

Fruits

For presenting recipes in which fruits are cooked through (like crumbles, pies and crisps) or they're used in purées (as in layered mousse and panna cotta),

it can be difficult for a viewer to identify what's on the plate. By referencing it with styling, you can better emphasize the character of a dish.

An easy way to do this is to place whole or cut pieces of the fruit on the dish itself … perhaps as a topping. You can also position pieces of the fruit in other areas of the composition as a reference. Just make sure that the fruit you use is as fresh and visually appealing as can be!

When baking the blackberry pie shown in the photograph on the left, I knew that the blackberries inside the tart shells would turn to a purée, so I saved some of the fresh blackberries and used them as a suggesting element in the styling.

When working with fruits that are poached, grilled or baked whole or sliced, it's important to always handle them with care, especially when positioning them on top of other sweet items, like mousse or ice cream. It's best to spoon them carefully rather than grab them with tongs that could leave marks or squish them too much.

Use fruits from the recipe to style your dish.

f/3.5, ISO 640, 100mm, Macro L

For this kind of setup, consider styling a practice version first. Use the least-nice looking item in the bunch for your practice run, and use this setup to compose the shot, get your camera

settings ready and adjust the light. Once you have styled the practice shot to your liking, replace it with the *hero food*, a term used by stylists to describe the best version of the dish. Doing this will eliminate your need to worry about things moving, being squished or losing freshness when it's time to really shoot.

For the picture of ice cream with grilled peaches and poached cherries on the right, I had gotten nice grill marks on about two peach slices. The rest were just so-so. Since I was also incorporating ice cream in the picture, my practice item was actually a cup filled with paper towels with the fruit on top. I used that stand-in to set up my exposure and white balance. When everything was all set, I scooped real ice cream inside the cup and used only the fruit that had the nicest grill marks and the best shape. These pieces show nicely in the foreground.

For recipes in which fruits are not baked or when you do ingredient shots, put a little extra care in selecting the best you can find. It's not always easy to end up with a perfect specimen; because fruits, especially berries, bruise easily. But taking the time to find the best pieces of fruit for your shot makes a big, big difference.

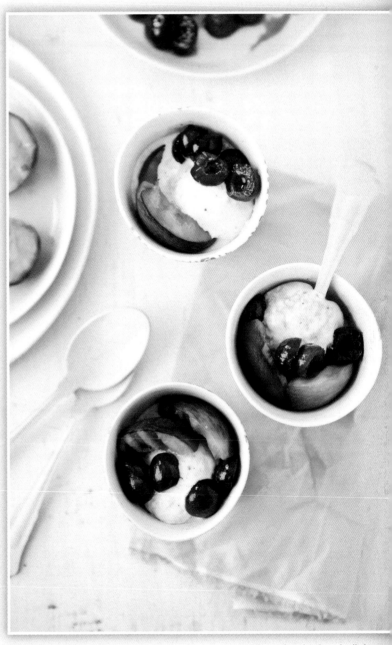

When styling this shot of grilled peach slices and ice cream, it was important to show grill marks and shapes.

f/3.5, ISO 500, 24-70mm L

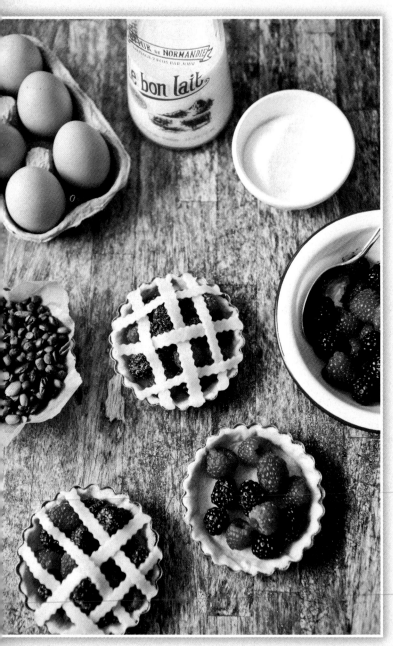

Always try to set aside the best-looking fruits for your garnish shots.

f/3.5, ISO 400, 24-70mm L

I was working on a blog post featuring mixed berry pies when I created the picture on the left. An overhead shot showing the sugared berries in the tart shells prior to baking them seemed important. So I picked out the best-looking berries and the best-looking shells. And instead of packing the berries in tight, as the recipe suggested, I deliberately left space for people to see that the berries were really fresh. This opened up the view of the filling and encouraged people to notice what type of berries were used.

In some cases, it's good to remember the old saying, "Less is more." This definitely applies when photographing raw fruits (and vegetables, too) before they are used in a recipe. You do not need to show three pints of blueberries going into a pie to suggest that blueberries are indeed the main ingredient.

A problem that can arise when photographing sliced fruits is oxidation, which is the browning that occurs when the flesh of a pear or apple remains exposed to the air. One easy trick that your mom or grandmother may have taught you is to squeeze some lemon juice over the fruit to reduce browning. That works

if you know your styling process will be quick. But if your setup process might take a little longer, you can place the fruit in a bowl of lemon water and let it stay there until you're ready to use it. Use two parts water to one part lemon juice.

Vegetables

Keeping vegetables looking appetizing once they are not refrigerated anymore seems to be a food styling challenge that's universal. It doesn't matter if your vegetables are raw, braised, roasted, poached or sautéed, it's always nicer to look at them when you don't wonder if they just got ran over by a produce truck—unless of course they're puréed. Ha.

Let's think about salads. This seems like an easy-to-style vegetable dish, right? Well, you'll find out soon enough that all salad leaves are not created equal and the shapes and textures of these leaves can make you feel scattered … in no time. To overcome this, some professional stylists who fill the bowl containing salad with a layer of mashed potatoes to anchor the first salad leaves and provide a good base for building a fluffy mound of greens.

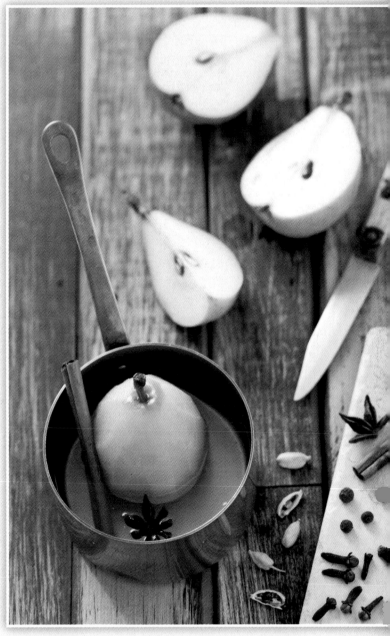

For this shot, the pear in the copper pot was soaking in lemon water. To keep the cut pears from browning, I rubbed them with slices of lemon.

f/5.6, ISO 100, 100mm, Macro L

177

I'm not a fan of this technique, because I don't like having to wash salad leaves that need to be plucked out of potatoes to be rearranged for a shot. But I have used the mashed potatoes trick (as well as a similar version requiring leftover cooked rice) when I was on a job and the art director decided to add a bowl of salad in the background for color. There was not enough lettuce to fill the bowl and look good, so we used instant mashed potato purée to add some height to the little bit of greens we had. My point is: Never say never to such a trick. You never know when it might come handy.

The photo series on the right breaks down the process for building and styling salads used as a side or main dish.

1) Start by gathering all the components and picking out dish props.

2) Throw a handful of the selected greens into the bowl to get an idea of their shape and height. Then, add a lot more leaves.

3) Take a step back and do a little quality control. Look for any bruised leaves or dirt.

4) Without spending too much time, look to see if there are empty spaces or holes in the salad. If there are, fill them with more leaves. These dark holes are likely to soak up the light and appear stronger than they should be, which can distract the viewer's eye.

5) With a good base of greens, start adding the other components, beginning with the larger items (e.g., the Granny Smith apple and radishes). This helps you avoid losing smaller components, like cheese crumbles and nuts, to the bottom of the bowl.

6) Add the smaller components last, targeting areas with empty space.

Try to make it all look as natural as possible. If something looks odd or out of place when you look through the viewfinder, don't be afraid to adjust it with tweezers or chopsticks.

Spritz!

Throughout your set up process, keep a water spritzer nearby to give the salad a little pep if needed.

❮◦❯

f/3.5, ISO 1000, 24-70mm L

f/3.5, ISO 1000, 24-70mm L

f/3.5, ISO 1000, 24-70mm L

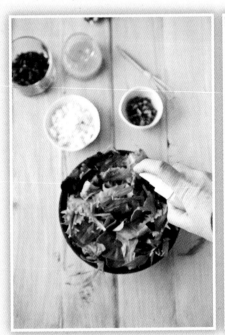

f/3.5, ISO 1000, 24-70mm L

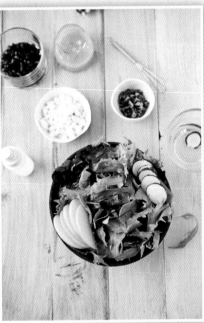

f/3.5, ISO 1000, 24-70mm L

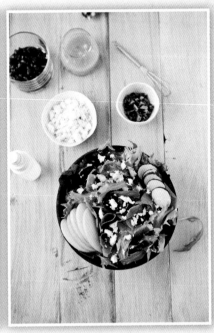

Build and style a fantastic salad.

f/3.5, ISO 1000, 24-70mm L

Fresh peas were blanched and cooled for a light summer pea salad with goat cheese and shallots.

f/3.5, ISO 100, 100mm, Macro L

Styling cooked vegetables actually begins when they're cooking. If someone else is doing the cooking and you're only styling, remember the advice in Chapter 6. That is, be sure to talk with the cook about your needs for styling and composition.

Unless you're styling vegetables that are puréed, mashed or finely chopped to serve as seasoning—which don't retain their shape when prepared anyway—try to stop the cooking process a couple of minutes before the vegetables are supposed to be done. They will continue to cook a little as they cool.

Ensuring that vegetables retain a bit of texture helps when styling. It ensures that pieces aren't squishing down on one another. For green vegetables like broccoli, asparagus and peas—whether they're being presented as sides (as in broccoli salad) or main dishes—blanch and place them in an ice bath to stop the cooking process. This will keep these veggies looking their best … with good texture and color.

Pea salad, shown above, is a warm-temperature summer salad with freshly picked peas as the main ingredient. Once plucked from their pods, these peas were blanched briefly to retain their vibrant green hue and keep them from turning the color of

canned peas. After running them under very cold water, I mixed them with a simple vinaigrette and the other ingredients. They retained good texture and vibrant color, which made the styling easy peasy.

In the shot on the right, the pan of baby fennel, had been braising in orange juice and anise liquor for about an hour over low heat. From the recipe, I knew the fennel was not supposed to get soft once cooked … just tender. I was both chef and stylist in this situation, so I checked the vegetables at 45 minutes and noted that they had a good golden colors and good texture. To avoid the risk of having to plate overcooked vegetables, I removed the pan from the heat at that point and let the veggies cool for about ten minutes. This made it easier for me to move the items around the pan if needed for the shot. After the ten minutes, I tasted a piece, and it turned out to be perfectly cooked and warm. The photo had been snapped and no tongue burning ensued. Always a good thing!

The shape and texture of the baby fennel were preserved by removing the pan of from the heat a few minutes before the recipe instructed.

f/3.5, ISO 500, 100mm, Macro L

I've found that fresh vegetables, instead of their canned or frozen counterparts, are much easier to use in cooking and food photography—as natural props or for ingredient shots—whether they're whole or cut, raw or prepared. Their colors seem richer,

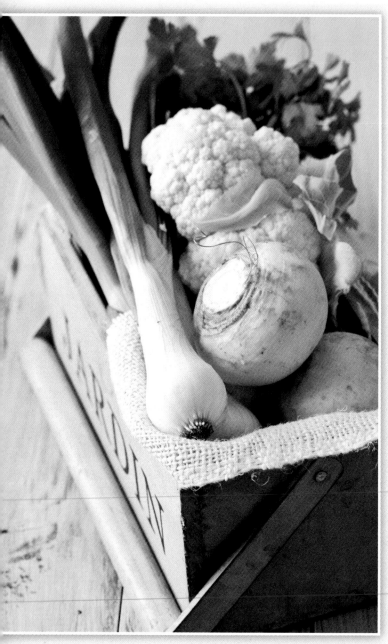

These vegetables were destined for a root vegetable soup (puréed) in which their shape would no longer be visible. They're photographed in a "before" type setting to show exactly which ones would go in the final dish.

f/8, ISO 100, 100mm, Macro L

their shapes tend to look more natural, and there are so many ways to style them. Even the most usual varieties look scrumptious.

As with whole fruits, when styling whole vegetables, be sure to look at their shape and height before deciding what camera angle will be most flattering for them. Does an overhead perspective work, or is a three-quarter view better? Explore a few different viewpoints before deciding which you like best.

Whole vegetables require very little actual styling, but be aware of the message you're sending with their presentation. For instance, if you want to give an impression that they've just been uprooted from the ground, it's okay to have some sand or dirt on them. If the scene is meant to depict a vegetable CSA or something similar, it's okay to pile them in a box … as long as it's easy enough to tell what's what. A grocer scene, however, might be better received if the vegetables are washed and vibrant.

For the root vegetable box photo, I didn't wash and dry the vegetables, because I did not need or want them to look pristine. I was trying to convey a nostalgic notion of fresh root vegetables picked from the garden moments before they went into a satisfying soup. I wanted the image to say "rustic" without looking completely abandoned.

As a blogger, I like to include pictures of vegetables that have a still-life quality to them. These images help to break down the content of a post rather nicely, especially between more formal shots of an actual dish. They show a reader exactly what I used, and this can be quite helpful, especially if the final dish is a casserole, a purée or a soup.

And as a photographer, using whole vegetables gives me new options for working with camera angles, light and perspective. They come in all shapes, colors and sizes, and this keeps my photography varied and interesting. Literally, each item offers the (welcome) challenge to style differently and create unique compositions, to use different props and backgrounds, and to work light and shadows in new ways. Vegetables aren't just good for the body; they offer good exercise for the eye and the brain, too!

As a stylist, I relish opportunities to combine multiple types of styling and to play with different prop textures and shapes against those of vegetables (or fruits). When I was working with the small and unusual size of the eggplants, I needed to figure out if they'd look better in a large bowl or a small one, decide what background to choose and so forth. Clearly, I decided on a

Ingredient still-life images, such as this one of Mini Eggplants can break down a post if you blog, or just adorn your kitchen walls if you're a foodie photographer.

f/4.5, ISO 250, 24-70mm L

183

Enjoy Mini Eggplant

If you're wondering what to do with mini eggplant—they're the size of my fingers—just cut them in half and roast them with salt, pepper and olive oil. So good…

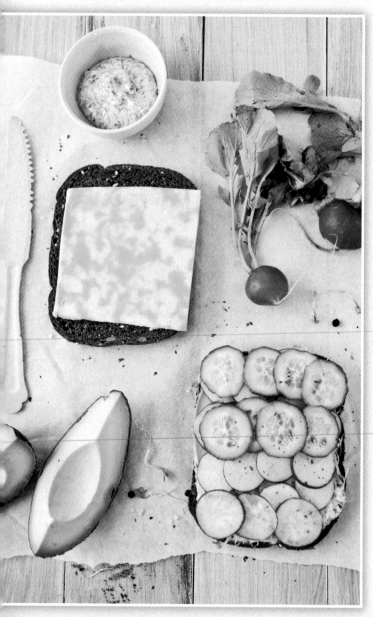

small bowl, so the eggplants would appear to be overflowing from it. And I love how the green ceiling tile in the background tied in with the green tops of the eggplants, while the splashes of color on the tile related to the paint-brush effect of the eggplant skins. This setup brings out the beauty of the eggplant and background.

Styling cut vegetables for ingredient shots can seem easier than styling a finished dish; but trust me, that's not always the case. I know a lot of people are uncomfortable with plating cooked vegetables, because they are softer and not always easy to stack, pile or move around, especially if they are sauced or their shape is compromised while being moved.

But cut vegetables, just like whole ones, have their set of challenges. Foremost, their shape is not always consistent or recognizable in a dish. For instance, a plate of vegetable

Open Faced Veggie Sandwich …
a food stylist's dream come true!

f/8, ISO 200, 24-70mm L

medley—comprised of mini oval carrots, rounds of cut squash, and cauliflower florets—offers many different shapes. Making them all look good together, and not too staged, can be difficult.

As always, keep an eye out for the best-looking pieces, and keep them as fresh as possible by tending them with a wet paper towel or soaking them in water until you're ready to use them.

When I shot the photograph on the left of the open-faced veggie sandwich, I was working as cook, stylist and photographer for a magazine feature dedicated to sandwiches. One of the sandwiches had so many great-looking ingredients going into it that we (the recipe builder, art director and I) decided it really had to be shot open-faced. This was the only way we could show all the yummy components!

Although the closed-sandwich version was good, the shot that highlighted the shapes and sizes of all the ingredients won over the other setup. It was vegetable heaven! So the photographer in me had to pay close attention to how the various shapes and sizes intermingled. To ensure that all the parts were visible and well in focus, I chose an overhead approach. This perspective works well in shots that include a large quantity of elements, because it ensures that they're all immediately visible to the viewer.

Sauces

On a magazine shoot a few years ago, I agreed to let a young intern help me prep and cook some of the foods, so I could focus on plating and styling the shoot according to the art department directives. When I reached for the salad bowl, the intern held her breath and said, "Oops! I already added the dressing." I replied, "Well, we're just going to have to be precise and quick then!"

She knew that once the dressing was added to the salad, the greens would slowly start to cook and wilt from the acidity in it. Since the scene was styled and I was ready to shoot, it wasn't too much of a problem. But usually, unless a recipe dictates that the salad be dressed before plating, just place a small container of it on the side until you're ready to take the picture.

When I do salads at home, it doesn't really matter if I dress them ahead of time, because I don't spend hours styling. But if I'm on a job and see that things may take awhile to prepare, it's best to wait until the very last moment to add the dressing.

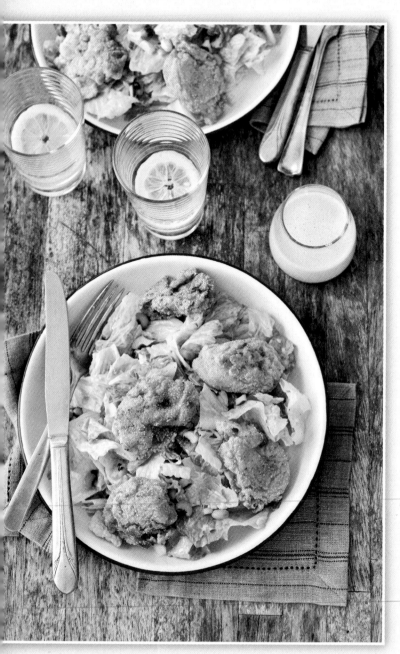

Dressing on the oyster Caesar salad
was added right before capture to
ensure that the salad stayed looking
fresh, even when dressed.

f/5.6, ISO 160, 50mm L

And when it's time, apply the dressing by either spooning it on or drizzling it with a squeeze bottle. Be sure to notice the effect of the light on the dressing and make any adjustments necessary based on whether or not you want the light to enhance the highlights produced by the oil.

The caption for the photo on the left may sound naughty, but everything's quite wholesome in this picture! It's the exact salad my young intern had dressed before I was completely ready for capture. And instructions were that it needed to be fully dressed for the photograph. All that scrumptious Caesar dressing couldn't be left on the side! But you can bet that within 15 minutes of finalizing the lights, exposure settings and composition … and styling the finished plates, the leaves of this salad had started to wilt. That fast!

I styled the Roasted Vegetable Salad shown on the right without dressing. Only after I had prepared my camera settings, positioned the props and styled the food did I add dabs of vinaigrette where I knew the light would hit it slightly. The salad already had lots of

colors, shapes and textures, so too much oil in the vinaigrette would have given off too many highlights, and this would have distracted focus from the main dish. A little oil goes a long way.

Sauces of all kinds are a great way to add some very easy and appealing styling to your final dish. If a recipe calls for a sauce to be made and mixed in with the food itself, you can decide to mix a little in the dish and set some aside, so that when the plate is styled and ready for capture, more can be drizzled on top. Or, you might hold off on mixing in any sauce until you're completely ready to style.

Waiting may be especially beneficial when working with acidic sauces, because they will start cooking the food right away. Just make sure that your sauce is visible in the image and that the natural coating of the sauce looks as fresh as possible. Also consider using the set-aside sauce as prop in the composition, as shown in the Oyster Caesar Salad shot on the previous page.

When plating a dish for which a sauce is a garnish and does not get mixed into the food, a stylist has lots of creative options. You can dot, dab, drizzle, coat, spoon

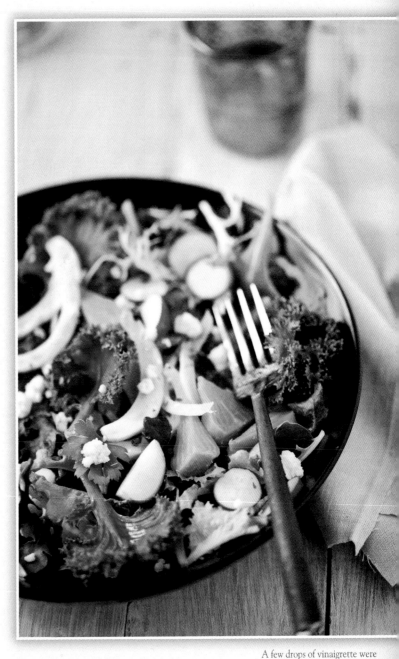

A few drops of vinaigrette were added to this roasted vegetable salad just before capture to prevent it from wilting.

f/2.8, ISO 400, 100mm, Macro L

Here are a few examples of sauce designs that can be used to add visual interest to plated slices of cheesecake.

f/4.5, ISO 250, 24-70mm, L

and pool at will! Often, a recipe will indicate what type of sauce to use as a garnish. This will read something like:

Serve with chocolate sauce.

Raspberry sauce suggested.

And there are times when you, as the food stylist, must put your thinking cap on and go beyond the recipe to see what could naturally enhance your setup. Ask yourself some questions, such as:

Would this tart be served with vanilla sauce?

Would dots or a pool of raspberry sauce look better with that cheesecake?

I began preparing the shot on the left by following the instructions in the recipe. It said to plate the cheesecake with a pool of raspberry sauce. And it looked fine when I did this. When I moved onto another plated slice, I squeezed some dots, and that looked a bit more fun. One slice was left without sauce and, of course, it looked pretty bland, so I added some cut fruit to the top. On the final slice, I played with a little melted vanilla ice cream in the raspberry sauce. The results of using my imagination were much better than the look I started with.

So unless you're under strict instructions to use sauce in your styling in a particular way, don't be afraid to let your imagination run wild. Style the recipe in a way that you think works best.

What I love most about sauces and jams is how wonderful they are as props. As I mentioned earlier, I always reserve some of the sauce in a dish to refresh a plate right before capture. And if the dish includes a dipping sauce or a sauce to be used tableside as a topping, definitely use it as a prop. Set a small dish filled with the sauce in the scene, so viewers can identify it right away and put it in context with the name of the dish. This is especially helpful for event photos, menu pictures and images that correspond to a featured recipe.

In the picture of the Strawberry Jam Swiss Roll, I knew it would difficult to identify the filling as strawberry jam. From the color alone, it could be any red berry jam. So I included the jar and fresh strawberries as props.

The pomegranate seeds, by the way, were just used as a garnish; this ingredient was not part of the filling. It was a stylistic choice. So here's a reminder that elements aside from those used in the dish can be used as garnish, too.

The jar containing the jam used to fill this Strawberry Swiss Roll is used as a styling tool to suggest it was the one used in the filling.

f/3.5, ISO 200, 24-70mm L

This Panna Cotta is topped with whipped cream for a fabulous finish.

f/3.5, ISO 320, 24-70mm L

At this point, I have a Pavlov reaction when it comes to reaching for whipped cream to finish off a sweet setup— whether it's in a recipe or not. Nine times out of ten, I'll also set aside some in a little container to be placed somewhere in the frame. This adds such a quick and simple touch that it has fast become one of my go-to food styling methods.

In the case of these Panna Cottas, I made up the recipe in my head by combining two of my favorite recipes: rice pudding and panna cotta. At the time of this shoot, I hadn't thought much about the styling. I sketched a few compositions in my head and, when I started to style the desserts and work on my frame, I realized something was missing. I couldn't quite place my finger on it.

I needed a garnish to give the dish a bit more texture, shape, taste and color. After deciding on cocoa nibs, I found that they showed better on the chocolate panna cotta if set against whipped cream. And this setup worked perfectly against the white insides of the porcelain cups. The chocolate color, the white of the whipped cream and the little specks of cocoa nibs created a nice, balanced look.

A word of advice: Before you add a sauce, dressing or jam to your dish, first see if it gives the food more substance or if it seems to hide it behind a mound of extras. Remember to keep the primary focal point on your main dish—not the garnishes.

The Main Dish

Of all the foods I most enjoy styling, savory dishes rank among the highest. And that's not something I thought I'd ever say. My first steps on this career path were taken when I was working at a restaurant and I began styling desserts. At home, I started writing my blog, which initially centered on desserts, and I was never certain I'd enjoy styling meats and fish, stews and soup. But then I started practicing on a few things like quiche and pizza … and found the process actually quite enjoyable. But it wasn't until one of my first pro jobs that I really found love for the big dish.

I was working as a food stylist on a feature dedicated to oysters. And thankfully, the photographer had such a natural and genuine approach to food photography that it clicked. He loved textures, shapes, colors; his photographic process was calm, and he was respectful of the dish. In those ways, he had the same approach to savories as I had to sweets, which lifted my concerns about how to handle savories.

It was just one of those hang ups for me; I didn't think I could do it very well. But the only way to know for sure was to get my hands in there and try. The photographer on that oyster project made me realize that a steak, an oyster or a pizza … is what it is. There's nothing to be intimidated about. I learned that I can't change the nature of the dish, but I can use simple techniques to make it look fresh and at its best without compromising its edible qualities.

Fish and Meats

With that insight, I was able to calm a nervous intern I was working with on a feature that required us to style Teriyaki Chicken and Steak with Bourbon Cream Sauce. When I told him about the project, he got a terrified look on his face. In an effort to diffuse his fear, I said, "Don't worry, we don't have to catch and pluck the chicken or capture the cow!" But that didn't help much.

At first, you might wonder what to do with this dish after putting it on a plate with a couple of side dishes. In fact, if there was a Scout Club of Stylists, making meat and fish look appetizing in a photo would be worthy of a badge of merit.

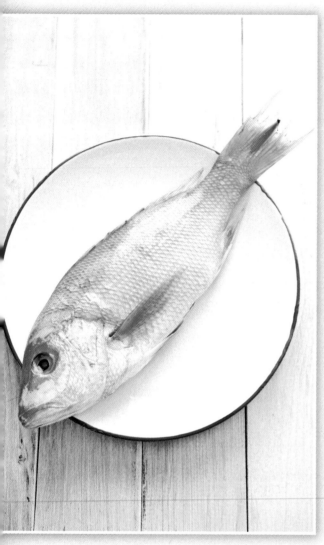

I focused on the color and shape of this fresh red snapper to guide the styling process.

f/4.5, ISO 400, 24-70mm L

Fresh whole fish, for instance, have great shapes; roasted chicken has beautiful golden brown skin to feature; and grilled steak offers nice markings to put forth in styling. But I'm only touching the tip of the iceberg. By focusing on one or two qualities of the item to be styled … whether it's whole, cut, raw or cooked … you can find a great angle to make them look irresistible.

When you need to style raw fish or shellfish, make sure to get the freshest pieces you can find. Make friends with the local fishmonger and do not be afraid to ask to see as many pieces as necessary. It doesn't matter how crazy you appear to be when selecting your fish. You don't want someone looking at the photograph of the fish you style and wonder when it was caught.

For instance, the red snapper in the picture on the left was caught on the day it was styled and photographed. I put the fish in the composition and spritzed it with some water. Then I took a couple of shots to adjust my camera settings. That's right, even with the freshest, most delicious food—especially with the best cuts—it's critical to make sure that your camera is ready to create the most flattering image possible. There are always minor adjustments you'll need to make once the food is on the plate … to handle shadows and reflections, so be sure to take the time for your settings. Then spritz more water on the dish and snap your capture.

If your responsibility is to style a grilled fish (or other meat) that someone else is cooking, ask to see several different pieces, and pick the one that's closest to perfect for your shot. For example, I was documenting my summer trip back home to Provence through

photographs of the food my family prepared during my visit. And the stylist in me couldn't help but meddle. I inspected all six of the fish plates that were grilled that day, and I picked the one with the best grill marks. I styled the plate with a couple of sides to add height and color.

If you're the one grilling, take your time and oil the whole fish a little, so it won't stick to the grill. I often see professional food stylists fix or apply grill marks with a heating element after the fish or meat is cooked. This is something to keep in mind if you don't naturally get the look you want.

Like a Fish Takes to Water

When it comes to fish—raw, steamed or poached—water is your best friend. Apply just a little to freshen the look of your dish.

Throughout the shoot, this Poached Cod with vegetables was freshened up with a few spritzes of water to keep it looking fresh and moist.

f/3.5, ISO 400, 100mm, Macro L

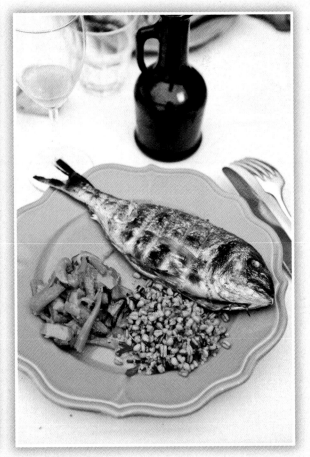

When photographing whole grilled fish, select the best-looking one you can find.

f/4.5, ISO 100, 24-70mm L

Here are the two protagonists in their pre-styled stage. The potatoes were randomly spooned into the pan.
(upper left)

f/4.0, ISO 400, 100mm, Macro L

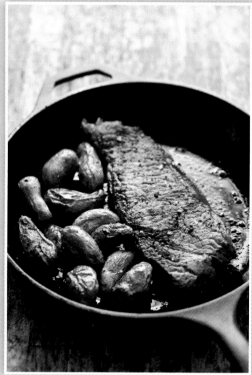

A few potato pieces were moved around to fill little holes that would appear darker (and thus stronger) in an image.
(upper right)

f/4.0, ISO 400, 100mm, Macro L

I added a sprig of rosemary while sautéing the potatoes. This serves as a natural prop to emphasize this enticing ingredient of this dish.
(lower left)

f/4.0, ISO 400, 100mm, Macro L

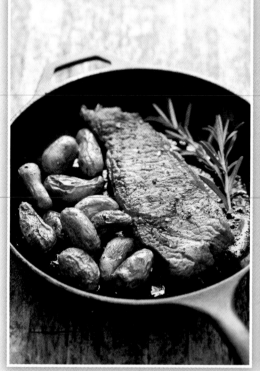

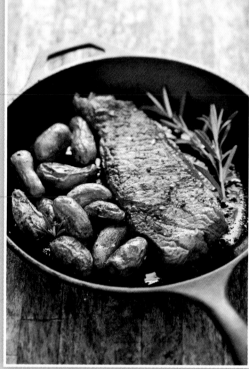

Alas … the styled plate, ready for capture. I balanced the setup with another leaf of rosemary tucked in the potatoes. Voilà … dinner time!
(lower right)

f/4.0, ISO 400, 100mm, Macro L

Styling meat can be intimidating. So I recommend using the following styling techniques to take your fillets or slices from ho-hum to wow. To start, let me show you how even the simplest plate of steak and potatoes can be quite sexy with a little care.

When styling a whole freshly sautéed steak, like the rib eye in the group of photos on the left, the best approach is the simplest. I kept the steak in the pan because I liked the rustic look of it, but feel free to set it on the plate. To keep the shine on the steak, I photographed it with the light in front me (back light) rather than lighting it from the sides.

I need to give credit to my friend and food stylist Angie Mosier for the styling idea for the steak shown on the right. We worked together on Virginia Willis's second cookbook, and I loved her idea of this bistro styling. The paper table runner and the wine marks on the paper cloth make it complete!

I cooked the steak medium rare so there'd be a difference in color between the core of the steak and its edges. And I let it sit the recommended ten minutes to avoid having juices running all over the place. The steamed vegetables add color to the plate.

To slice steak, get a sharp knife and cut across the grain. Arrange the cut slices in a way that's appealing to you. If you're unsure, cut half of the steak and fan slices on the plate. This is always appealing to the eye.

Use the Best Tools

When it comes to food styling, the quality of your tools will heavily influence the quality of your work. Sharp knives, high quality cookware and bake ware, and other appropriate equipment are critical. Do not put yourself in a position to worry about a dull knife ruining your edges or a cake sticking to the pan. Substandard tools can ruin the best conceived setup.

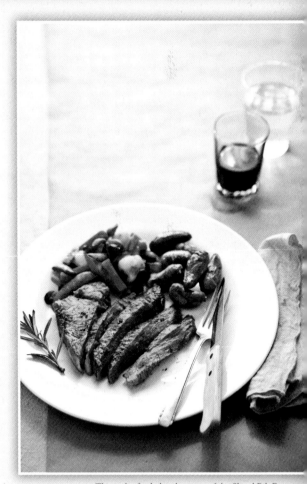

This is the final plated version of the Sliced Rib Eye Steak dinner with added vegetables for a nice color pop.

f/3.5, ISO 400, 24-70mm L

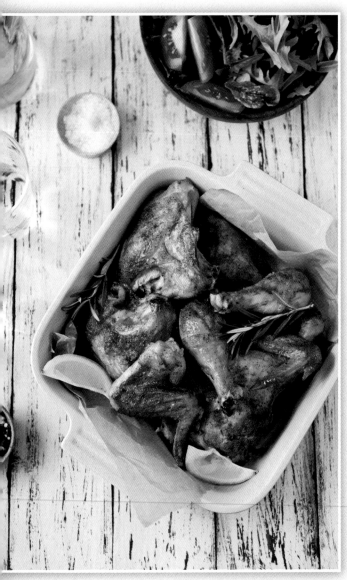

Chicken pieces come in all shapes and sizes.

f/3.5, ISO 320, 24-70mm L

Until now, the meat items we've seen have had a very even look. But let's say you're in charge of styling pieces of roasted chicken on a serving dish. The styling challenge is making them fit together in an aesthetic way.

The unspoken goal is to ensure that the reader can tell a drumstick from a breast, which becomes difficult if the pieces are piled on top of each other in a haphazard way. So resist the urge to cram the entire chicken in the serving dish. With so many naturally occurring shapes and sizes, this dish offers you plenty of opportunities to arrange the pieces in a pleasing manner.

When composing the picture on the left, I placed one of each piece of chicken in a dish and checked to make sure it would work with the size of my dish. I didn't want to have lots of empty spaces that would distract a viewer's eye from the chicken itself. Nor did I want to hide the colors and shapes of each part. So as more pieces were added, I arranged them so the most easily identifiable ones (e.g., wings and drumsticks) would be visible right away. This would let viewers know that it was indeed a bird in that dish.

Ingredients from the recipe, such as lemon wedges and rosemary, completed my styling and filled gaps created by the shape of the chicken pieces. An overhead shot provides a nice view of the completed setup.

When you have foods with naturally interesting shapes, build your setup almost one piece at a time to make sure a person looking at the picture can figure out what they're seeing.

Stews, Stir Fries and Pasta

Gooey, goopey, mixed up foods … Nothing can better show how all the aspects of food photography come together to create a great image as much as stews, stir fries and pasta. And I really enjoy styling dishes of the sort. They push my comfort zone as a stylist and challenge me to use all the aspects of food photography—from light source, perspective and focus selection to composition, props and food styling. I can style the same type of stew several times in a day and always find a new way to make it appealing.

When getting started, as previously advised, be sure to read through the recipe several times to mentally flag herbs and spices that might help with styling. Also pay close attention to the shape of the vegetables and meat. Focus on keeping them as intact as possible to enhance the overall look of your final setup. Indeed, now is the time to recall everything we've covered so far … and put it all together.

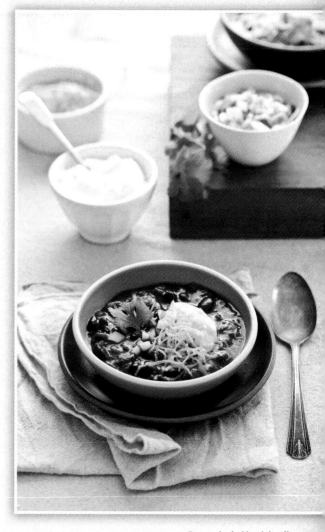

Goopey foods, like chili, offer a food styling challenge.

f/5.6, ISO 400, 100mm, Macro L

When pouring the chili for the picture on the right, I was careful to stop just short of the desired amount. This gave me enough room to spoon some of the beans out and heap them a bit on top to give the chili some texture on the surface. I then made full use of all the traditional garnishes, like sour cream, cheese, red onion and fresh cilantro.

To keep them as fresh as possible, I kept the chopped red onion and cilantro under a wet paper towel until I was ready to add them. And I deliberately sprinkled them off-center to reveal more of the chili's texture and provide a visual point of interest. It also added some freshness to the setup.

The diffused back light enhances the surface shine and better defines the shapes of the ingredients in the dish.

When styling uniformly colored food such as Shells & Cheese, focus on shape and texture.

f/4.5, ISO 400, 100mm, Macro L

Monotone foods, such as Shells & Cheese, can be daunting to style, because there are no varying colors or shapes to work with. Instead, focus on the shape and texture of the noodles.

For the shot on the left, I made sure to cook the pasta just until al dente, so it retained a good consistency that ensured the dish would look anything but mushy. I plated it within five minutes of the sauce being mixed, and I had my camera settings and light ready to go. I did not use any herb garnish, but focused instead on props of complementary colors—blues and greens.

I carefully spooned the shells into the bowls and checked for any large empty spaces. Again, while not unattractive by themselves, empty spaces tend to absorb the light and create deep shadows. Fortunately, pasta can easily be moved with a spoon or a pair of chopsticks to fill gaps and adjust the overall styling.

Styling Grilled Salmon Pasta

In the photos of Grilled Salmon Pasta, a dish without tomato sauce, it's easy to see the styling steps, which apply equally to a simple plate of spaghetti and meatballs. It's a building process:

1) Boil the pasta until al dente.

2) Drain the pasta and drizzle it with olive oil.

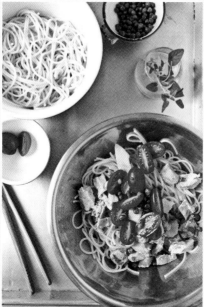
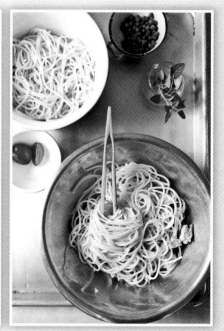

Pasta and salmon are in the bowl. No
tomatoes or capers have been added.

f/5.6, ISO 250, 24-70mm L

Tomatoes and capers are
added to the bowl.

f/5.6, ISO 250, 24-70mm L

All the ingredients are being mixed ... and fall to the
bottom. The stylist will work his/ her magic to make
it all visible and appealing.

f/5.6, ISO 250, 24-70mm L

3) Return pasta to the pan and cover with a kitchen towel off the stove.

4) Grill the salmon and set it to the side to cool.

5) Separate salmon into large chunks.

6) Cut tomatoes.

7) Set out garnishes: capers and oregano.

8) Begin building your dish.

For this dish, styling can go two ways.

* You can place some spaghetti on the plate and then position
 the tomatoes and salmon with your fingertips or tweezers. Eeh …
 Call me hippy stylist, but this just doesn't seem natural to me.

* The other option is to mix the ingredients together and spoon some of
 the pasta onto the plate. See where the ingredients land naturally. Then,
 adjust any tomatoes or salmon pieces that fall to the sides and bottom.

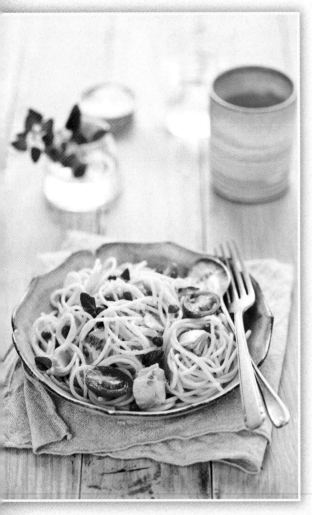

Here is the final styled version of the Grilled Salmon Salad.

f/3.5, ISO 250, 100mm, Macro L

Either way, take a step back and move a few pieces here and there to guarantee that with one look, a viewer will see all the components, know what the dish is and understand what to expect from it.

I recommend using tongs to style pasta. Grab hold and give your wrist a little curl as you place the pasta on the dish. Give the noodles room to naturally fall by moving it onto the plate in an arc that peaks at about your chest. This will boost the volume to add more shape to the finished dish.

Looking at the final styled dish (left), I wish I could move that piece of salmon that fell to the base of spaghetti right in the front. It never ends… !

Burgers and Sandwiches

I'll always remember the first time I styled a burger for a cookbook. To prepare for the shoot, I went online and looked at a bunch of pictures to get a feel for how burgers could be styled. On the shoot, I knew I wanted to use techniques that are natural to the home cook—the folks who would be replicating the recipes based on the photographs. I did not want to cheat their trust by using gimmicky styling methods.

How-To Resources

Flickr.com or a broad image search on Google for *burgers* will reveal plenty of variations on the theme. A search for *how to style a burger* on YouTube will give you access to informative how-to videos by professional stylists. There are also some helpful books, including *Food Styling: The Art of Preparing Food for the Camera* by Dolores Custer, that offer great tips and techniques on this subject, too.

To achieve this, I paid close attention to the recipe I was illustrating … and prepared the burgers as directed. I even grilled the patties without pressing down with the spatula, just as the recipe advised, until they were medium rare in the middle. This helped the burgers stay moist.

While allowing them to rest (like a steak), I prepared the rest of the ingredients. I kept the tomatoes under wet paper towels so the edges would not dry, and I spritzed the avocado with lime juice to keep it from oxidizing. I picked out the best-looking lettuce leaves and placed them on a bun. I held the lettuce in place with a couple of toothpicks so it would stay in place while I built the burger.

After placing the beef patty on the lettuce, I removed the toothpicks. Next came the avocado, tomato, cheese and top bun. I purposely didn't add the mayonnaise to the bottom bun, because I knew it would not show well after everything piled on. Instead, I used a squeez bottle to apply some to empty areas on the letetuce. I also dabbed a bit of oil on the patty to freshen it up a bit.

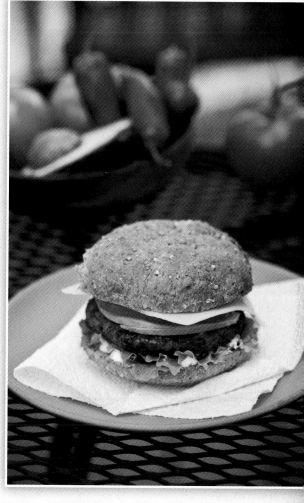

The final styled and plated version of an all-American Burger tasted as good as it looks.

f/4.5, ISO 100, 100mm, Macro L

I admit that mid-way through the shoot, I switched out the tomato and avocado, because they had started to dry. But as soon as that shot was in the bag, so to speak, I sat down at that table and ate my burger! Yes, it was as tasty as it looks.

Stick It

If the layers of your burger are not staying in place as you build it, use a few toothpicks to secure them for your photo. Just remember to remove them before you chomp down.

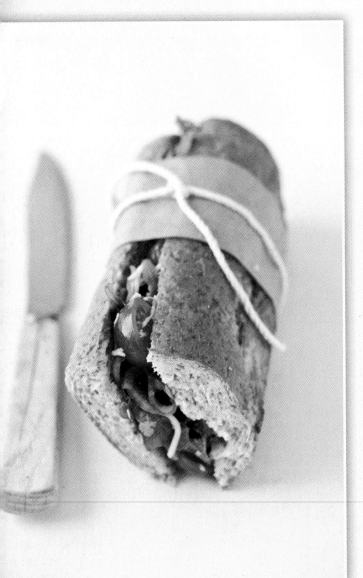

This image of an Italian Style Veggie
Baguette uses minimal props and
focuses entirely on the sandwich.

f/5.6, ISO 200, 100mm, Macro L

To illustrate the Italian Style Veggie
Baguette recipe, I had to follow the
recipe to a T and ensure that the
photograph did not mislead anyone who
tried to make the dish for him/ herself.

The recipe called for very little spread
to be applied to the sandwich halves,
and I knew this would not show well
on the finished product. So I made
a little extra spread and put it in a
ramekin to place on the side of the
plate. In the end, it wasn't crucial to
the composition because I decided use
minimal propping and focus entirely
on the sandwich. The ramekin would
have been distracting, so I left it out.

After I spooned the salad onto the
sandwich and closed it, I held things
in place with a few toothpicks. This
allowed me to adjust some of the
ingredients with chopsticks without
destroying the entire sandwich. I
pulled forward some red onion and a
couple of tomato halves to interrupt
the mass of greenery from the salad.

The serving suggestion was to wrap
the sandwich in tinfoil or parchment
paper until ready to eat, so I wrapped
mine with band of parchment paper
and held it together with kitchen string. Thus, anyone reading
the recipe and looking at the sandwich would get a good view of
what was going on inside. And the tie-around bands retained the
idea of portability.

Nothing about styling foods of odd shapes or with fillings
is complicated. You just need to think about how to best
illustrate the recipe. Simplicity is key.

Breakfast Baked Goods

It might seem easier to style pancakes or a muffin than a bowl of soup, because breakfast baked goods tend to be visually more appealing. But just as it is with soups or meat, these foods do present some challenges of heights, colors and shapes. Some of those challenges can be solved with composition and prop styling. Others will require a little fiddling to make stomachs growl. Breakfast baked goods require an equal amount of focus and care as their savory counterparts.

When I openly ask people to divulge the item(s) they most dread to style, many … *many* … answers relate to brown bakery or breakfast items, such as muffins, pancakes and waffles. Let's see if I can help.

As with anything you're styling, always take the time to select the best-looking items available, particularly the foods that will be the most visible in your image. If you're working with pancakes or waffles, try to pick ones with a nice golden brown color, and make a stack of some that are roughly the same size. No worries if there are irregular edges in the bunch; this actually adds a bit of texture to the overall look.

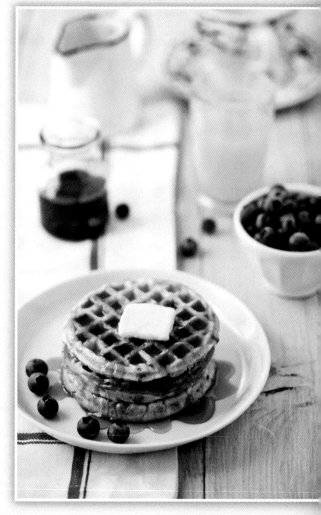

These Blueberry Waffles look as if they were right off the waffle iron.

f/3.5, ISO 250, 100mm, Macro L

If you're styling a recipe that includes berries or nuts, you're set regarding natural propping and food styling. If not, focus on elements that usually accompany pancakes and waffles, like a dab of butter and syrup.

When setting up this photograph of blueberry waffles, I set aside some blueberries to use as styling props. Once the waffles were stacked, I placed same of these plump berries at the base of the stack and added a dab of butter right on top before pouring syrup around it and over the waffles.

Colors and natural props were important styling tools for these Cinnamon Streusel Muffins.

f/3.5, ISO 250, 100mm, Macro L

These waffles were room temperature, so the butter didn't soften at all on contact. To keep it from looking too "clean cut," I placed a hot iron over the square until it started to melt. And since I wasn't going for an action shot of syrup being poured, I started with a little bit and took a few pictures. Then I added a little more and took a few more shots. I did that three times total to see which image looked best. The second version was my winner—not too little and not too much syrup … just right!

In context of your item, think about what color scheme and props would work best, and consider what natural props you can use. Build your frame from there.

So if your muffins contain fruit … as in blueberry muffins … add some fresh blueberries to the scene. Less obvious are muffins that have interesting toppings, like streusel and nuts, which can be bit difficult to show off. So think about what's most appealing about the item and focus there.

If the filling seems particularly interesting, think about cutting the pastry in half to bring the focus to that. If the shape is more appealing than anything else, leave the muffin whole and find a camera angle that enhances the styling. An

eye-level view or a close-up shot, for example, won't require much composition or styling and will put the focus on the item alone.

If the topping consist of nuts or crumbs, like streusel-topped pastries, check to see if there are areas that look nicer than others—more nuts, more golden brown color. It's perfectly fine to use your fingertips or tweezers to fill in unattractive gaps.

There was no filling in the cinnamon streusel muffins shown on the left, and the main ingredient was cinnamon, which can be tough to show when grounded in a dessert. And because the muffin had no color except its natural soft beige, I decided to bake them in pretty gingham cupcake liners. This use of color contrast toned down the brownish color of the muffins but kept the focus on the item as a whole … not just the topping.

I made sure to pick the best-looking muffins of the entire batch for my photo. To convey that cinnamon is the main ingredients in the recipe—and to give this image some other sensory perception, such as smell and taste—I placed some pieces of whole cinnamon in the scene. Looking at the frame before taking the picture, I noticed that the sticks were naturally pointing toward the muffins, as if they were arrows giving direction. It was not intentional, and it didn't look too staged, so I left them in place and took the shot.

Some photographers and stylists have a natural ability to work the lines of a frame to help support their composition. However, knowing how to use leading lines in a picture can add to the message you are trying to convey. The notion of leading lines is a concept in art that uses natural lines in a scene to lead a viewer's eye to a specific point or to add a natural and pleasant flow to the composition.

No matter how small or big your dish is, keep nearby a few important tools:

- Cotton swabs to wipe spills and smears
- An offset spatula to re-apply frosting or fix an area that's not smooth
- Pastry bags and tips to mend a cake that has specific frosting decorations
- Tweezers or chopsticks to move items on the dessert itself

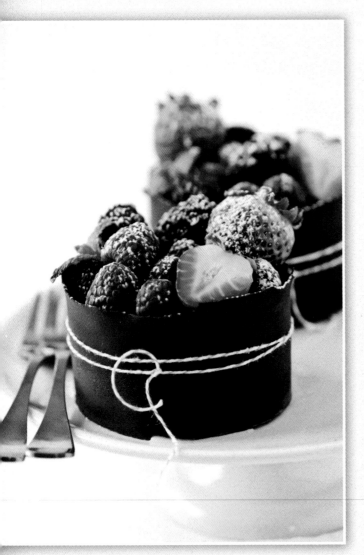

This chocolate cake is wrapped in chocolate ribbon and topped with fresh berries. The setup offers great visuals but requires attention to the details.

f/3.5, ISO 200, 100mm, Macro L

Desserts

Desserts—big or small, cut or whole—offer a wide variety of styling options. Some people find that whole cakes are difficult to make look appetizing, and others will be driven to the brink by a slice of apple pie falling apart on a plate. There is always a solution or a technique you can use to make desserts look as appealing as they should be.

Cakes

When styling a whole cake, regular or mini sized, don't stop working after you find the right props and backgrounds. Dig deeper and look for garnish ideas—key ingredients, sauces, accompaniments and decorations—to make sure your styling and composition fully tell the story of your subject.

The recipe for the flourless chocolate cakes (left) yields four small individual cakes. The instructions did not include any particular styling suggestions, so I figured a few berries and some mint would look good with chocolate.

To style the cakes, I decided to wrap them with a chocolate ribbon to add both an element of creativity and style and to hide the air pockets that naturally occur during the baking process. Ask any pastry chef and you'll hear that moving chocolate ribbons from the work surface to the outside of a cake can feel like a game of luck, because there's a always the chance that they'll break before being fully applied to the cake. I wasn't sure that my gamble would work, so I focused on the topping and made sure to use the freshest berries I could find. I also used another one of my favorite dessert accompaniments: a dusting of powdered sugar.

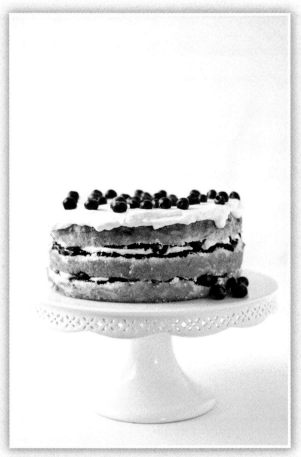

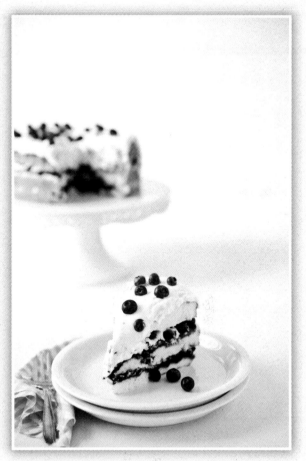

A whole Blueberry & Cream Cake was styled as simply as possible to emphasize its height and shape.

f/3.5, ISO 200, 24-70mm, L

Style a slice of Blueberry & Cream Cake to show the inside of the dessert.

f/3.5, ISO 200, 24-70mm, L

If you're working with a cake that does not need to remain whole, photograph it as a whole and then as a slice. You may be surprised at which photograph you end up liking best. Keep an open mind to learn new techniques during the course of your projects.

The two pictures above show the same cake presented in two different ways. The goal was to show it as the recipe intended—majestic with all the whipped cream and fresh blueberries—and then to show how it looked inside.

From a food stylist perspective, getting the inside shot turned out to be a major headache because of the soft consistency of the cake. Situations like this are

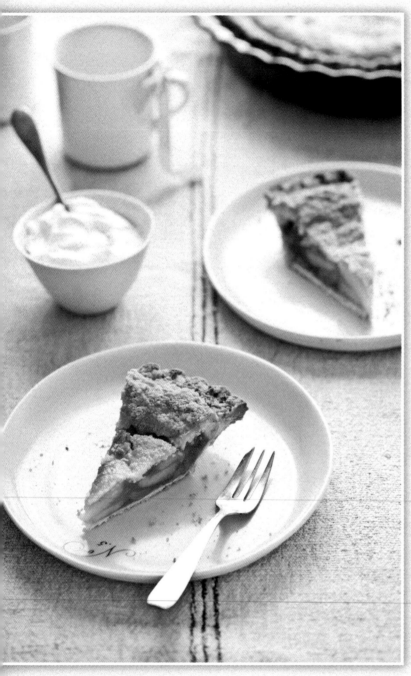

Styling a slice of pie is always a bit challenging, especially when working with a soft filling like the one in this apple pie.

f/4.5, ISO 400, 100mm, Macro L

why I recommend always being armed with the right tools. It'll give you the best results for your work. Yet even though I used a sharp hot knife to cut through the Blueberry & Cream Cake, it didn't turn out so great. The slices were very soft, and both the cream and blueberries ran out on the sides, making the slices look more like a big spoonful of fruit and cream than a neatly cut slice of cake.

That was the inevitable result due to the cake being so soft and creamy. Yet I knew styling this slice would be my saving grace. It would be better than trying to cut another. And yes, it took a bit of work to clean up the edges of the cut slice, but I didn't clean it perfectly, because I realized it would be almost impossible for a person making this at home to get a clean cut.

I added a few blueberries to the base, and since the cake was a bit of a mess … with all that cream and fruit … it was okay to leave it imperfect. I think it made the scene more real and accessible to people reading this recipe.

Pies

I'm often asked for my best styling tips regarding pies. Well, when it comes to individual tarts or mini pies, I always suggest using some of the fruits in the recipe as natural garnishes if possible. And you really can't go wrong by adding a sprig of mint and a dusting of powdered sugar or cocoa powder.

Yet when it comes to styling *slices* of pie, such as the typical apple or cherry, it's a different ballgame. And right off the bat, know for certain that your refrigerator is your pie-slice styling best friend.

If you can prepare the pie you want to shoot one day ahead, you'll be much better off. I promise, no matter what the intended use of the picture—blog post, magazine feature, postcard or fun—you'll be glad if you can refrigerate the pie once it's cooked. This will firm up the filling, so you can cut a slice with a bit more ease … without it falling apart.

Similar to the first crepe or a first batch of pancakes, never count on the first slice of pie to be the one you use. Instead, make incisions for two slices with a sharp knife. Remove the first slice and then get the second one by sliding your spatula from the center out while gently holding the crust with your fingers. Set the slice on your plate and check for any falling pieces or crumbs that can be easily picked over with your fingertip or a toothpick.

If you can't refrigerate the pie overnight, make sure it's at least cooled to room temperature before slicing it. And if your plated piece isn't ideal in the looks department, consider a wide shot that includes the table and the remaining pie. A close-up may not be the best option for a warm oozing pie.

Ice Creams & Frozen Treats

Someone asked me once if I used mashed potatoes or chocolate-colored clay to mimic ice cream in my shots. I don't. The type of photography I've been doing so far does not require me to use this technique. But I know a lot of commercial stylists who must, because their shoots require long hours of stand-ins that would not be possible with the real thing. Ice cream and frozen desserts are challenging, yes; but I believe that every food item comes with its own challenge. So with an understanding of some basic yet important techniques and steps, along with focus and preparation, you can get great-looking ice cream shots, too!

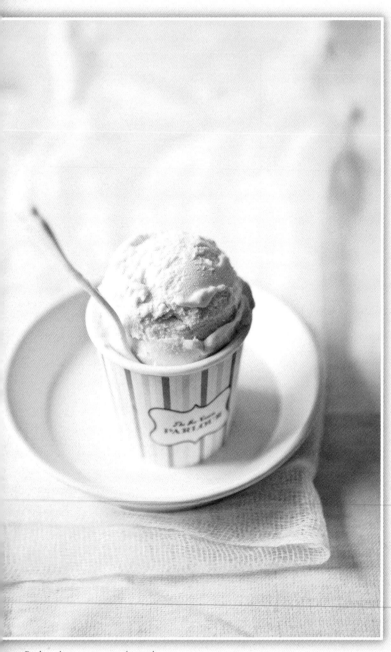

Replace the ice cream stand-in with
the real thing before finalizing styling.

f/3.5, ISO 400, 100mm, Macro L

As a food stylist, there are some simple things you can do to make ice cream last longer on your setup. The first thing is to lower your freezer temperature by five degrees to give your subject an extra cold edge. Then, scoop out four or five servings of ice cream and place them back in the freezer on a parchment or wax paper for about 20 minutes. Take this opportunity to set up your camera and finalize your composition.

Some like to freeze the bowls or cups they'll be using to plate the ice cream. And this works great, too. Just pay attention to frost that develops on the glass or cup as it sits at room temperature. If this is a look you like, then it's perfect. If not, arm yourself with a paper towel and be ready to wipe.

In the photo of the Raspberry & Vanilla Lollipops, the ice cream was poured directly into the glasses after being made, and it was left to freeze until solid. When the shot glasses came out of the freezer, they got frosty and it was difficult to see that there was a red bottom layer. I liked some of the frost effect, but I ended up scraping the glasses every so often to show the different layers.

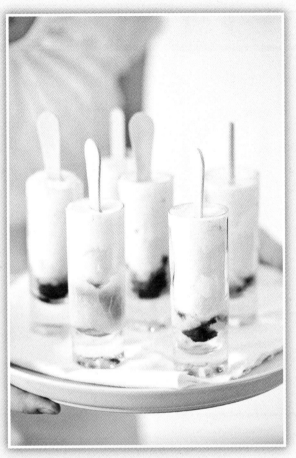

These Raspberry & Vanilla Lollipops are still in shot glasses, showing frost, to indicate they were frozen.

f/3.5, ISO 125, 100mm, Macro L

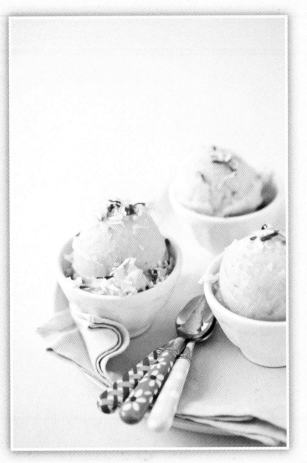

When styling this Pineapple Sorbet, I made sure to not let condensation droplets ruin the linens underneath.

f/3.5, ISO 200, 24-70mm, L

For the photo of Pineapple Sorbet, I did not want to wipe down the bowls, because the art director had determined that we already had enough shots with a frosted or dewy look. Yet I still needed to keep things cold. It was fairly warm in the studio that day, so I decided to freeze the tray on which the bowls would set. The towel underneath the tray was an integral part of the prop styling, and I did not want to run the risk of getting water stains on it due to condensation. So I covered this portion of the tray with a layer of plastic wrap. This actually worked very well and held the cold air between the tray and the bowls.

So keep in mind that you can use a variety of means to keep things cold—such as freezing containers and props—to prolong the life of your ice cream scoops.

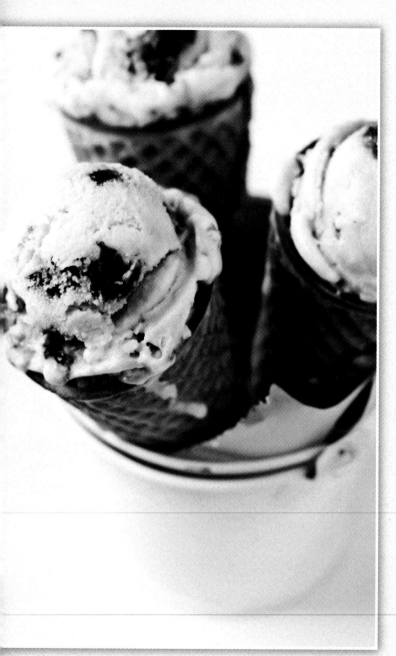

This scoop of Coconut Cherry
Ice Cream is soft on the edges.

f/5.0, ISO 100, 100mm, Macro L

Yet there is one aspect of making and freezing scoops ahead of time that's not ideal. It's that they become rather stiff and lose that freshly scooped look. When one runs an ice cream scoop inside a container to form a nice rounded ball of ice cream, the edges get a bit softer than the rest of the scoop.

The following techniques can fix this easily:

◈ Take a drinking straw and gently blow on the edges of the scoop to create a more natural look. The warmth of your breath will soften the edges if they look too hard after the scoop is placed on a cone. But only do this a little bit at a time, because once the ice cream is melted, you can't really fix it. If you don't get your shot shortly after doing this, you'll need to start over. This is why you want to have more than one scoop ready.

◈ Place the scoop in the bowl or cone and wait a couple of minutes. Then take an ice cream scoop and gently press it over the ice cream to push the edges down and to the side. This one, used for the picture above, is my favorite.

Cones or bowls? The choice of how to contain your ice cream depends entirely on the look you need to create. If you're styling and photographing ice cream for yourself, you can decide ahead of time what scene and mood you want to convey—or not. But if you're working on a feature for someone else, all that's probably been decided. If you're unsure, I suggest shooting your ice cream with both a cone and a bowl if timing allows. You just never know what will end up working best. I've been on a job for which we had decided to go with a bowl, but the ice cream looked better in a cone. Go figure.

The same goes for different kinds of cones and how many scoops. You just need to know what look you're trying to achieve. There are techniques specific to handling wafer or sugar cones. An odd number of scoops is always nice but not always manageable. Just try to style the top scoop really well.

When shooting the picture of the Strawberry Ice Cream Cone, I placed a piece of crumpled paper towel inside the cone to create a buffer and prevent the bottom of the cone from becoming soggy. This would have made it hard to handle the cone when the ice cream began to melt. Once stuffed, I put ice cream inside the cone, up to the rim, and placed

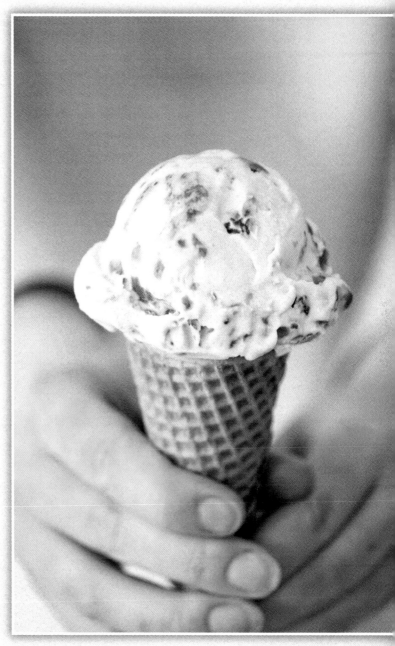

A few little tricks went into styling this Strawberry Ice Cream Cone. Keep reading to find out!

f/2.8, ISO 200, 100mm Macro

213

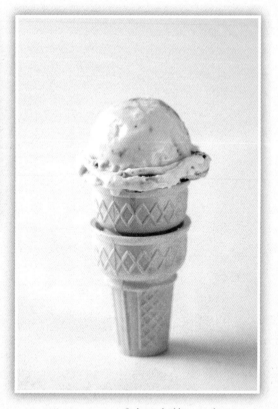

Handle a Sticky Situation

If you ever need to make things stick, think first of natural substances, especially those that make it easy to hide the connection: honey, mashed potatoes, mashed bananas, cream cheese. These foods work great. But also keep in mind that there's no shame in using a small piece of double-sided tape to hold things steady!

my best scoop on top. With the straw technique described above, I gently blew on the base to create a soft edge.

In the picture on the right I was styling a single scoop in a double cone for a stand-alone shot. The weight of the ice cream made the cone tip slightly every so often, so I resorted to sticking the cone in a dab of honey directly on the table.

Styling a double cone of ice cream is much more than just stacking scoops.

f/4.5, ISO 200, 100mm Macro

Hot and Cold Beverages

I remember the day I told a stylist friend of mine that I had agreed to photograph beverages for a friend who was starting a coffee shop. His response—"Well, good luck with that!"—should have made me pay closer attention.

He was right; that shoot was no breezy walk in the park. But he was wrong too; luck has little to do with it.

While you may get a perfect photograph of a steamy hot cup of coffee one day when you're out and about, luck really doesn't have a role. *You* made it happen by being ready at the right time and not allowing the coffee to get cold. You were attracted to the light steam color against the type of light that was making it visible to you. Similarly, at home or in a studio, you have to be sharp to catch nice drips of dew on a cold glass of beer or the steam coming from that hot cup of cocoa you're styling.

Stemware

If you work with hot beverages a lot, white ceramics work well because they provide a good contrast with the dark of the liquid, especially coffee, tea and hot chocolate. But if you need to show that a beverage is cold … and show the dew, frost or ice … a clear or light-colored container will usually work best. Try using back light and work from the shine it puts on the glass.

Hot Beverages

When styling steam, you have but one thing to do and it is to *be ready*! It's important that both camera settings and composition are ready when the steam starts rolling.

Use back light to see steam more clearly, and pick a dark or contrasting background. Pro stylists working on commercials and advertisements can't always rely on naturally occurring steam, due to the circumstances dictated by the photo shoot itself. That's why they'll often use techniques, like dry ice, to mimic steam. You can play with that, too, if you wish. Just remember to not drink your cup of joe.

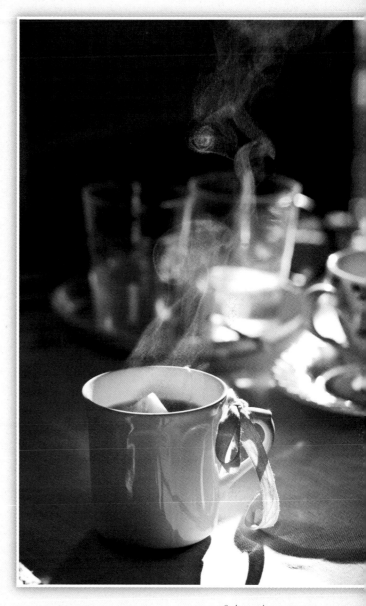

Styling and capturing a steaming cup of tea is all in the timing!

f/5.6, ISO 400, 100mm, Macro L

The cup in this image is positioned in front of the main light source, which lights it from the back and plays off other cups and glasses in the background. Instead of setting up on a dark linen, I decided to play off the deep shadows coming onto the table at this time of day. When everything was set up, I poured boiling water into the cup and started taking pictures. It went fast. After just five to eight minutes, the steam was half that height!

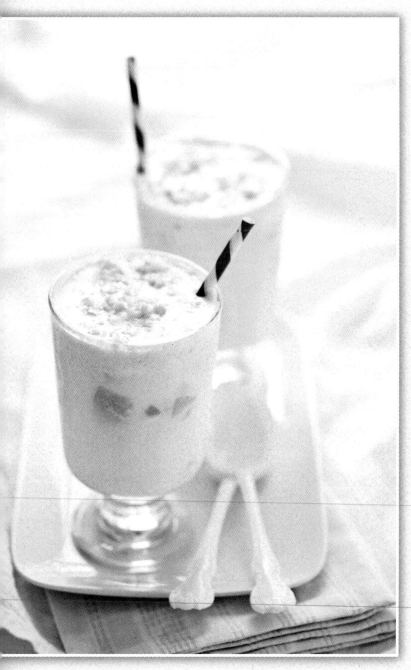

Styling cold or semi-frozen desserts such as Peach Almond Milkshakes can almost feel like performing surgery.

f/3.5, ISO 640, 100mm, Macro L

Cold Beverages

The same idea applies to cold beverages. If you want frosted cups, make sure to place your glasses in the freezer for a few hours (as described in the section on ice creams). If you want a dewy look, use very cold liquids and a cold glass. Real alcohol has a tendency to make ice melt faster than water, so be prepared for that if photographing cocktails. The key to capturing cold beverages is to have everything very cold.

There are a couple of techniques that professionals use from time to time to add dew to a cold drink. One is to use a steamer against a cold glass. The other is to apply a mixture of light corn syrup and water with a stiff toothbrush. Online, you can purchase or rent fake ice cubes, drops, spills, bubbles and other gadgets. (www.trengovestudios.com is a good resource.) It's frightening and fascinating to see all the illusionist equipment that's available for food photography!!

Garnishes

Garnishes add a nice touch to drinks, especially cocktails and cold beverages. When

you think about sugared rim glasses, consider different colored sugars for a new look. Twisted lemon rinds or peels are great, too, or a sprig of herb … if the recipe for your cocktail or drink includes it. And use fun silverware sometimes, like colorful long-stemmed spoons or fun striped straws.

For the picture of Peach Almond Milkshakes (left), I made sure that both the liquid and glass were really cold when I began styling. The recipe called for whole pieces of peach in the milkshake, but once poured in the glass, these pieces kept moving away from the front. So it was impossible to tell they were there. To make this important ingredient visible, I used straws to hold the peach pieces in place at the front.

Instead of using plain white straws, I picked up some fun candy-striped ones online. Still, I had to move quickly, because the warmer the milkshake became, the more the pieces of peach pushed up the straws … up and out of the glass!

Snapping good images of hot and cold items is really a question of timing. Even if you use techniques that are meant to enhance what you already have, you must be ready. As a stylist, you need to make sure that you have all your tools and props ready to go when the food is set on the table. As the photographer, be sure you have all your camera modes and settings adjusted. Because once that hot cup of coffee is in front of your camera … tick tock. The clock seems to move much quicker.

Helpful Tools

Before you say *gross* when I suggest using things like tweezers and cotton swabs to style your food, consider that using such tools is just a matter of upgrading from your fingers. Being prepared with the proper equipment to fix things quickly will help you keep the food you're photographing looking as fresh as possible.

If you're a blogger with a hungry family waiting on you to style and shoot so they can eat, having the right tools at your fingertips will make you even more efficient. If you're a budding stylist, it's absolutely necessary for you to get acclimated to using tools other than your fingers. Some foods might be slimy or greasy … or things might be hard to reach and move, especially pieces of vegetables in pasta or soup.

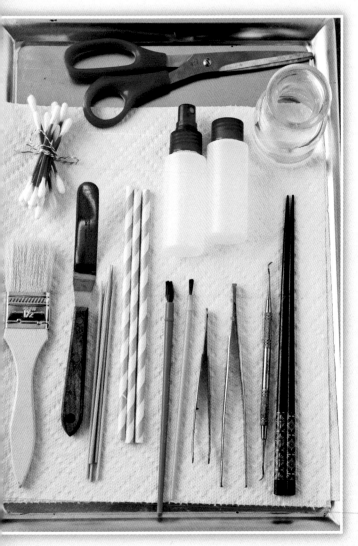

Some of my favorite styling tools include tweezers, cotton swabs, paint brushes and chopsticks.

f/8, ISO 400, 24-70mm L

I keep all of these tools close to me when I work. As the cook, photographer, food and prop stylist, and image post processor, being ready for any situation is imperative. Since I haven't figured out how to squeeze that 25th hour in a day, I still need to make the best use of my regular time and space. Of course, using these tools took a little getting used to, but now I can't do without! So let's go through my basic tool kit (pictured left).

Tweezers

I usually carry both a short and long pair of tweezers for versatility, but I find myself using the little one more often—probably because it fits better in my hands. They came from a regular pharmacy store, and these tweezers are used only with food.

If you think about it, fingers can easily move from the food to the tripod, lenses, filters and reflectors … and then onto your computer if you shoot tethered. They can make this round several times during a shoot; and frankly, I don't feel like wiping down my fingers every time I must move something on the plate, especially if the dish is greasy or has a sauce. So my tweezers function as my fingers when I'm styling. It's more hygienic and a lot more precise.

Cotton Swabs

Cotton swabs are to a food stylist what a napkin is to a chef or waiter: a perfect tool for wiping a plate clean of any unattractive spills or splashes. Yes, that too is part of food styling. There's always one minute available to look at your setup and wipe things clean.

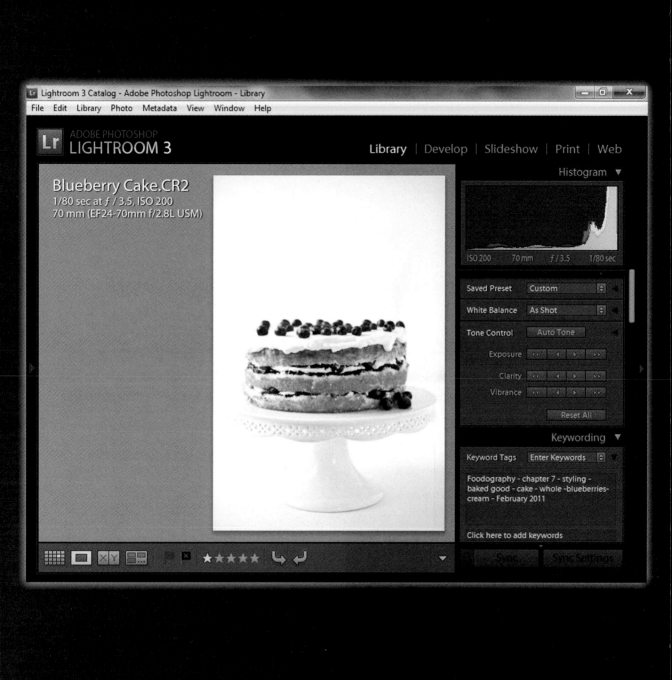

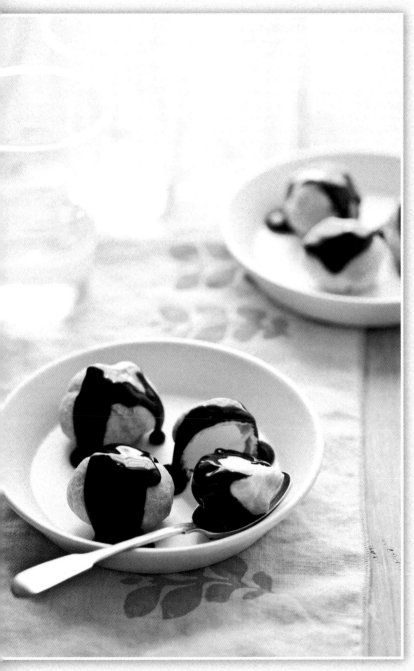

A squeeze bottle with a large opening in the nozzle made it fast and easy to pour the sauce on top of the profiteroles.

f/4.5, ISO 400, 100mm, Macro L

Squeeze Bottles

When time comes to plate sauces or add sauce to the top of a dessert, nothing gives you as much control as squeeze bottles. They make it possible for you to control the speed, direction and amount of a pour much better than a spoon. Plus, squeeze bottles can prevent spills and drops that are a hassle to clean.

Drinking Straws

These are very helpful for softening the edges of ice cream and giving scoops a ruffled edge that makes them look as if they've just been scooped by the hands of a pro in a ice cream shop. They can also serve as great props for beverage shots.

Food styling centers on coherent and focused decisions. There is nothing complicated about it, but good styling requires close attention. Having the ability to think quickly … and adapt in a snap helps, too. The most beautiful shots of food are realistic, accessible and balanced. Make it happen.

Paper Towels

Always keep a roll of paper towels around. Here's why:

* If you forget your tweezers, you can always wipe your hands clean with a damp paper towel after you've been messing with the food.

* If you forget cotton swabs, you can still clean off the plate.

* If you have to plate a dish on a pretty linen or a nice tabletop, you can cover that surface with paper towels to help avoid stains made by spills.

Paint Brushes

As mentioned, a nifty trick to enhance certain foods is to dab a little vegetable oil or water on the surface. A fast, precise way to do this is with paint brushes. In my tool box are various sizes ranging from very thin to three-inches wide. I prefer brushes with plastic handles, because paint from the wooden ones has been known to chip … and I don't want that additive in my shots or my food.

Water Spritzers

I'm rarely more than a few centimeters away from my water spritzer. That's because there is just nothing like water to bring life back to a dish, especially if you've been having issues with the camera and light setups, composition or other photo techniques. As it happens, by the time you're finally happy with what you see in the viewfinder, you realize that things on the plate haven't been as patient as you'd have liked. When food begins looking a little drab, dry and lifeless, a spritz of water can do wonders.

This is also very handy for giving fresh fruits and vegetables a natural dewy look.

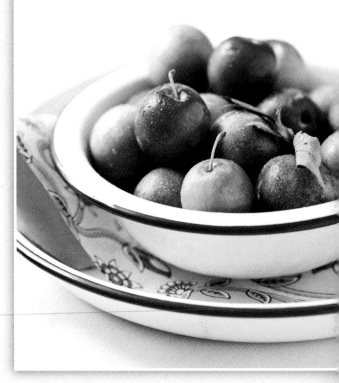

These plums were styled with a few spritzes of water to suggest they were freshly picked or just washed and set out to dry.

f/5.6, ISO 640, 100mm, Macro L

8 ✤ After Capture

Yay! All of your pictures are now in the box, so to speak!
What's next?

Ask five photographers what they do after shooting and
chances are you'll hear five different ways to approach
downloading, editing, storing and sharing files. With
different priorities, equipment, preferences and skills,
photographers do not operate in a universal way.

Yet a functional level of organization for handling image
files is crucial for every photographer—casual to pro.
Without a good system in place, files and data are easily
lost, and depending on how many photo files you have on
your computer, it can require lots of precious time to find a
specific picture—time you could spend photographing some
good food!

This chapter covers the basics of transferring files from
your camera to your computer, editing and organizing those
files, and considerations for sharing your images. But it only
scratches the surface of all the tools available for you take
care of your pictures after capture. Since each tool and
software program comes with its own way of operating and
a set of pros and cons, it's smart to become familiar with
a range of options by doing a thorough research online,
reading reviews and asking other photographers you trust.

Transfer

There are numerous ways to transfer your pictures. The two most popular methods:

* Use a USB cable to attach your camera and computer.
* Use a memory card reader.

Cables

No matter what type of camera cards you use—Secure Digital (SD), Secure Digital High Capacity (SDHC) or Compact Flash (CF)—you can transfer files from your camera to your computer with a USB cable. Almost all new cameras come with a dedicated USB cable. If you're missing one, this accessory is inexpensive and available at electronic and office supply stores (e.g., Best Buy, Fry's, Office Max, etc).

To use a USB cord to transfer your images from your camera to your computer, it's usually as easy as plugging one end into your camera and the other into your computer. Then turn on your camera. From there, the software installed on your computer will likely provide a pop-up screen and guide you through the process to transfer files.

If by chance, nothing happens when you connect your camera to the computer, don't panic. Through the software, you can set up the program to open automatically when connected. Or, since your computer reads your camera as if it is another drive, you can access your image files by going to your computer panel and finding your camera. Click to open and begin the transfer process.

> **TIP**
>
> Given the sheer number of camera brands and models as well as types of computers, it's important for you to refer to the manuals of your equipment for specific information on how to download files properly with a USB cable.
>
>

Card Readers

You don't always need your camera to transfer files to your computer. You can do it by inserting the memory card into a card reader, leaving your camera out of it. Your computer will recognize the card reader as another removable device. In some cases, this will prompt a pop-up window to let you pick the photo-editing program you want to use.

Card readers cost anywhere from $20 to $100+ depending on the brand and model you choose. Readers that are compatible with multiple kinds of cards will cost more than those designed for a single kind of card. A more flexible reader may be useful if several users in your household will use the reader with different cards.

Why consider a card reader instead of relying on a USB cord? Well, let's say you forget that your camera is still hooked up to your computer, and you enthusiastically grab it to go shoot. Uh oh, you just pulled your USB cord from your computer, which is never good for sockets. This is even worse if your computer is a laptop. It could end up on the ground before you realize it. And if you grab your laptop with the USB still in the camera, then you've got a case of flying camera. Unfortunately, I've done both. And even if you are way too observant to ever make this mistake, kids and pets running across cables can have the same effect, and it's a stomach-wrenching feeling.

With a card reader, if you forget to unplug the device from your laptop, all you risk is a dangling card reader that will stay there until the next time you use it. Definitely the less traumatic scenario.

File Size

The size of image files you receive from your camera depends wholly on the model of your camera. The files on my Canon Rebel XTi, for example, are smaller than those on my Canon 5D Mark II. So, if you choose to switch cameras, make sure that your computer and software can handle the upgrade. And if you shoot in RAW format (covered in Chapter 1: Photography Basics), be prepared for huge files no matter what kind of camera you use. Bigger files mean more image data is available and therefore higher quality. But you need to have the space to accommodate them.

Edit

Now that you have downloaded your files, it's time to play! Editing is an important part of what happens after capture. I hope that I convinced you, in Chapter 1 to shoot RAW images. So remember that these must go through a little bit of editing before they become viewable pictures on a screen.

Think of a RAW file itself as an editing tool. If you try to upload one to your blog or your work portfolio, chances are it'll be rejected. It's not you; it's the file. Much like a negative going through various chemical baths, your RAW files needs to be edited and converted into viewable files, such as a JPEG format.

Thanks to the world we live in, there are as many editing software options as there are ways to bake a cake. So take some time to look around, do some research online and read reviews to decide which editing program matches your needs.

Photo-Editing Software

Many manufacturers of digital cameras offer free photo-editing programs that are specific to their products. Read your manual and find the program that's offered for your type of computer (Mac or PC).

Free online editing programs are also available for download if you aren't satisfied with the one that comes with your camera. Not all of them will let you transfer and edit RAW files, so read the specifics and make sure that the program you use is appropriate for your goals and your camera.

Some of the most popular free online editing programs include:

- **GIMP** (www.gimp.org)
- **Paint.NET** (Microsoft specific)
- **PhotoFiltre** (www.en.softonic.com)
- **Photoscape** (www.photoscape.com)
- **Photoshop Express** (www.photoshop.com)

An online search will reveal many more options. Just be sure to read the site's specifications, terms of use and online reviews to see if one you like will be a good fit for your editing needs.

GIMP Editing Software

Not all free editing programs, whether they come with your camera or are available for download, are good and not all of them are bad. Some, like GIMP, have good reviews and are easy to navigate. But some are quite limited as far as options and results go, especially because not all have the capacity to handle RAW files.

So if you take pictures on an daily basis and edit large files, it's probably well worth an investment in a pro-grade editing program. The following list of popular options is by no means exclusive, but for professional results and a higher level of control over your editing work than the free programs offer, check into these:

- **Adobe Photoshop,** including Photoshop Elements, Lightroom, Creative Suite: www.adobe.com

- **Photo Mechanic:** www.camerabits.com

- **Downloader Pro:** www.breezesys.com

- **Apple's Aperture:** www.apple.com/aperture/

The choice you make for which photo-editing software to use is as personal as your brand of toothpaste. The program that's best for you is the one that meets your needs and accomplishes the tasks you desire. Take advantage of free trial versions to explore the capabilities and limitations of various programs.

Adobe Lightroom Editing Software

Apple Aperture Editing Software

227

Corrections and Adjustments

Depending on the image-editing program you choose, you'll have various kinds of tools for correcting and/ or enhancing your pictures, especially if you shoot RAW files. As explained in Chapter 1, RAW files are the digital equivalent to negatives before chemical baths in the days of film. They require a little bit more editing than a JPEG.

I always encourage new photographers to train themselves to shoot as if they were shooting film and not rely on their editing software to fix things digitally. It's time spent at a computer that could be spent practicing photography instead. But nothing is 100% perfect; there will be times when you need a little post-processing help.

You can, if you need to, use editing software to correct and remove spills from a scene, erase finger prints and clean up crumbs. Most offer ways to correct these problems, but some programs produce better results than others. While each company has proprietary ways to name and place those functions in their programs, look for words such as *cloning, erasing* and *healing*.

Enhancements can make your image a bit better than the version you shot. Again, it would be too easy if each manufacturer used the same words to describe applications, so I can only give you keywords to research your options. I recommend looking on amazon.com or at your local library for more thorough guides on how to use the various photo-editing programs.

Some of the most common enhancements relate to exposure, contrast, tones, saturation and white balance.

- **Exposure:** Balance your lights and darks if your out-of-camera photo is under- or over-exposed.
- **Contrast:** Enhance or minimize the gap between highlights and shadows in your image. This is especially helpful if you work from RAW files, as they tend to be less contrast-y than JPEGs out of the camera.
- **Tones:** Control the degree of shadows and highlights to balance the look of your photo.
- **Saturation:** Adjust the intensity of the colors in your photo by lowering or increasing saturation.

- **White Balance:** Adjust the white balance of a photo if needed. This is particularly helpful if you forget to reset the white balance on your camera when your lighting situation changes.

- **Digital Noise Reduction:** Reduce the digital look of grain in an image shot with a high ISO. Not all programs offer this, but it's a great tool when you need to minimize digital noise in your pictures.

Color Space

An important factor for post-processing is *color space*, which is the range of colors available for an image. The AdobeRGB (1998) color space produces a wider range of colors than the sRGB color space, which is used for most web applications and has less nuances of colors available. Most people know how to handle sRGB, but to ensure your picture is presented in the best way possible, it's a good idea to see if your end user(s) can work with large resolution Adobe RGB files.

HP and Microsoft cooperatively created sRGB in 1996 as a standard color space for use on monitors, printers and the Internet.. Print labs typically use sRGB as their default color space, but since AdobeRGB (1998) has a larger color range than sRGB, you want to process your images in AdobeRGB as much as possible. When you are completely done and settled on a finished image, you can convert to sRGB for printing. Oh, by the way, *RGB* stands for red, green and blue.

Effects

Digital photography has opened an entirely new world for imagery manipulation. Film photographers could play endlessly in the dark room on negatives and come up with really neat effects, so it's no surprise that amazing things can be done to enhance and manipulate digital photography. But just because you *can* do certain things doesn't mean you *should*. For food photography especially, keeping things as natural as possible is almost always the way to go.

> ### Pretend It's Film
>
> Despite the wonderful—and seemingly magical—power of post-processing editing tools, I strongly recommend capturing images as if you are shooting film without access to these tools. It's really no fun to spend hours post processing a shot when you could be taking ten new ones for another project. Save time by putting extra care when first capturing a scene.
>
>

Store

Right out of the gate, declare that you will be systematic and organized with your image files! If you don't, your work will quickly grow to an overwhelming mess, and it will likely require hours at your computer to locate a specific image. It's just not worth it to allow such a situation. So here's a system that can get you started.

1) **Create Folders**

Every time you transfer a batch of files from your camera, put them in a new folder. Name the folder with specific keywords of the shoot or maybe with a date. Just use a name that you'll be able to relate to quickly. The more specific you are, the more ways you'll have to find your pictures later.

Whether you use a Mac or PC, labeling your image folders well will let you search for files by alphabetical tag, month, year ... you can even rate them by order of importance.

2) **Name Files**

After editing a file, you'll need to save it again—with a new file name. This is important, as it preserves the original version of your image. You can save the edited versions in the same folder you created when originally downloading them to the computer, or you can create a new folder for the edited versions.

When you name the image files, be specific. Use keywords that will help you identify the subject matter quickly. For example, let's say you took a picture of blueberry waffles for your blog. A generic title, like "breakfast," likely won't be too helpful months or years from now. Instead, describe the image and its use. Something like "blueberry_waffles_breakfast_blog_March2011." Or, if it's a photo for a magazine, use "blueberry_waffles_breakfast_ CharlestonMagazine_Issue 9_March 2011." You get the idea.

3) **Add Tags, Labels**

Editing programs such as Lightroom and Photoshop have great systems for flagging, rating, tagging and labeling images. This saves a great deal of time when looking for them. Each editing program being different, refer to the help menu of the one you're using (or use the how-to manual specific to your program) for information on how to use the various tools.

Tag and label your image files in Lightroom.

Being organized and systematic with your image files makes the business of photography much more efficient and fun. Don't waste your time being sloppy with your files, especially after working so hard to create them.

And take the extra five minutes needed to add metadata to your images. *Metadata* is information about your photo. It contains camera settings and other image data that your camera automatically embeds into your file, but metadata can also include any information you want to add about the image or yourself: name, email, street address, copyright info ... and even your cat's name, if you want.

This information can be embedded into any file format, but it is particularly useful if you work from RAW and save to a compressed format, such as JPEG or TIFF. Although metadata can be changed to appear as if your image is the work of someone else, the one you enter and save on the RAW file makes it easier to track the image back to you if you ever need to show proof of ownership of the image. (See section Copyright Consideration.)

Backup and Storage

Trust me, it's always when you least expect it that you lose files. I've had it happen with Word documents, and I definitely don't want to go through that kind of anxiety with my image files. It's a huge time eater to try—sometimes in vain—to retrieve or re-create important files.

While I don't always keep 100% of the files from any given shoot, I do select a handful of pictures to keep from every project—even if it didn't turn out as well as I'd hoped. I've been surprised by requests—even months after a shoot—to purchase images I didn't think were particularly good. It's reminded me to keep at least three backups of every file and samples of everything.

With your RAW files especially, backup your images in at least three places. Your computer may crash, your external hard drive may get corrupted, a DVD may get scratched or broken. Or a fire, flood or other natural disaster may occur. So try to ensure that one of your backup places is offsite. … to protect your hobby, your livelihood, your memories.

One of the most popular ways to store files is to use DVDs. But this may not be practical if you photograph with semi- to pro-level cameras, given the size of the files. This is definitely a problem if you shoot RAW or high resolution JPEGs. So in many ways, storing is like editing, a highly personal affair that depends heavily on your budget and specific needs. Below are a few popular options to get your search underway.

- **RAID:** Redundant Array of Independent Disks is a drag-and-drop file backup system that divides and replicates information among several disk drives. This technology increases data storage reliability and improves the input/ output performance of your storage system.

- **External Hard Drives:** It's always good to have a few external hard drives around the house. These handy devices plug into your computer and allow you to drag and drop files onto them. It keeps all the data as it is on your computer hard drive, so you can delete the folder from your hard drive to free up some space and create additional capacity to your computer system. External hard drives come in a wide range of shapes and sizes, and different models have various levels of storage capacity. External hard drives are not foolproof though; they can get corrupted, so it's always wise to check how yours is doing before uploading more files.

- **Online Remote Backup and Storage Devices:** These online "facilities" allow you to back up and store documents and pictures for a monthly or annual fee. Some of the most popular are SOS Online Backup (http://www.sosonlinebackup.com) for Mac only, Carbonite (www.carbonite.com) and Mozy (www.mozy.com). They all offer different storage options, back-up schedules and recovery options, so read online reviews thoroughly as well as each site's Terms of Usage and FAQs page.

- **Drobo Data Storage Box:** *Drobo* is an abbreviation for "data robot." This is a physical box that you store in your home. Depending on which model you select, a Drobo can house up to four, five or eight hard disk drives. Some key features that users appreciate are that Drobos easily add new storage devices very fast and without downtime and that multiple hard drives do not need to match to work with the this device. Manufacturer, capacity and speed can be different among drives supported by a Drobo.

- **USB Flash Cards:** Also called *thumb drives*, these compact storage devices are highly portable and practical for photographers on the go. I usually keep a couple thumb drives close by when I travel, because they require very little physical space, each one can store up to 32GB, and they are well-priced.

Share

Fortunately, photography is not only about the nitty gritty of camera settings, file backups, storage and post processing. Sharing your pictures online and in print with friends and family—and maybe even clients—is a huge reward after working so hard to create them. So let's say you want to send your mom a picture of your latest creation or a magazine wants to feature your work in their upcoming issue (woohoo!). Well, there are several options available ... and the ones I mention are by no means the only ones.

Email

A quick and easy way to send low-resolution files is to just email them. Of course, you need to be careful about how many images you attach to an email and the size of each file, because there are limits. And the more files you attach to a message, the longer it may take for your computer to upload and send them—and for your recipient to access them. But you can easily send a dozen low res files if you need to use this platform.

File Sharing Programs

At a certain point, email is not going to cut it. When you need to distribute high-resolution files, for example, look into online file sharing programs. Some suggestions:

- **YouSendIt:** www.yousendit.com

- **Box:** www.box.net/signup/g

- **Cloud Files:** www.rackspacecloud.com/cloud_hosting_products/files/

- **ShareFile:** www.sharefile.com/

These services require a minimum payment per use or a monthly or yearly membership, but they are very easy to use and they're convenient. These programs can take the headache out of exchanging large files in a secure way.

File Transfer Protocol

You may be asked on occasion to use a different method for uploading and transferring files securely. And the most common platform, aside from email and subscription-based file-sharing programs, is the File Transfer Protocol (or FTP). This is a standard protocol used to copy a file from one host to another over the Internet.

Typically, this works as follows:

1) Your client will create an account, username and password.

2) You will receive the server name in order to begin copying files from your computer to the client's server.

3) You will need to download an FTP access tool to start the process. Since there are many different ones out there, check with your client to find out which ones they use the most. I recommend using the same tool as your client, so if you have any technical issues, someone on their end might be able to help. Widely used access tools include:

 - **Filezila** (www.filezila.com)
 - **SmartFTP** (www.smartftp.com)
 - **FireFTP** (www.fireftp.mozdev.org)

4) Drag and drop your files.

Dropbox

This is a popular file hosting program founded rather recently, in 2008. It relies on cloud computing technology, which synchronizes files, to enable users to store and share files with others across the Internet. One of the greatest attributes of the Dropbox system is that it keeps track of a file you're working on while letting other people edit, modify and re-save it … without erasing its previous form. This is especially helpful if something goes wrong with your computer or files.

Printing

When preparing your images for print, you must be aware of resolution levels. In the digital camera world, the term *resolution* is often used to reference a pixel count. You'll also find the term *dpi* (dot per inch) used where *ppi* (pixel per inch) is more appropriate. But both refer to resolution of an image and indicate the number of dots per inch that the printer will render to form your image on a printed page. Without going into details, know that you will get a better-quality image with a greater dpi count.

A printer or a publication will ask you for a high resolution image, either JPEG or TIFF, because they trust that you will have already edited them according to your photographic style or the job specifications.

And although it's not likely to happen, don't disregard the possibility of theft. Never share your originals, your RAW files. These precious files store a huge amount of information, including metadata. (See section Add Tags, Labels above for info of metadata.) So if a client requires a copy of an original, be sure to copyright it first to establish proof it is yours.

Resolution

Format your images as JPEGs or TIFFs to email or upload them to sharing programs. Because the physical resolution in pixel per image (ppi) of a computer screen is between 72 and 96 ppi, it won't make much difference to what you see on your screen whether you look at a high or low resolution image there. But resolution matters a lot when you take your pictures to print.

Just Ask

Always ask questions, it's your photography after all! Never be afraid to ask a printer for a sample of their work to see how it is in real life. You want it to be represented the best way possible. If your image is going to a client, ask who will be handling the files. If you have doubt that it will be reproduced well, ask to be put in touch with this person to establish a rapport.

Copyright Considerations

Never think that your photography is not good enough to be stolen. Never think that you are "just a food photographer." The day might come (if it's not already happening) when you'll get picture requests from online or print publications—or that you'll find your photos on a website without your permission.

To protect your work, you need to secure copyright for your images. It may not prevent people from *borrowing* pictures (ahem …), but it will give you recourse to make the thieves stop using your work.

A deterrent is to watermark your pictures. A watermark simply puts a seal or a sentence directly on your photo. This is better than nothing, but it doesn't offer any solid legal protection. A watermark is sometimes a one-line sentence that can be easily cropped out of your picture. If this is your only measure of security, and it is removed through editing, then there is nothing visible that says it is your property.

To avoid this trick, some people place a seal or sentence somewhere on the photo that cannot be cropped out without compromising the quality of the image. This is a good alternative, but it's distracting to a viewer, especially if the watermark is right in the middle of the photograph. It works, but it's not ideal.

TIP

Even if you think of your food photography as a hobby for the time being, I strongly recommend you start thinking about the time when you'll sell a few images here and there or make a career of it. It is a great job, trust me. But it's important to understand the legal side of things.

Watermark, register and copyright your pictures. You never know where one of your images will appear without your knowledge and who will maliciously make money off of your work. The ASMP (American Society of Media Photographers) has a wealth of articles for you to explore and research the topic of fair use and copyright:

- **Copyright Overview Tutorial:** http://asmp.org/tutorials/copyright-overview.html

- **Videos on Copyright:** http://asmp.org/content/registration-counts

- **Best Practices for Registering:** http://asmp.org/tutorials/best-practices.html

- **Terms & Conditions for Image Use:** http://asmp.org/tutorials/terms-and-conditions.html

Most, but not all, editing software programs have a watermarking function. If yours does not, there are programs available online for download. They vary in terms of ease-of-use and price, so I'll say it again … explore the options.

The second and by far the most effective way to copyright and protect your work is to register it with the US Copyright Office. Even if you deal with countries other than the US, this will establish that the photograph is originally yours. You can start registering your copyright for $35.

There are different types of registration. The best one for you depends on how you wish to register your files: online or paper filing. Each option has a different price. Please visit the US Copyright Office online at www.copyright.gov/ and start reading! There's a wealth of valuable information there on how to protect your work. Find a detailed tutorial on how to register your work electronically on the ASMP website at http://asmp.org/tutorials/online-registration-eco.html.

The information provided in this chapter is meant to provide you with some ideas to explore for editing, storing and sharing files. There is an entire universe of products and services available for managing photographs. It really pays to spend some time researching and comparing the options to find the tools that can help you.

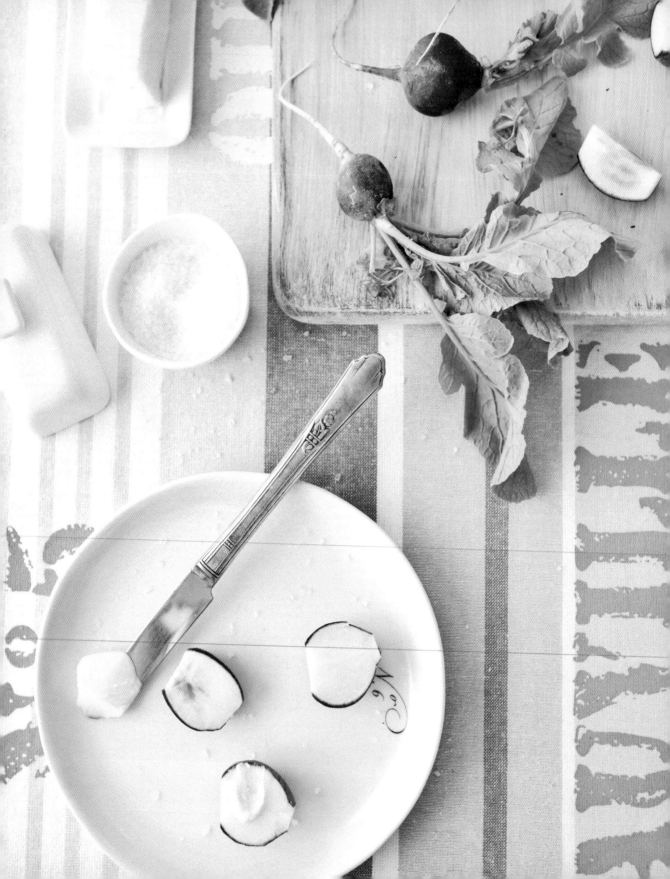

Appendix A: Glossary

Adobe: Creator of Photoshop, Lightroom and numerous other applications for media creation.

Aperture: Term that refers to the size of your lens opening. Aperture is measured in f/stops and affects the exposure and depth of field present in a photograph.

Auto-Exposure: A setting that tells the light meter in a camera to determine automatically what shutter speed and aperture to use in order to obtain a balanced exposure.

Auto Focus: A setting that tells the camera to determine when the subject is sharp and to bring it into focus using motors and a sensor in the camera or lens.

Back Lighting: A setup in which light enters a scene from behind the subject, facing toward the photographer.

Camera Shake: Movement of the camera and/or lens when a picture is taken, which results in visible blur. Camera Shake most often occurs at low apertures and low shutter speeds. A tripod can help photographers avoid this.

Camera RAW: An unformatted digital camera file that requires conversion software before it can be edited. Unlike with a JPEG file, the camera does not format or compress a RAW file as it is stored on the memory card. This preserves the original quality of the image. A RAW file is considered a digital negative, because it is not yet usable as an image but contains all the unprocessed data to work with in post processing.

Continuous Lighting: Term that is the opposite of *flash lighting*. The sun, hot and fluorescent lights, and studio lights are examples of continuous lighting.

Depth Of Field: Often abbreviated as DOF, this term refers to the amount of space in picture that is in focus. Shallow DOF is characterized by very little of the scene (usually the forefront area) in focus; deep DOF means that more of the image is in focus.

Diffuser: A photography tool (anything sheer) that is used to soften and disperse incoming light.

f/8, ISO 400, 24-70mm L

Digital Noise: Appearance of little specks or grain on an image. More likely to be present at high ISO settings.

Directional Light: Any type of light that comes from a particular angle onto a scene.

dSLR: Acronym representing "digital Single Lens Reflex camera." This type of camera uses a single lens that's attached to a camera body.

Exposure: Refers to the amount of light received by a camera's sensor (or film). Exposure is determined by a combination of aperture, shutter speed and ISO settings. Images are either correctly exposed, *overexposed* (too light) or *underexposed* (too dark).

Exposure Compensation: A setting that allows one to override the camera's suggested exposure value when working in Aperture or Shutter Priority modes.

Fill Flash: Accessory lighting that supports a primary light source. A fill flash is used to reduce heavy shadows and fill in areas of a scene where light is insufficient.

Filter: Piece of glass that can be attached to the front of a lens to protect the lens or to change the quality of the light for a photograph.

Flash Lighting: A momentary burst of light shone unto a subject. This is the opposite of *continuous lighting*. On- and off-camera flashes, such as pop-up flashes and speedlights, are examples of flash lighting.

Front Light: Light source that faces the subject and comes from behind the photographer.

Gray Card: Simple tool that helps a photographer custom-set white balance. This is usually a piece of plastic or cardboard that's calibrated to a neutral gray of 18%.

High Key: Refers to a lighting technique that produces evenly distributed, low contrasted light with a predominance of light grey tones or light colors.

Hot Shoe: Metal piece located on the top of some cameras that connects an external flash or a wireless transmitter to the camera body.

LCD Display: Acronym for Liquid Crystal Display, which is a screen that's located on the back of a camera to enable a photographer and others to preview and review images, access the in-camera menu, and view the histogram and other tools.

Manual Focus: Non-automatic setting that requires a photographer to adjust focus settings of the lens manually by turning the ring located on the outside of the camera until subject is in focus.

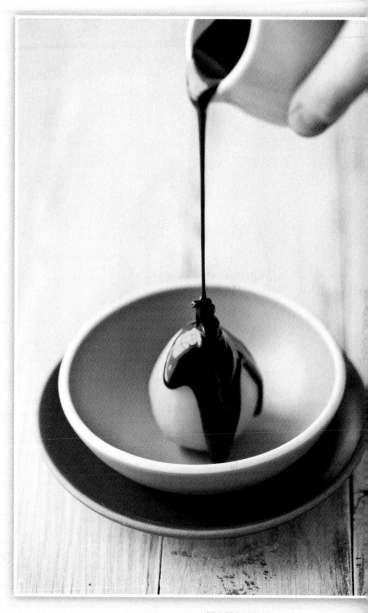

f/3.5, ISO 320, 100mm, Macro L

f/3.5, ISO 1250, 100mm, Macro L

Memory Cards: Small, square-shaped plates used to record images. The cards can be reused many times if images are erased. The most common memory cards are SD (Secure Digital) and CF (Compact Flash).

Overexposure: A visual situation in which the camera sensor is exposed to too much light or to appropriate light for too long of a time. This produces exaggerated (or *blown out*) highlights in an image. The opposite effect is *underexposure*.

Pixels: Visual data that appear as dots comprising a digital image.

Post Production: Any editing or manipulation of an image file that takes place after the picture is taken and downloaded to a computer program.

Prime Lens: A lens with a single focal length, different from a *zoom lens*. The most common primes are 50mm, 100mm, 85mm and 35mm.

Reflector: Anything that reflects light, including white paper, white porcelain, white foam board, aluminum foil, and store-bought products that combine gold and silver surfaces.

Radio Triggers: Device that enables wireless trigger of flash units.

Shutter Speed: Camera setting that refers to the amount of time the shutter is open during an exposure.

Side Light: Light source that comes from the side of a subject.

Speedlight: A small detachable flash lighting unit that works off the camera's hot shoe, whether it's connected directly to the camera or via a wireless system.

Sync Cord: Accessory used to connect a camera to an external flash, especially in studio lighting situations.

TTL: Acronym representing "through the lens"—a pre-signal that measures the amount of light coming from the subject. The tool uses this information to calculate how much power needs to come from the flash to get an appropriate exposure.

Underexposure: A photographic situation in which the camera sensor is exposed to too little light or to appropriate light for too short of a time, resulting in a loss of details in the shadows or dark areas of the scene.

Vignetting: Technique used with filters and lenses or while using specific effects in post processing to create darkened edges and corners on an image.

Zoom Lens: A lens that has a variable focal length, such as a 24-70mm lens.

f/3.5, ISO 200, 100mm, Macro L

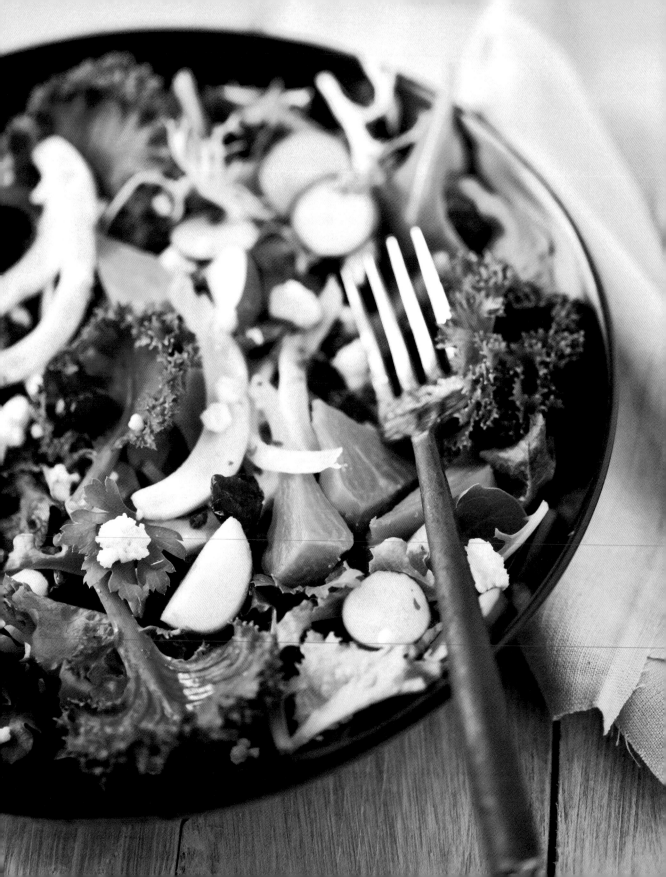

Appendix B: Equipment

What's in your camera bag?

When it comes to camera gear, everyone has favorites. And when people ask me what I use, I have no problem telling them. But when they ask what they should buy, I always tell them I can't answer that question.

Photography equipment is personal. To find the best stuff for yourself, think about what kind of photography you want to do as well as your budget, what you're already familiar with, etc. For instance, both my husband and I were satisfied using a Canon film camera and gear. So when we moved to digital, we continued to use Canon products. Between us, we have lots of gear. But he does portrait and architecture photography, while I shoot food, so we have two different approaches to our work. The upside of this is that we rarely fight over gear.

I love my camera bag!
f/3.5, ISO 200, 24-70mm L

My Camera Bag

It took me a while to find the right bag for my camera equipment, but I finally grabbed the Jill-E Jack Large Rolling Bag. I love that I can easily carry it on the plane … even for international travel. I carry it on photo shoots in town, too. The inside is made of padded compartments that you can move around and adjust with Velcro strips.

Here's what I carry inside my camera bag:

- Canon 5D Mark II + vertical release battery grip
- Canon 24-70mm f/2.8 L series
- Canon 100mm f/2.8 macro L series
- Canon 50mm f/1.8 prime lens
- Canon 35mm f/2.0 prime lens
- Radio Popper (transmitter + receiver)
- Canon 580EX II Speedlight

- AA batteries for pack
- Spare LP-E6 Lithium battery
- Memory cards
- 1 set ExpoImaging Rogue FlashBenders
- 1 ExpoImaging ExpoDisc
- 1 flash cap
- Clear lens filter
- Clamps

Take a peek inside my camera bag.
f/4.0, ISO 200, 28mm

Canon 5D Mark II
+ vertical release battery grip
I have small shaky hands, so the vertical release battery grip helps me a great deal when I have to shoot hand-held, especially when using the heavy 24-70mm lens. Some say it makes the camera as big as my head!

FlashBenders
I just started using FlashBenders, and I really like them. They are pliable reflectors that you wrap and snap around your speedlight with a Velcro belt. They come in different sizes and can be used either to bounce light back onto the subject or to shield light from it. It can also be used as a snoot to produce a tight and narrow circle of light. For food photography, I mostly use them as bounces.

ExpoDisc
I always carry an ExpoDisc, even though I've only used it twice so far. It's more of a safety blanket for me, but it's a great little tool for setting a custom white balance. In my studio, I know the light very well, and I know the appropriate white balance settings for this setting; but I carry the ExpoDisc whenever I shoot on location, in places where I'm not familiar with the light.

I'd rather adjust my white balance before I shoot than spend hours correcting it in post processing, and the ExpoDisc has been very helpful the couple of times I needed to be especially quick on my feet. To use it, simply place the ExpoDisc in front of the lens and capture the incoming light while setting your camera's custom white balance according to your camera's manual.

My Backups
I keep these items in the studio or in separate case while on location.

- Canon Rebel XTi
- Canon 100mm f/2.8 macro (old model)
- Canon 28mm f/1.8 prime lens
- Canon PowerShot A610

What's in your prop/tool box?

When it comes to props, we have all our own style and favorites. I covered some of my own preferences and resources in Chapter 6 (Setting Up for Capture) and Chapter 7 (Styling), but here's the gist.

- White dishes will never go out of style. They make it easy for your food to "pop" in the frame. You can also try lightly colored dishes.

- Dishes with lots of color and prints are fun to use, but be sure they don't distract from the food itself.

- Cotton linens are great and easy to care for, but try textured ones too, like hemp, grain sack or burlap. Colors and prints are also fun to incorporate into your shots, but again … make sure they complement and don't distract from the food.

- Vintage silverware is always fun to use and it's cheap to find.

Resources for dishes, silverware and other props:

- **Crate & Barrel:** www.crateandbarrel.com
- **Pier 1:** www.pier1.com
- **Anthropologie:** www.anthropologie.com
- **Dinnerware Depot:** www.dinnerwaredepot.com
- **Horne:** www.shophorne.com
- **Etsy:** www.etsy.com
- **Ebay:** www.ebay.com
- **Amazon:** www.amazon.com

For anything linen, I always check with the craft store or fabric stores in town and ask for 1 or 2 yards of the fabrics I like.

And never underestimate the power of yard sales, estate sales, garage sales and antique and vintage stores. Just be sure to leave some room in your suitcase when you travel!

Appendix C: Recommended Resources

Camera Equipment

Amazon: www.amazon.com
This is always a good place to start to compare and read reviews on products from customers.

B&H: www.bhphotovideo.com
Site offers new and used camera equipment.

Gary Fong Light Dome:
www.garyfongestore.com
flash diffuser

Jill E Jack camera bags:
www.jill-e.com/jack.html
Find feminine yet functional and sturdy bags, including small shoulder bags and carry-ons.

KEH: www.keh.com
Find new and used camera equipment here.

Light Bulb Emporium:
www.lightbulbemporium.com
halogen & fluorescent bulbs

Lowel: www.lowel.com
Find fluorescent lights, Ego Light, studio lights and more.

Opteka: opteka.com
Flash diffusers, lenses, flashes, brackets and more are available here.

Pocket Wizards:
www.pocketwizard.com

Radio Poppers:
www.radiopopper.com

ThinkTank Photo:
www.thinktankphoto.com
Large selection of camera bags,
is available here, including
everything from messenger
bags to carry-ons for travel.

Westcott:
fjwestcott.com
This is a great place for
finding pro diffusion
panels & lighting gear.

Websites by Food Photographers & Food Stylists

❖ *Still Life With* by Lara Ferroni:
www.laraferroni.com/category/still-life-with/
Great info for beginners and intermediate photographers
about equipment, techniques, gear and software.

❖ **Matt Armendariz – LA-based food photographer:**
www.mattarmendariz.com

❖ **Adam Pearson – LA-based food stylist:**
www.adamcpearson.com
Matt and Adam are among the kindest and most hardworking
people I know in the industry. Their constant enthusiasm for
their craft is seriously contagious.

Running With Tweezers by Atlanta based Tami Hardeman:
www.runningwithtweezers.com
Tami has fantastic styling posts on her site, where she takes you through the process of styling the most difficult foods out there, like curries, egg salads and soups.

Peter Frank Edwards:
www.pfephoto.com
Just go take a look at his photography. Then feel like you know nothing. Take a deep breath and feel inspired again.

The Strobist:
www.strobist.blogspot.com
Lots of information on lighting, including topics ranging from speedlights to studio kits.

Delores Custer:
www.delorescuster.com/home.php
Check Delores' site for updates on the food styling classes she offers.

FoodFanatics:
www.foodfanatics.net
Site by Denise Vivaldo and Cindie Flannigan Learn from trained chefs and stylists the techniques of food styling.

How To …

Distress Wood

There are many online sources for how to distress wood, but here are a couple of good options to get you started.

- **Basic guidelines on how to distress wood:**
 www.howtodothings.com/home-garden/how-to-distress-wood

- **Faux Fun – great website for all kinds of wood finishes and techniques:** fauxfun.com

- **Video – Distressing Wood How-To From Doctor Dan:** www.youtube.com/watch?v=4Iotye7dvAQ The editing is a bit cheesy but the explanations are clear and very useful.

Handle Photo Editing/ Post Processing

Photoshoplab, www.photoshop.com, is a great source of various tutorials that range from basic to advanced levels of post processing. Here are a few to get you started:

- **Photoshop Tool Basics:**
 www.photoshoplab.com/photoshop-tool-basics.html

- **The Elegant Studio Shot:**
 www.photoshoplab.com/the-elegant-studio-shot.html

Tutorials from Lightroom News, www.lightroom-news.com, offer great how-to videos of the most common tools you can use to post process your food shots:

- **Exposure and Brightness Adjustments:** lightroom-news.com/2009/03/21/exposure-and-brightness-adjustments/

- **The Tool Strip – Spot Removal:** lightroom-news.com/2009/03/13/the-toolstrip-spot-removal/

- **Mastering The White Balance Controls:** lightroom-news.com/2009/04/27/mastering-the-white-balance-controls/

General Photography

- **Creative Live:** creativelive.com/ Free online live workshops cover basic and advanced photography techniques as well as business-related issues for professionals.

- **On Choosing a Camera Lens:** www.chookooloonks.com/blog/2011/3/8/occasionally-technical-tuesdays-on-choosing-a-camera-lens.html *Occasionally Technical Tuesdays* is a series of photography articles by Karen Walrond.

Setup Supplies

Hardware Stores

These stores can be a photographer's treasure trove. Find wood planks and boards, paint, stains, paint brushes, and anything else you need to create your own backgrounds and surfaces. This is also a great place to find lots of different sizes for canvas drop cloths as well as different sizes of clamps to hold your reflectors and diffusers in place.

Fabric Stores

* **Online Fabric Store:**
 www.onlinefabricstore.net

* **Fabric Depot:**
 www.fabricdepot.com

* **Michaels:**
 www.michaels.com

* **Fashion Fabrics Club:**
 www.fashionfabricsclub.com

* **Cicada Studio:** cicadastudio.net

Props

There are so many places to find props that fit your budget and needs that it's impossible to list them all here. But here are a few options to get started:

* **Anthropologie** offers lots of great unusual colors and pieces, sometimes by overseas designers. Lots of little kitchen gadgets are here, too, that can be used as accents in photos. Their linen section is simply gorgeous.

* **CB2:** Described by many as the less serious sister store of Crate & Barrel, CB2 offers lots of fun-shaped dinning and drinking wares.

- **Crate and Barrel** is great for basic white china and some more interesting pieces, too. The store's seasonal items are a nice touch in photos.

- **Dinnerware Depot:** www.dinnerwaredepot.com

- **Ebay.com:** Anything you can think of can be found on Ebay … from dining ware and pots and pans to linens and vintage items. Be ready to bid!

- **Etsy.com** is great for vintage accessories, linens, handmade pottery and ceramics. You can even find some vintage furniture pieces.

- **Horne:** www.shophorne.com

- **Pier 1:** Price and quality here is hard to beat, especially if you like to rotate your props. Lots of items start at less than $5 and this store has great sales too.

Professional Photography Resources

The American Society of Media Professionals (ASMP) website (www.asmp.org) provides new and seasoned professional photographers with resources regarding licensing, pricing, copyrights, contract writing, and other legal advice.

Creating an online portfolio is easy, but price may vary according to what bells and whistles you decide to have on yours. If you are not keen on building your own portfolio website, the following service providers are among the most popular:

- Photobiz: www.photobiz.com

- LiveBooks: www.livebooks.com

- Blue Domain: www.bludomain.com

255

Books

- Adobe Creative Team, *Adobe® Photoshop 7.0 Classroom in a Book*, Adobe Press, 2002

- Bellingham, Linda, and Jean Ann Bybee, *Food Styling for Photographers: A Guide to Creating Your Own Appetizing Art*, Focal Press, 2008

- Custer, Dolores, *Food Styling: The Art of Preparing Food for the Camera*, Wiley, 2010

- Davis, Bob, *Lights, Camera, Capture*, Wiley, 2010

- Kelby, Scott, *The Adobe Photoshop Lightroom 3 Book for Digital Photographers*, New Riders Press, 2010

- Long, Ben, *Real World Aperture*, Peachpit Press, 2006

- McMahon, Ken, *Apple Aperture 3: A Workflow Guide for Digital Photographers*, Focal Press, 2010

- McNally, Joe, *LIFE Guide to Digital Photography: Everything You Need to Shoot Like the Pros*, Life, 2010

- Rand, Glenn, *Lighting and Photographing Transparent and Translucent Surfaces: A Comprehensive Guide to Photographing Glass, Water, and More*, Amherst Media, Inc., 2009

- Sammon, Rick, *Confessions of a Compact Camera Shooter: Get Professional Quality Photos with Your Compact Camera*, Wiley, 2010

- Smith, Jennifer, *Photoshop CS5 Digital Classroom*, Wiley, 2010

- Vivaldo, Denise, *The Food Stylist's Handbook*, Gibbs Smith, 2010

Index

A

American Standards Association (ASA), 20
angle of composition, 120–123
aperture. *See also* Aperture Priority
 adjusting, 16–18
 defined, 16
 depth of field and, 28–32, 111–112
 f/stops and, 16–18, 31
 lens speed and, 18
 shutter speed adjustments and, 19
Aperture Priority
 practicing with, 18
 using, 28–32
artificial lighting. *See also* flashes
 about, 67, 128
 creating studio kit, 38, 68–71
 distance between subject and, 74
 free standing lights, 90–91
 scrims, 71, 74–76
 selecting gear for, 68
 setting up, 72–75
 soft boxes, 91–93
Auto mode
 adjusting White Balance in, 24, 72
 ISO settings in, 20
 using with remote flash, 82

B

back lighting, 58–61
backgrounds, 152–155
backing up images, 232–233
beverages, 214–217
bouncing light
 reflectors for, 43–45, 76
 softening images by, 40–41
 speedlights for, 82–87
 umbrellas for, 72–74, 75
bread, 142, 171
breakfast baked goods, 203–205
burgers and sandwiches, 200–202

C

cakes, 206–208
camera, mounting speedlights on, 81, 82–87
camera modes. *See also specific modes*
 about, 5–7
 adjusting for off-camera flash, 82
 Aperture Priority, 19, 28–32
 Auto mode, 27, 82
 capturing movement with, 28, 32–35
 Manual mode, 27–28, 82
 mastering, 15
 selecting ISO using, 20
 Shutter Priority, 19, 32–35
camera shake, 18
cameras. *See also* camera modes
 balancing image exposure, 22–23
 built-in flash for, 76–80
 exposure, 16–23
 firmware in, 10
 hot shoe on, 78
 ISO scale for, 16, 20–23
 mastering settings for, 15
 metering for, 23, 74, 83, 92
 practicing with, 26
 selecting, 3–5
 setting White Balance for, 23–26
 shutter speeds, 16, 17, 18–19, 32–35
 soft boxes on, 91–92
 speedlights with, 82–87
 tethering to computer, 162–165
 transferring images to computer, 224–225
card readers, 224–225
centered compositions, 101–102
chopsticks, 205
cloudy weather
 adjusting White Balance in, 24, 25
 shooting outside in, 52
cold foods
dishes displaying, 215
 ice cream and frozen treats, 209–214
 styling cold beverages, 216–217
color
 lighting effects and umbrella, 70
 monochromatic, 158–159, 160–161